Floral Paintings

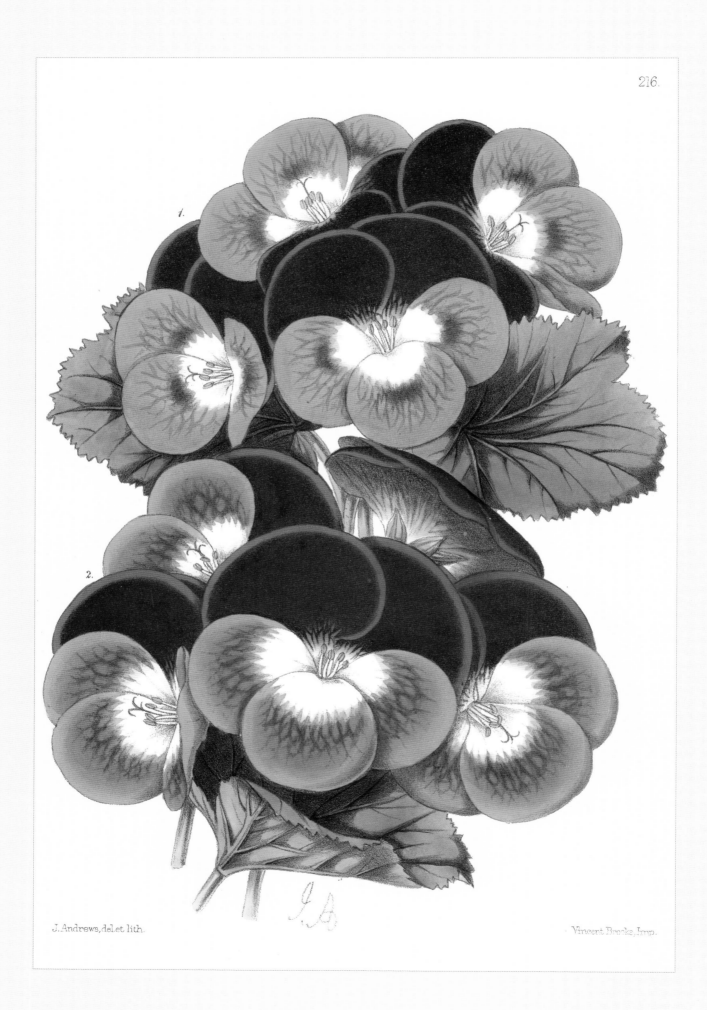

1.

2.

J. Andrews, del.et lith.

Vincent Brooks, Imp.

Floral Paintings

OF POPULAR GARDEN FLOWERS

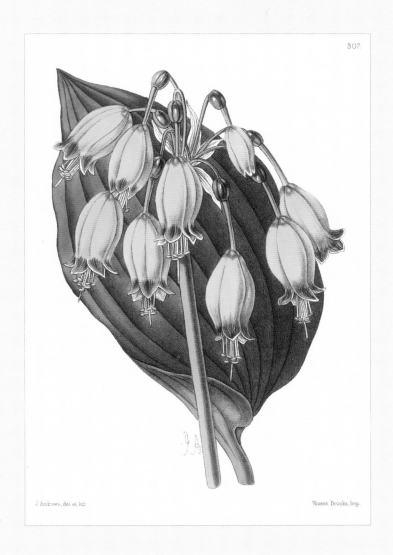

First published in Great Britain in 2011 by
Papadakis Publisher

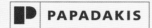

An imprint of New Architecture Group Ltd.

Kimber Studio, Winterbourne,
Berkshire, RG20 8AN, UK

Tel. +44 (0) 1635 24 88 33
info@papadakis.net
www.papadakis.net

Publishing Director: Alexandra Papadakis
Edited by: Sheila de Vallée
Diana Moutsopoulos, Sarah Roberts, Caroline Kuhtz
Designed by: Shirlynn Chui
Additional design: Aldo Sampieri
Intern: Connie Wong

ISBN 978 1 901092 69 1

A CIP catalogue of this book is available from
the British Library.

Printed and bound in China

Frontis: Pelargoniums, British Soldier and John Hoyle
Title Page: Urceolina Pendula

Plants illustrated

Achimenes, New Hybrid
Achimenes Rollisonii
Allamanda Hendersonii
Alpine Auricula, Victorious
Alternanthera Sessilis, var. Amœna
Anemone Fulgens
Aquilegia Cærulea
Astelma (Gnaphalium) Eximium
Aucuba Japonica variegata
Auricula, Princess of Wales
Azaleas, Charmer and Vivid
Azalea, Fascination
Azalea, Forget-me-not, (Ivery's)
Azalea, Surprise
Barkeria Skinneri Superba
Begonia Digswelliana
Berberis Stenophylla
Bignonia Argyrea Violescens
Bougainvillæa Lateritia
Calanthe Veitchii
Calceolaria, Bird of Paradise
Calceolarias, varieties of Herbaceous
Carnation, Lord Clifton
Carnations, varieties of Tree
Cattleya Exoniensis
Chrysanthemum, Lord Clyde
and St. Margaret
Chrysanthemums, Large-flowering,
Her Majesty and Lord Palmerston
Chrysanthemums, Pompon, Fairest of
the Fair, Mary Lind, and Julia Engelbach
Clematis Jackmanii
Clerodendron, Thomsoniæ Balfourii
Clianthus Dampieri, var. Marginata
Coccosypsilon Discolor

Cyclamen Europæum Peakeanum
Cypripedium Lævigatum
Dahlia, Alexandra
Delphinium, Triomphe de Pontois
Dipladenia Amabilis
Disa Grandiflora, var. Superba
Epidendrum Vitellinum Majus
Epiphyllum Truncatum Elegans
Eranthemum Tuberculatum
Fuchsias, Lucrezia Borgia and Fantastic
Fuchsia, Pillar of Gold
Fuchsias, Sanspariel and Hercules
Gastronema Sanguineum
Gladiolus, Charles Davis
Gladiolus, Eleanor Norman
Godetia Rosea Alba, Tom Thumb
Greenovia Aurea
Imantophyllum, Orange-coloured
Iresine Herbstii
Kerria Japonica variegata
Linum Chamissonis
Lobelia Coronopifolia
Lobelia, Progress
Lycaste Skinneri, var.
Monochaetum, Free-flowering
Nemophila, New Disk-shaped
Nerine Fothergillii
Orchis Maculata Superba
Ourisia, Pearce's
Pansies, varieties of Fancy, Impératrice
Eugénie, Harlequin, Admiration, and
King of Italy
Pelargoniums, Lord Lyon and Favourite
Pelargonium, Nosegay, Duchess of
Sutherland

Pelargonium, Queen of Whites,
and Monitor
Pelargonium, United Italy
Petunia, Mrs. Smith
Picotee, Colonel Clark
Pinks, Hybrid
Pinks, the Rev. George Jeans
and Lord Herbert
Pitcairnia Tabulæformis
Pyrethrum, varieties of
Ranunculus, Persian, Fidelia, and Linden
Raphiolepis Ovata
Rhododendron, Prince of Wales,
Rollison's
Rhododendron, Princess Helena
Rhododendron, Princess of Wales,
Young's
Rhododendron Thibaudiense
Rose, Bernard Palissy
Rose, Hybrid Perpetual, Miss Margaret
Dombrain
Rose, King's Acre
Rose, Tea-scented, Comtesse Ouvaroff
Saxifraga Japonica tricolor
Siphocampylus Fulgens
Solanum, variegated
Sphacele Cærulea
Swainsonia Magnifica
Sweet William, varieties of
Tacsonia Van Volxemi
Tricyrtis, Thunberg's
Tropæolum "Ball of Fire"
Tropæolums, Beauty and Attraction
Vallotta Eximia
Verbena, Really Blue

The Victorian period marked the pinnacle of British gardening periodicals and the botanical illustrations that decorated their pages. While botanical drawings had existed since ancient times for the practical use of identification, never before had a collaboration between art and science produced such a profusion of artists who focused on disciplined accuracy as much as the exquisite beauty of the specimens.

A time of relative peace and prosperity in Britain, the Victorian era was characterized by the height of the British Empire and the achievements of the Industrial Revolution. For the upper classes at least, indulging in leisure activities was the order of the day. Photography, scientific exploration, and the arts all thrived. In 1851, six million people visited the Great Exhibition in London's Hyde Park – the first of a series of nineteenth-century world fairs – featuring the bold architecture of the Crystal Palace, designed by Joseph Paxton, one of Britain's leading gardeners, whose design for the vast exhibition hall was based on the lily house he had built for the Duke of Devonshire at Chatsworth House, where he was head gardener.

It comes as no surprise, then, that cultivating and coaxing a flower to its fullest splendour was more than just a hobby. As new gardening techniques were developed and exotic flower and plant species were brought to England from across the globe, stoves and greenhouses became increasingly popular to house flora only before seen in the tropics. The introduction of new species, and the development of new varieties through selective breeding and hybridization, reflected the explorative spirit of the times; not only did Charles Darwin survey new lands on *HMS Beagle*, but nurseries sent plant hunters across the globe to find new species for their wealthy clients. The whole concept of gardening was changing. The bedding-out system was replacing the old mixed herbaceous borders. This in turn led to a huge demand for spring bulbs and other spring-flowering plants that were resistant to frost, to avoid the ignominy of empty beds until June. In addition, there was an increasing demand for plants and flowers. "For fêtes of all kinds nothing now is of any service but natural flowers and plants – the day for tolerating artificial flowers is past."

The term "florist" was applied to those who cultivated flowers or who were knowledgeable about flowering plants, both professional nurserymen and wealthy amateurs. The tulip, which was imported from the Continent

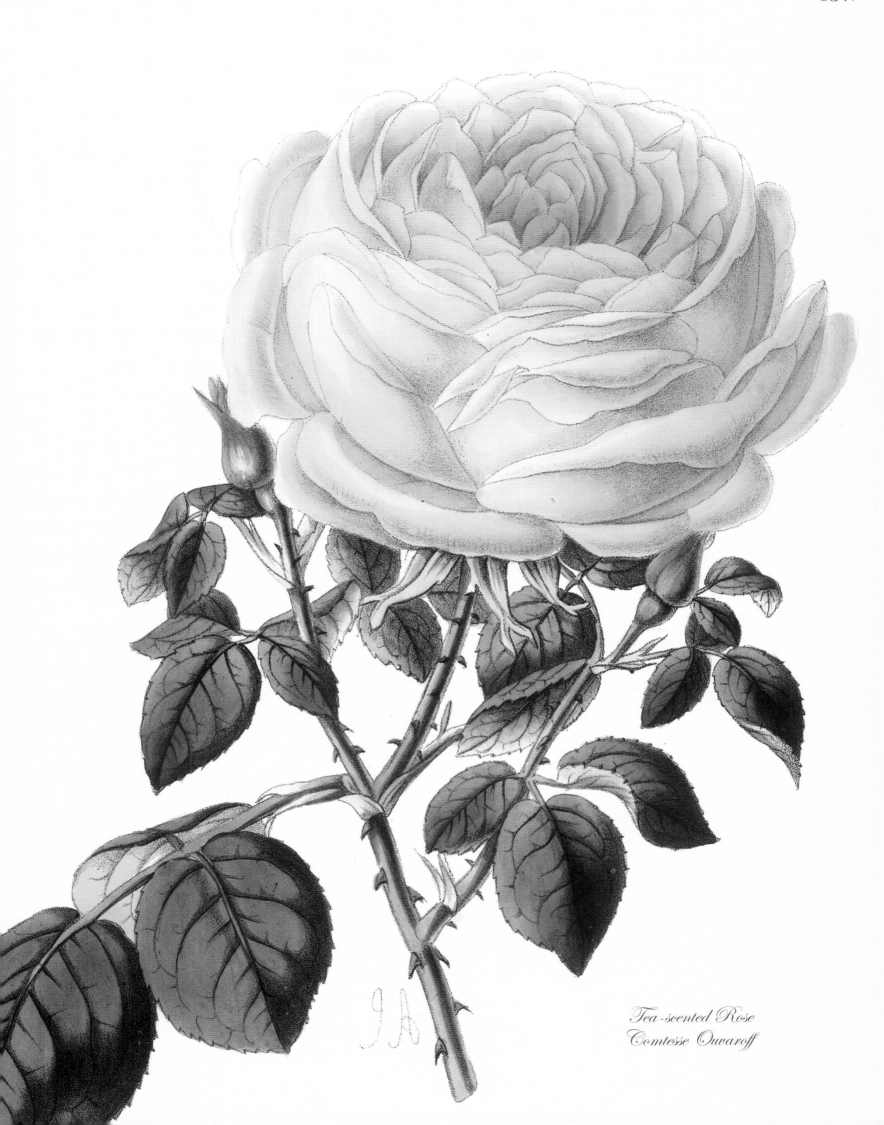

Tea-scented Rose
Comtesse Ouvaroff

in the late sixteenth century, was doubtless the first of the "florists' flowers" although the term was not coined until much later. By the eighteenth century there were a further seven – auricula, primula, ranunculus, anemone, hyacinth, pink and carnation – which all had their own specialist societies and flower shows. By the nineteenth century "fancies" had been added to the list and included chrysanthemums, dahlias, pansies, violas, and gladioli.

Florists not only grew flowers in their gardens and greenhouses. They showed them off at exhibitions and entered them in competitions organized by the many gardening societies. The Royal Horticultural Society was established in 1804 as the Horticultural Society of London and held an annual flower show in the grounds of Chiswick House, before moving to its present location at the Royal Hospital, Chelsea, in 1913. Medals and certificates were awarded for the best plants and flowers and all the leading nurserymen exhibited there, as well as amateurs who devoted much time and energy to the flowers they were so passionate about.

The wealth of gardening magazines in the latter half of the nineteenth century undoubtedly reflected and fuelled this national interest. *Curtis's Botanical Magazine*, now the longest running botanical periodical in the world, was established in 1787 for plant scientists, horticulturists, and those with a special interest in botanical illustration.

The 1830s saw the first wave of inexpensive gardening publications. Sixteen titles were introduced in that decade alone, and the cheaper publications proved fatal for higher quality, luxury magazines such as the *Botanical Register*, which ceased publication in 1847. The range of periodicals featured practical guidance as well as ornamental botanical drawings. Readers found illustrations of new varieties and indispensable advice on how to grow them. The best nurseries and plant breeders shared their gardening successes and secrets.

This volume captures a brief but delightful moment in the heyday of Victorian botanical illustration. Perhaps overshadowed by its publisher's most successful title, the renowned *Botanical Magazine*, *The Floral Magazine* is often forgotten in today's historical recollections of the era's gardening periodicals. As the only known volume dedicated to *The Floral Magazine*, the following pages serve to ensure it is remembered, presenting some of the

best illustrations by James Andrews, along with accompanying text by the Rev. Henry Honywood Dombrain that reveals the joys, setbacks, and preoccupations of flower-growers at the time. Little is recorded about the history of the magazine, and even less about Andrews and Dombrain.

Lovell Reeve, the founder of *The Floral Magazine*, was one of the most successful publishers of the Victorian era. He purchased the *Botanical Magazine* in 1845. Though the publication had been hugely successful at its inception, the arrival of several competing – and cheaper – periodicals during the 1830s brought a decline in sales. Perhaps in a move to diversify his offerings, in 1860 Reeve approached Walter Hood Fitch – arguably the most prolific of all botanical illustrators with an estimated 9,960 published drawings – and Thomas Moore, then curator of the Chelsea Physic Garden, to contribute to a new magazine targeted at "florists." And so *The Floral Magazine* was born. Reeve was disappointed, however, when he received less than profitable interest from the florists for whom the publication was intended. He was quick to lay blame on the magazine's editor and illustrator, as demonstrated in a letter to Moore, dated 29 April 1861:

> I have for some time past had a growing impression that our *Floral Magazine* has not been the sort of work that is desired by florists; and now that our first year of publication has expired and the gardeners and nurserymen have pretty freely expressed their opinions on the matter, I am no longer in doubt… My error has been that while desiring to establish a companion to the *Botanical Magazine* that should treat only of florists' varieties of garden flowers, I had recourse to a botanical editor and a botanical artist instead of a floral editor and floral artist… Having the *Botanical Magazine*, we not only do not want botanical subjects, but we want floral subjects treated both by editor and artist more florally, if I may be allowed the expression.

Reeve had replaced Moore and Fitch with the Rev. Henry Honywood Dombrain and James Andrews by the time the pages reproduced here were published in 1864, 1865 and 1866, evidently deeming them more of a floral than a botanical disposition.

The Floral Magazine was published monthly for two shillings and sixpence with a remit to devote its pages "chiefly to the meritorious varieties of such introduced plants only as are of popular character, and likely to become established favourites in the garden, hothouse or conservatory." Dombrain later extended the magazine's coverage, as he described in 1865:

"We have hitherto confined ourselves to those plants which were cultivated in the open air or greenhouse, but we have felt for some time that as the efforts of the hybridizers were no longer confined to these, but had extended to the denizens of the stove and orchid-house, and that owing to the more wide-spread taste for horticulture a larger number of persons cultivate these flowers than formerly, we should meet their wishes and give a greater variety to our Magazine, by figuring from time to time such plants as were valuable for their decorative effect, and not mere botanical curiosities."

Dombrain was born in Pimlico in 1818 and descended from the Huguenots. Unlike Moore, he had not worked on any other gardening publications prior to *The Floral Magazine*, although he was a member of the Floral Committee of the Royal Horticultural Society and a regular exhibitor at horticultural shows, where he won many prizes. He was the perpetual curate of the Church of St George the Martyr in Deal, Kent, and, from 1852, its first vicar. In 1868, he became the vicar of St Mary's in Westwell, where he remained until his death in 1905.

Dombrain harboured a passion for roses, becoming a celebrated amateur grower and distinguished lecturer on the subject. He later published his own volume, *The Rosarian's Year Book*, and founded the National Rose Society, both in 1876. It was speculated that his enthusiasm for roses stemmed from his French heritage, earning him the unofficial title of "The Consul for French Roses in England." He is also credited with introducing the Noisette rose, originally a French variety, into England. But he remained convinced that English roses, gardens and indeed gardeners were far superior to any on the Continent: "Nowhere does the real love of flowers exist in so remarkable a degree as in our own island and nowhere, albeit the many disadvantages of a climatic character for which we suffer, is their cultivation carried out with such great success."

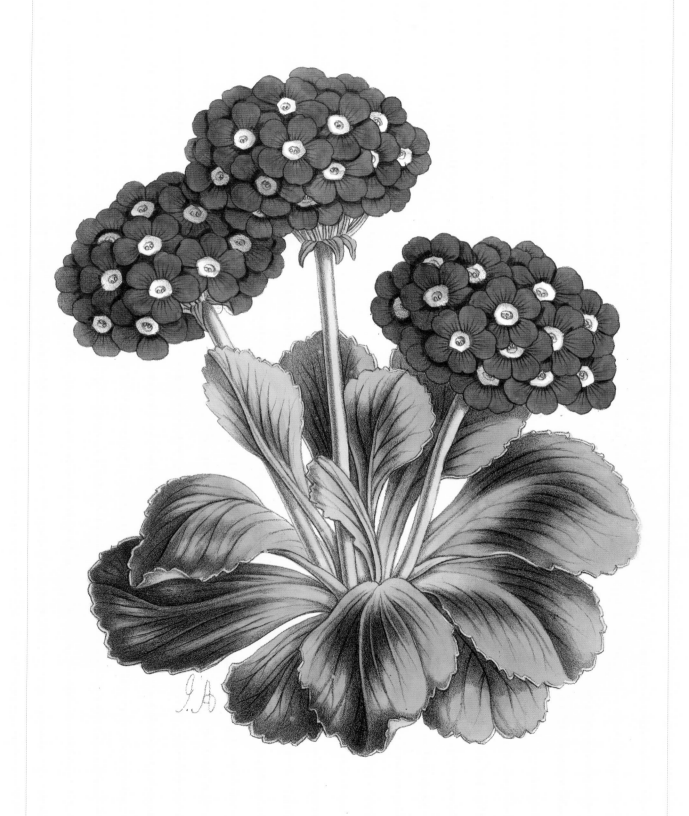

J.Andrews, del. et lith.

Vincent Brooks, Imp.

Primula Intermedia

Little is known of James Andrews, despite his great talents as a botanical artist. He was born about 1801 in Southwark in London, lived for many years in West Street in Walworth, also in London, where he died in 1876. He published his first flower drawing at thirty-four years of age and went on to produce thousands of illustrations for several authors. He is perhaps best known for his sentimental flower drawings featured in Robert Tyas's language-of-flower books, a genre that originated in France and paired floral drawings with poetry and prose, and for his how-to-paint flower books. His *Lessons in Flower Painting* is considered to be one of the best instructional manuals of the time.

In March 1857 he was awarded a medal by the Royal Society of Agriculture and Botany in Ghent, Belgium for a large still life watercolour painting of fruit and a bowl and for his watercolours. All the plates reproduced here – there were four in each number of the magazine – were drawn and engraved by him.

Despite Lovell Reeve's death in November 1865, *The Floral Magazine* continued until 1871 with Dombrain as editor and Andrews as illustrator. Ownership of the firm passed to F. L. Soper, who had worked with Reeve since 1862. The exact reason for the demise of *The Floral Magazine* is unknown, though it can be speculated that the increased number of gardening magazines had taken its toll. Before Soper took over, even the company's star publication, the *Botanical Magazine*, was experiencing a decline in sales. By 1865, its circulation was so low that returns were barely sufficient to cover production costs. When *The Floral Magazine* ceased publication in 1871, Soper tried to sell the leftover plates for one shilling.

The Floral Magazine was an ideal vehicle for Andrews' scientific and artistic abilities as an illustrator, and the richness and meticulous attention to detail of the lithographs reproduced in the following pages reveal his familiarity and intimacy with the subject. This book stays true to the format of the magazine: accompanying each drawing is the text by Dombrain that originally appeared alongside it. The words reveal more than the character of each flower, taking us back in time to provide a glimpse into the world, interests and difficulties of the Victorian flower grower. James Andrews' floral illustrations are timeless – an elegant marriage of art and science as much appreciated today as they were in Victorian times.

J. Andrews, del et lith.

Vincent Brooks, Imp

Pentstemon Jaffrayanus

We figured in our last volume a very fine new hybrid of the *longiflora* section of this very pretty and free-flowering class, called *Mauve Queen*, and we have now the pleasure of placing before our friends a sterling novelty of the scarlet-flowered section, of which *Meteor* and *Dazzle* form such excellent examples; it has been named *carminata elegans*, according to the fashion of giving Latin names to garden hybrids, a practice which we should be glad to see discontinued.

At the present time, the tubers are in a dormant state, and if properly treated, they have remained in the pots in which they were grown, placed on their side, in some dry shelf in the greenhouse. We have seen them taken out, dried, and hung in paper bags, but this is quite a mistake; they will, it is true, start, but they will take much longer to do so, and frequently they rot altogether, owing to the sudden change of situation. Those who are desirous of having an early bloom will set them to work soon; this is done by placing them in a gentle heat, and potting them in small pots, and amongst the little things necessary to be attended to in their successful cultivation, is that of seeing that the sides of the pots are clean, as if the soil adheres to them, it is liable to prevent the water from running away and so causing the tubers to rot; indeed, in all stages of their growth, it is well to recollect that they do not require a too frequent application of water, and therefore a situation in the house not too much exposed to the influence of the sun's rays, is the most desirable place for them. We have known some growers to place several plants of the more free-flowering varieties in boxes, and so to bloom them, and the effect is exceedingly good; they can be then removed into the dining-room, where they will continue in beauty for some time, and though the dry atmosphere and dust of such a situation is injurious to them, yet as they are treated as annuals this is of little consequence, provided that, after their beauty is gone, they are placed where the tubers will have an opportunity of making their full growth.

Achimenes, var. *carminata elegans*, is no doubt the finest of all the small and free-flowering section, producing spikes eighteen inches in length; its good branching habit is capable of producing specimens of three and four feet in diameter; thus making it a charming object for the summer and autumn months. It was raised by Mr. Parsons, of Danesbury, near Welwyn, Herts., and has passed into the hands of Mr. B.S. Williams, of Paradise Nursery, Seven Sisters Road, Holloway, by whom it will be distributed, along with *Mauve Queen*, about the middle of April.

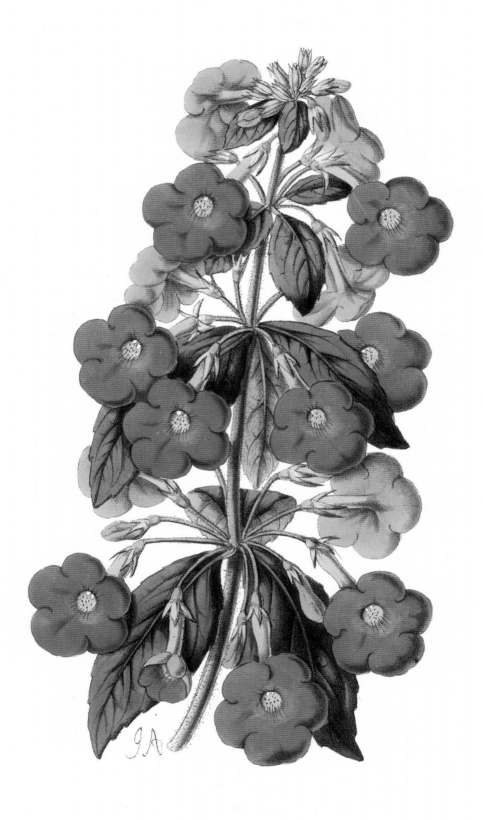

J. Andrews, del. et lith.

There seems to be always a danger in pronouncing how far flowers are capable of improvement, and when the limit of progress has been reached, for it has been said frequently that we could not expect anything further in this section of plants, while in various quarters this year some decided advances on former varieties have been made.

We were much interested, for example, when in Paris this summer, by seeing, at the celebrated establishment of Thibaut and Keteleer, some very curious varieties of both *Achimenes* and *Tydæa*. Those in the former section had been obtained by crossing *Achimenes* with *Sinningia*, the result of which had been a number of varieties most curiously spotted, and retaining the characteristics of both parents. Then we have also seen that Mr. Parsons, of Welwyn, so long and so favourably known for his success in hybridizing these beautiful flowers, has brought forward some very fine varieties, amongst which *Rose Queen* seems likely to hold as conspicuous a place in its class as *Mauve Queen* has done; while the Messrs. Rollison have also struck out into a new path, the result of which is shown already in the very beautiful variety now figured.

"*Achimenes Rollisonii*," say the raisers, "is a cross between *Achimenes gloxiniflora* and *Achimenes Shearii*, raised by us. It flowered for the first time in June last, and is without exception the largest and most beautiful variety obtained by seed from the Achimenes section of plants. It flowers during the months of June, July, and August, and will be found an invaluable acquisition to the greenhouse and conservatory, being robust in habit and a very free-flowering plant. The colour is a purplish-lavender, the lobes being very large and smooth on the edge; the throat is yellow, while the centre of the flower is thickly spotted with purplish-crimson spots; the diameter of the flower is large, and altogether it is a very striking plant."

It has surprised us much to see the very inferior specimens of this beautiful flower that have been brought forward at some of the metropolitan shows, the drawn and lanky appearance of many of them seeming to show that the culture of the plant had been but little understood; and yet few are more easily grown. The mistake is too often made of giving them more heat than they require, and the result is inferior plants; at any rate, we have seen at many provincial shows specimens far better grown than those sent in to some of our metropolitan exhibitions.

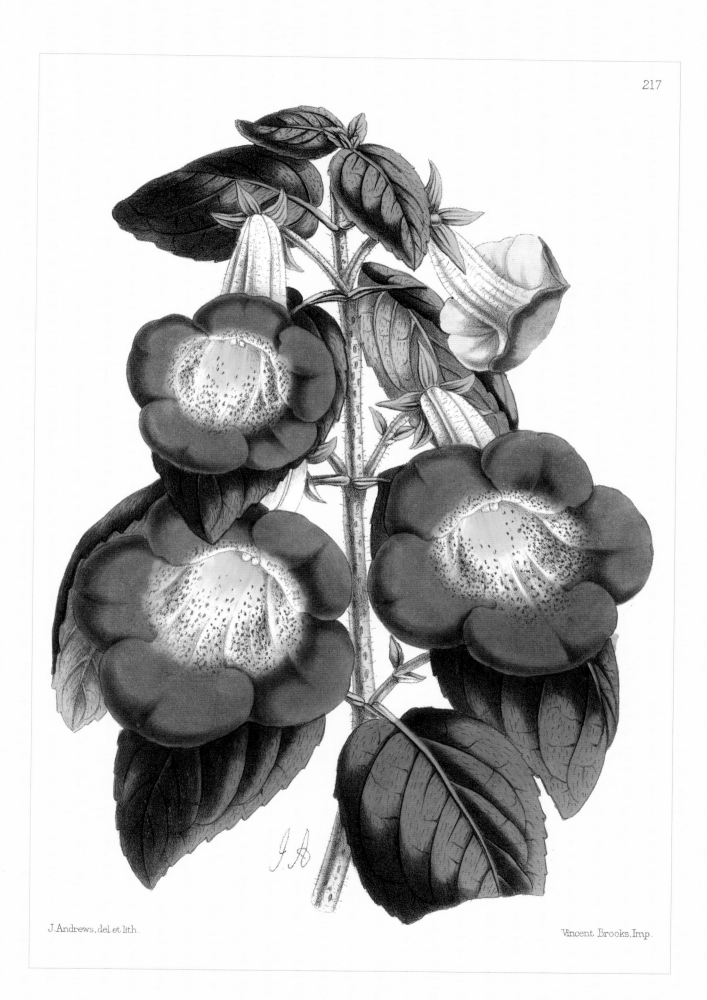

J.Andrews, del.et lith.

Vincent Brooks, Imp.

Few frequenters of the great Metropolitan shows can have failed to observe the very fine plants of *Allamanda* which are exhibited there by some of our leading plantsmen, the vigour of the foliage, and the bright clear yellow of these large and handsome flowers, always marking them out as objects of much interest.

Beautiful, however, as they are when thus treated, it is not in such positions that they are seen to the best advantage, it is when trained along the rafters of a stove, and allowed free liberty to roam at will, that the beauties of the several varieties are seen. *Allamanda cathartica* and *Schottii* are the kinds most generally in cultivation; and we have seen a beautiful effect in the stove produced by one of these varieties, and the glorious *Stephanotis floribunda* mingling together their flowers and foliage, the latter attracting as much by its delicious perfume as by its pure white waxy-looking flowers.

None of the varieties of this remarkable family are, however, at all to be compared with the very beautiful and striking flower which Mr. Andrews has so faithfully represented in our Plate. It was originally imported from Guiana by Messrs. A. Henderson and Co., of Pine Apple Place, from whom it was purchased by Mr. W. Bull, of Chelsea, and will be by him distributed during the present month.

The description given of it by Mr. Bull is as follows: – "*Allamanda Hendersonii* is the largest-flowered orange-yellow Allamanda known, lobes finely formed, immensely thick and wax-like, and tinged with brown on the reverse side. The plant begins to flower about the same time as the other Allamandas; but, when once it commences, it possesses the excellent property of being continuous; thus the blooming is prolonged throughout the season, so that it will be available for exhibition purposes, and as a free-growing stove-climber unequalled. The habit is good, with excellent rich dark-green glossy foliage; it has received two first-class certificates for its superior merit," distinctions which, in this case, we believe to be well deserved.

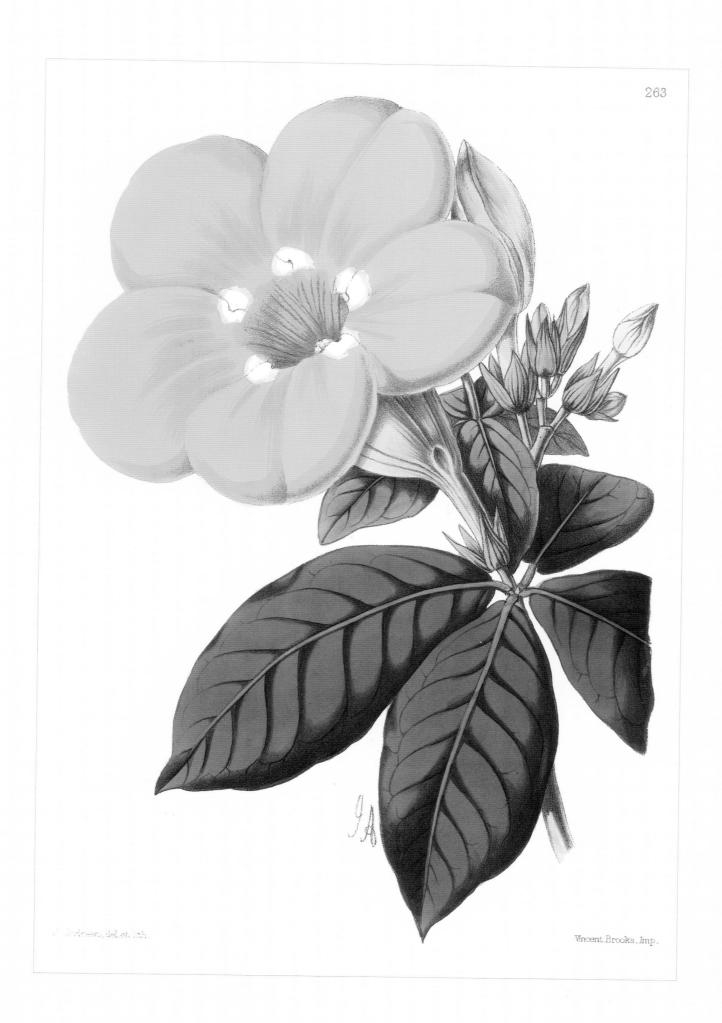

Andrews, del. et. ith.

Vincent Brooks, Imp.

The class of Auriculas commonly designated Alpines is not in much repute amongst connoisseurs, and indeed some of our very best growers will not admit them into their collection, for fear of lowering the quality of the seed; for being much more hardy than the florists' favourites, their pollen is much more likely to impregnate the other flowers; and yet they are very beautiful, and generally, we imagine, more attract the general lover of flowers. Mr. Turner, of Slough, has lately turned his attention to them, and has succeeded in adding several of great beauty to the comparatively small number hitherto cultivated.

The *Alpine Auricula* is readily distinguished from the florists' varieties by the colour of the ground (or paste, as it is technically called), which is of a deep yellow or orange instead of white; the petals are generally shaded, and the contrast of colour is very pretty; the foliage is also very different from that of the florists' varieties; being shorter and firmer; their constitution is also much more robust, and they therefore present few of the difficulties in cultivation which pertain to the other classes.

We have ourselves during the past year experienced the extreme precariousness that belongs to the culture of the Auricula. A fine collection of upwards of three hundred plants having been entirely destroyed by the use of loam in which some deleterious quality existed; what it was we do not even now know. Pelargoniums potted in it throve admirably, but the whole of our collection of Auriculas, one after the other, either rotted or dwindled away, the alpine varieties being only those which survived. Those only who know the extreme difficulty of getting together a collection of this character can understand the greatness of the loss, and yet there was nothing to suggest such a misfortune.

Victorious is a flower of bold character; the pip is large and well shaped, the paste solid and bright, and the colour of the flower a rich shaded brownish-crimson or maroon; the truss is large and well formed, and altogether it is a valuable addition to the hitherto comparatively limited class of Alpine Auriculas.

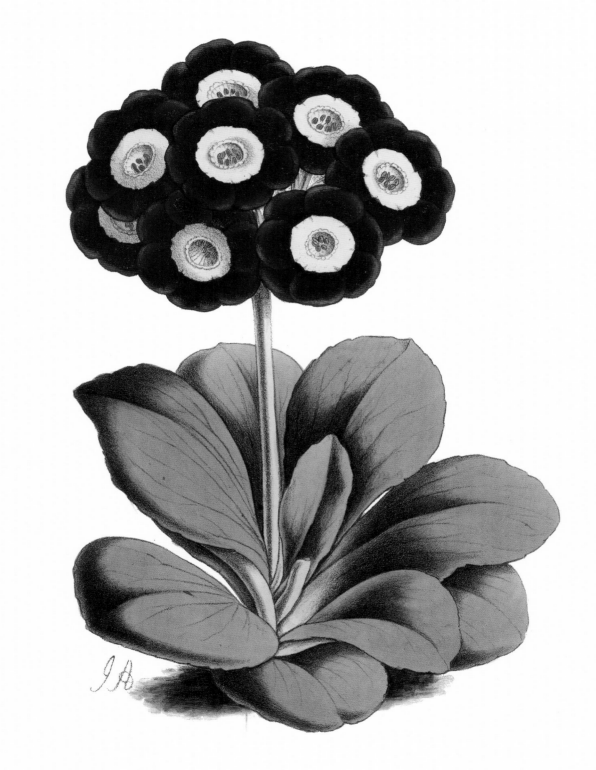

J. Andrews, del et lith.

Vincent Brooks, Imp.

Alternanthera Sessilis, var. Amœna

The changes that have taken place in the decoration of our gardens of late years have been very remarkable; all the old-fashioned notions have been discarded, the old occupants of our borders voted useless, and beds, filled with masses of gay flowers, and borders formed into elaborate ribbon-patterns, have taken their place; but even this is in process of alteration, and now, after a cold and cheerless summer, many of our most ardent gardeners are seriously discussing whether it would not be better to depend more on foliage and less on flowers, saying that while Verbenas looked draggled, and Geraniums even failed to please, *Coleus Verschaffeltii*, *Iresine Herbstii*, and others of a similar character were full of beauty.

From this cause it has happened that many hitherto little-thought-of plants have been brought into notice, and others have been introduced as likely to be of use. Three new plants have been much spoken of; we saw them all on trial at Battersea Park, and decidedly that which we now figure bore away the palm. *Alternanthera spathulata* is a dwarf-growing plant, with spathulate leaves, marked with pink-crimson and chocolate-brown, but it has a dingy appearance, and we do not think will ever be a favourite. *Teleianthera ficoidea versicolor* is a dwarf-branching perennial, with narrow ovate leaves, tapered below, and variegated with rose-colour and deep red; we have grown this ourselves as a border plant, but cannot say that it seems to us to be likely to be generally useful. *Alternanthera sessilis*, var. *amœna*, is, as a reference to our Plate will show, a very dwarf, neat-habited plant; the leaves are spathulate, and are richly coloured with red, crimson, and amber, with dark olive-green tips. In some instances, where small beds are used, this is, we think, likely to prove an acquisition; we have not as yet seen it largely tried, but in all cases where we have seen it, it has certainly proved to be the best of the three plants about which so much has been written. We may here say that we saw *Iresine Herbstii*, about which such contradictory statements have been made, in excellent condition at The Denbies, in Dorking, the seat of Mrs Cubitt; and under the able care of Mr. Drewett, it amply repaid any trouble expended on it.

J. Andrews, del. et lith.

Vincent Brooks, Imp.

We have again taken one of the many new spring flowering-plants which have been brought forward lately by Messrs. Backhouse and Son, of York, for our illustration, and, although not remarkable for its rarity, we are inclined to believe it will, for the brilliancy of its colouring, be a valuable acquisition.

There are already two varieties of Anemone well known to our gardens, the common garden Anemone, *Anemone coronaria*, distinguished for its brilliant scarlet flowers (and of which many fine varieties have been recently imported from the mountains of Greece), and *Anemone hortensis*. This differs considerably from the previous variety, as the flowers are of a delicate shaded rose, ruby or rosy-purple, the petals more numerous and narrower than in *A. coronaria*. The species now figured has been recently imported by Messrs. Backhouse from the mountains of Greece, and is thus described in the report of the Floral Committee of the Royal Horticultural Society: – "*Anemone fulgens*, exhibited by Messrs. Backhouse and Son, of York. This beautiful Anemone had been imported last year from the mountains of Greece. It was closely allied to *A. stellata* or *A. hortensis*, which it resembled in foliage; but the numerous large flowers, which sprang up in a tuft to the height of six inches, were of a brilliant crimson, with a centre of black stamens. ... This will be a charming flower for the spring garden, in which probably it may require a sheltered situation. It received a first-class certificate."

All who know what pretty and brilliant objects the Anemones are for early spring flowering, will agree in the estimate thus formed of it; and as Messrs. Backhouse, who are no mean judges on such points, say that as a scarlet flower it is unrivalled, it will no doubt be largely grown for spring-gardening purposes.

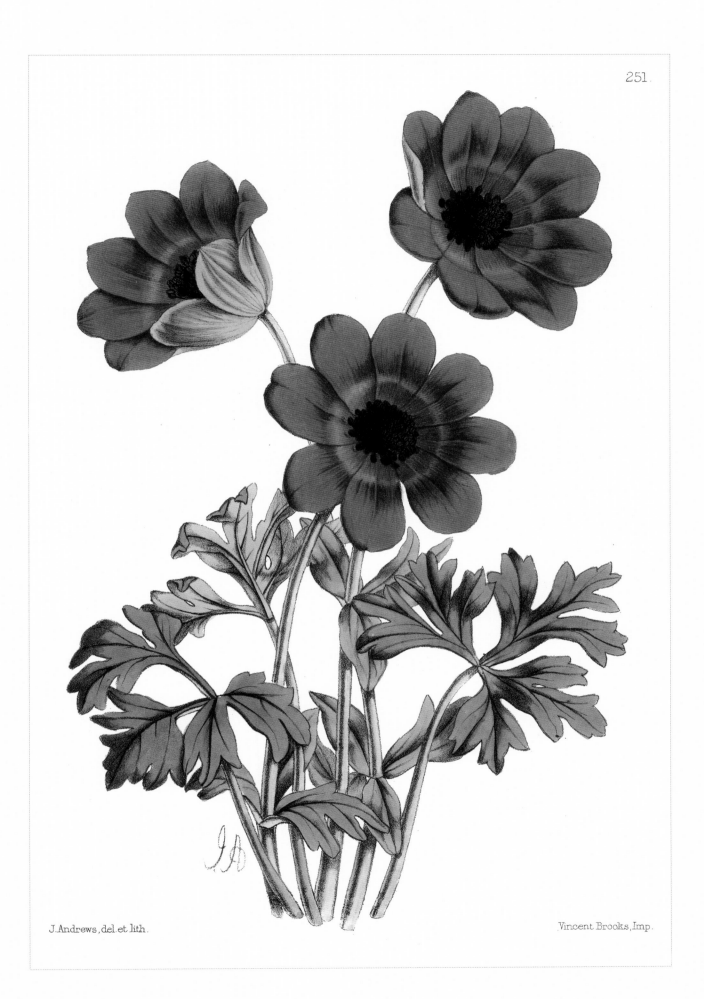

J.Andrews, del.et lith.

Vincent Brooks, Imp.

"In a genus noteworthy for including in its limits some of our most popular hardy perennials the *Aquilegia cærulea* stands conspicuous, if not pre-eminent, for its striking and highly ornamental features. Though perhaps rivalled in beauty by the well-known Siberian species, *A. glandulosa*, it possesses a great advantage over that Plant (which, as every gardener knows, is a shy bloomer) in the facility with which it yields its flowers under the simplest conditions."

"Its most salient feature ... is the long spurred petal so characteristic of the genus, and which in this species attains its maximum development and attenuation. In most specimens the tube of the spur is fully two inches long, and a graceful outward curvature adds considerably to the effect produced by this extreme length. It is scarcely less remarkable for the reversed position of the flowers at the time of their expansion. As our readers are aware, in most, if not all the other species of this genus, the fully expanded flower is pendent until fertilization is effected and the blossom begins to wither, when it assumes an erect position. In the *A. cærulea*, the bud only is drooping, but as the period of expansion approaches the flower gradually becomes nearly erect, thus presenting its mouth to the observer and exhibiting more fully the contrast of colour between the white limb of the spur and the violet-blue of the sepals."

"This leads to the remark that in a few instances the cærulean tint is replaced by a blush colour, and the plant is known to exist in a wild state with deep-yellow flowers. The singularly inappropriate specific name needs therefore hardly be pointed out, and it is the more inapplicable that in so many other species the blue or violet colour more or less obtains. As the name of *cærulea* has, however, the right of priority, we have thought it inadvisable to substitute Sir W.J. Hooker's far more judicious designation of *macrantha*, abandoned, as it appears to be, by botanists."

"The *Aquilegia cærulea* is a native of elevated regions of the Rocky Mountains, in about lat. 40°, having been originally discovered by Dr. James, subsequently by other explorers. By the collector Burke it was found just twenty years since near Medicine River, growing in rich loamy soil in great abundance, and was described by him as being in his opinion 'not only the Queen of Columbines, but the most beautiful of all herbaceous plants.'"

"Though this eulogium may now appear somewhat exaggerated, the award of two first-class certificates at the exhibitions of the past spring will doubtless be received as evidence that it was in a degree merited. The plants in question had been raised by the writer from seeds collected in 1862, by Dr. Parry, in a district where they were first discovered by Dr. James." – W.T.

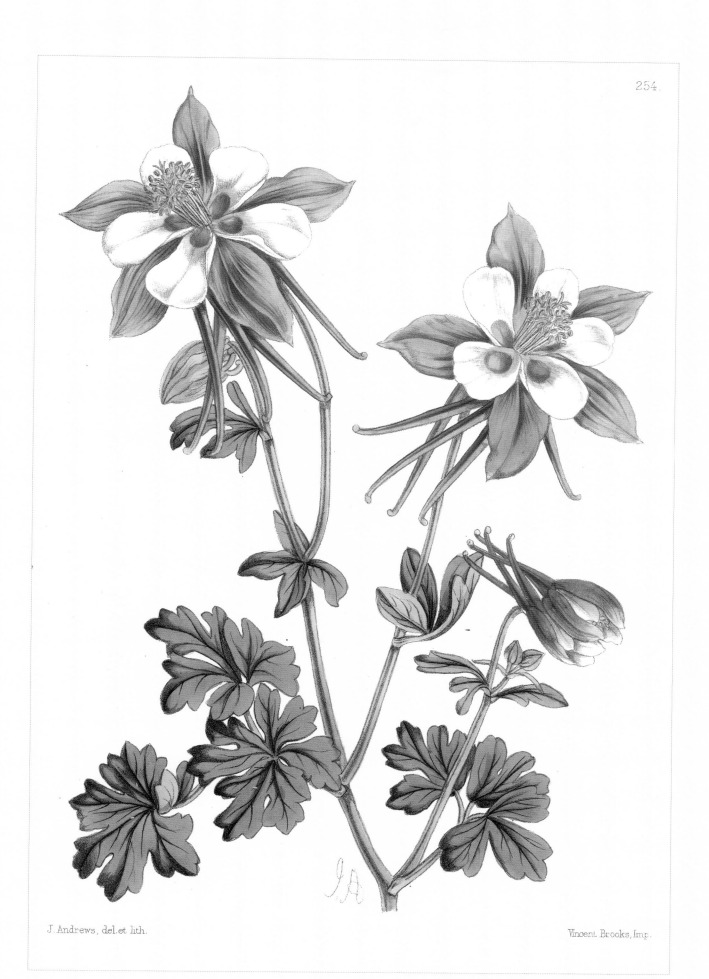

J. Andrews, del. et lith.

Vincent Brooks, Imp.

Astelma (Gnaphalium) Eximium

The curious flower, which forms the subject of the present Plate, lays no claim to novelty, as it was introduced to our greenhouses about the year 1793 from the Cape of Good Hope, but it nevertheless is deserving of a place in our Magazine of *popular* flowers, for such it once was, and we hope may again be considered, – for when exhibited this season at what we may well designate the most successful show of this year (that held at the Alexandra Park), by Mr. Arthur Henderson, of Pineapple Place, it was universally admired, and a good deal of wonder expressed that it was not more generally grown.

The manner in which plants once well known and popular are driven out of memory by novelties, oftentimes strikes us as very singular; we frequently read of a "Hue and Cry" for some plant thus treated, and for whose neglect no reasonable cause can be assigned; sometimes indeed it arises from some either real or supposed difficulty in cultivation, but more generally from the want of room; for the love of plants is like the love of money, it increases as they increase, and those who were satisfied with a few, when those few are increased still desire more; and even although the older plants have the greater beauty, yet the desire to have what everybody is growing, too often balances the scale against them. For no other reason do we believe that this beautiful and curious plant has been for so many years neglected, for about thirty years ago, we are informed by an eminent cultivator, it was exceedingly common.

In the present instance no difficulty of culture has led to this neglect, for we are informed by Mr. Henderson, that it is simply a greenhouse plant, requiring plenty of light and air, and no heat whatever, more than to keep away frost. "It is raised," he adds, "from seed, usually sown in spring, blooming finely the following season, and for many successive seasons; it will not strike from cuttings, and lasts a long time, coming into bloom and on the turn, altogether three months." With such properties it ought to be valued, and we can hardly conceive anything more effective than it would be for window gardening, or wherever decorative plants are required, there being a richness in the light-orange, contrasted with crimson, and the woolly character of the foliage, which is quite remarkable; and we have very little doubt that its having been again brought forward as an exhibition plant, and successfully too, will tend to bring it once more into favour.

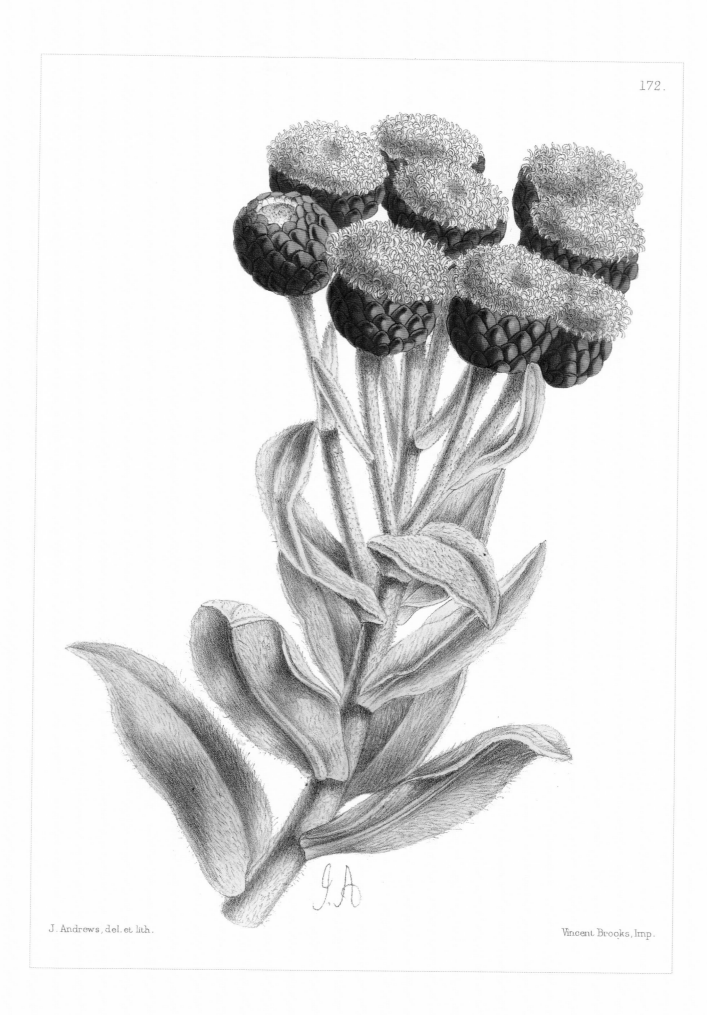

J. Andrews, del. et lith.

Vincent Brooks, Imp.

It may surprise some of our readers, perhaps, to see so old and common a shrub as the common Aucuba re-presented in our pages; but we have felt that the value of the discovery of the male plant by Mr. R. Fortune, and its consequent introduction to this country, through Mr. J. Standish, is best represented by the effect likely to be produced when it becomes common; and so, instead of giving a representation of one of the many plain and variegated-leaved varieties which have been recently introduced, we have figured the common variegated variety in fruit.

We extract from the Journal of Horticulture the following notice: – "Few plants, if any, have received such un-animous and well-merited approbation as the specimen of *Aucuba Japonica vera*, exhibited by Mr. Standish. It has been the only new plant of the year which has been signalized by having the Society's Silver Flora Medal awarded to it. At the time when this fruit-bearing Aucuba (it being a female plant) was introduced, the stamen-bearing, or male plant, was brought with it, by the fertilizing powers of which we were, in due time, promised to be able to make the well-known *Aucuba japonica variegata* a fruit- or berry-bearing plant. The time is not far distant when the male, or pollen-bearing plant, of this shrub will be attainable by all; but, at present, few only possess it, the value being so great, and the stock so limited; in the meantime, we may anticipate the privilege of seeing these shrubs, which grow so luxuriantly in every situation in this country, covered at Christmas (a rival with our truly-loved English Holly) with brilliant scarlet berries."

Being much struck with some bushes of these at Mr. W. Bull's some time ago, we determined to give a plate of it rather than of one of the newer kinds. We question if any variegated will be prettier or more constant than the old one.

Amongst the newer varieties which we have seen at Mr. Bull's, and introduced by Dr. Von Siebold, we may enumerate of the female variety A. *fœmina elegans*, *latifolia*, *variegata*, *macrophylla*; and of the male plant, *angustata*, *bicolor*, and *maculata*. We anticipate quite a change in the aspect of our shrubberies when these plants come to be extensively grown.

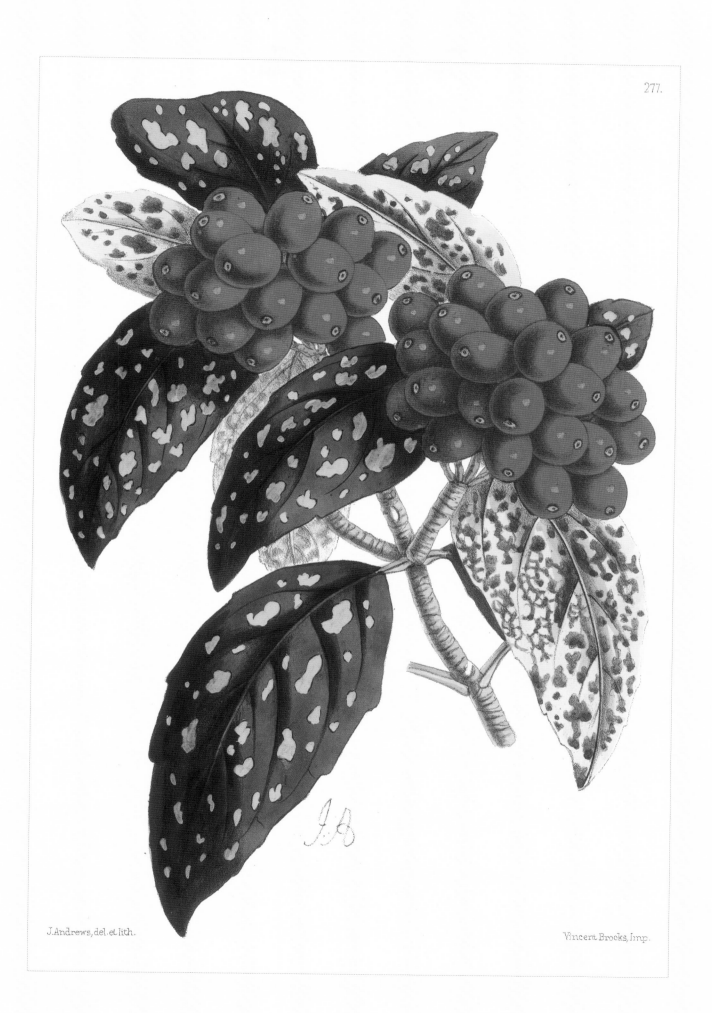

J. Andrews, del. et lith.

Vincent Brooks, Imp.

The great interest excited in the various collections of these beautiful spring flowers that were contributed to the Exhibitions of the Royal Horticultural and Royal Botanic Societies, induces us to bring before our subscribers the portrait of a seedling of Mr. Charles Turner's of Slough, for which he obtained a first-class certificate.

After having been for some years almost excluded from public favour, the Auricula seems to be on the eve of occupying once more its former position, and to become (we use it in the best sense) a fashionable flower.

We have before alluded to the supposed difficulty of cultivation as one reason for this flower having been so long neglected, and stated that the difficulty has been rather created than to have had any real existence, and we are borne out in this by the opinions of all our eminent cultivators. Like most flowers, they require careful watching, but not that mixture of materials which it was once considered necessary to grow them in; and we are glad to see that the veteran florist, Mr. George Glenny, has raised his voice against the monstrous quackery which did more than anything else to discourage amateurs from growing it. More common-sense views now prevail; no gardener, worth the name, thinks of keeping any information to himself, but is glad enough through the columns of the various periodicals devoted to gardening interests to make it known to the world; and thus all become benefited by the experience of others.

Princess of Wales is one of that class of beautiful blue self-coloured flowers which is ever attractive, especially to those who are not influenced by the many considerations which guide the mind of the florist, with whom the edged varieties are perhaps greater favourites. It will be seen that the colour is very brilliant, the form excellent, and the paste, as the white portion of the flower is technically called, very solid; this oftentimes is not the case in self-coloured flowers, and therefore materially increases the value of the flower. It is in the possession of the raiser, Mr. Turner, and it must be (owing to the slow manner in which the Auricula increases) some years before it comes into the hands of the public, but we cannot do better than advise those who derive real pleasure from the contemplation of beautiful flowers to attempt the culture of a tribe so beautiful and chaste in its appearance as the Auricula. There are many varieties of moderate price which even the rarer and high-priced kinds do not excel, and these we should recommend to be grown in the first instance, and when their cultivation is seen not to be difficult, the more expensive sorts can be obtained.

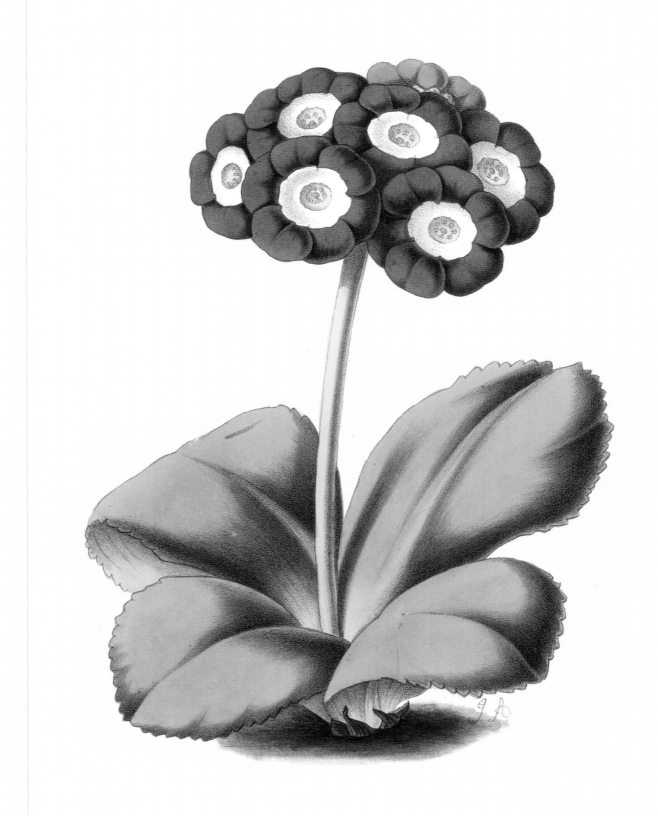

J Andrews del et lith Vincent Brooks, Imp.

Azaleas, Charmer and Vivid

Notwithstanding the formal method of training adopted by our great Azalea growers, there was nothing which excited more admiration amongst the foreign visitors to our Great International Exhibition than the immense masses of bloom which our leading exhibitors, more especially Mr. Charles Turner, of Slough, and Mr. Veitch, of Chelsea, produced; for although other exhibitors did well, the collections of these gentlemen, especially the former, threw all others into the shade. It was not merely that the plants were so thickly covered with bloom, but that the individual flowers were so excellent, and the whole appearance of the plant testified to such great care and skill.

The present year has not been very productive in new sorts of Azaleas raised in England, none of any great merit having been raised here, or at any rate exhibited, and therefore the introduction from Belgium, whence so many of our best flowers have come, of two new varieties of great merit will be hailed as a great acquisition, and such we believe those now figured to be. In order to do them full justice we have given them in a double plate, and Mr. Andrews has admirably caught the character and colour of the flowers.

Charmer and *Vivid* were purchased in Belgium by Mr. W. Bull, of King's Road, Chelsea; the former was raised by M. Dominique Vervaene, and the latter by N.M. Joseph Vervaene et Cie, the entire stock of both being now in Mr. Bull's hands. *Charmer* (Fig. 1) is a remarkably coloured flower, and, we think we may say, hitherto unknown amongst Azaleas; there are several that approach it, but none of quite the same shade; the flowers are large, well formed, and of good substance; the upper petals are slightly spotted with a deep shade of the same amaranth-colour as the petals. *Vivid* (Fig. 2) is perhaps the most beautiful bright Azalea ever yet introduced, putting into the shade *Vesuvius*, *Stella*, and other flowers of the same character; the flowers are very wax-like and beautifully shaped, and are very abundantly produced.

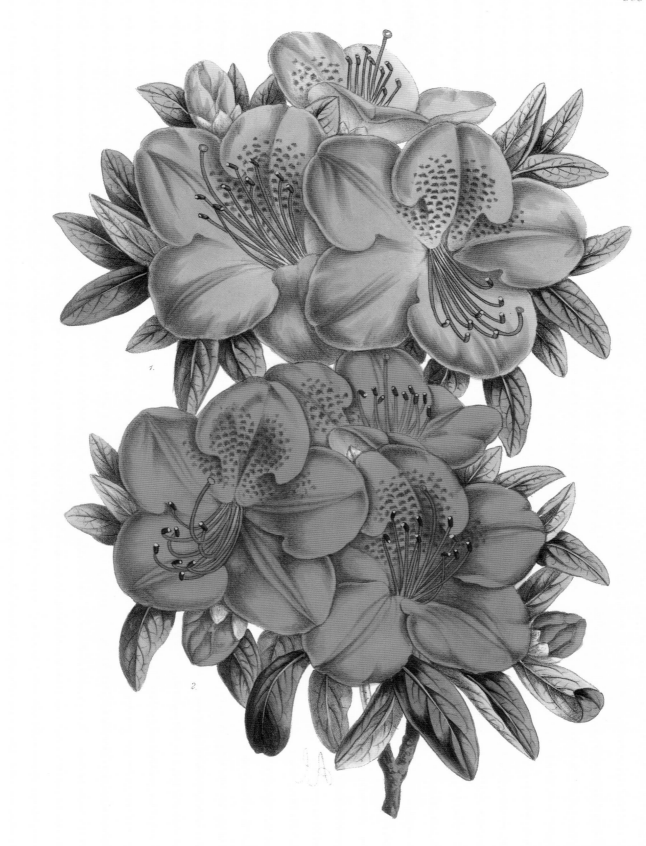

J. Andrews del. et lith.

Vincent Brooks, Imp.

We have in former years figured different varieties of variegated Azaleas, but we have never had the opportunity of noticing so fine a flower as the one which forms the subject of the present Plate, for it has been universally pronounced to be the very first in the class to which it belongs, and fortunate indeed is Mr. Ivery to have raised so lovely a flower.

It is well known that many of the variegated varieties of Azaleas are merely "sports;" a shoot of a red or pink variety has become blotched, or in some cases white, portions of this shoot have been propagated, and thus a supply of a new variegated variety is obtained. Unhappily there is a great tendency in such kinds to return to their original character, and their flowers are to some extent uncertain; when such varieties are introduced, as they frequently are, from the Continent, their character ought to be given with them, whether they are really seedlings or sports, as this would prevent much disappointment in regard to blooming.

Notwithstanding all the discussion that has taken place with regard to the manner in which Azaleas should be exhibited, and the fault that has been found with the huge masses of *crinolined* and hooped plants which every year in still larger and ever-increasing proportions are brought forward, there does not seem at present as if any change would take place, but the non-exhibitor, who grows for his own gratification, is happily not bound by these inexorable laws, and will in his home natural though not overgrown plants, find a more beautiful and pleasing object; in time, perhaps, exhibitors and the public will come to the same conclusion.

Fascination is, as we have said, a flower raised by that well-known and most successful cultivator and raiser, Mr. James Ivery, of Dorking; it was exhibited by him at the spring shows of the Royal Horticultural and Royal Botanic Societies, from the latter it received a first-class certificate and was regarded as one of the very finest Azaleas ever raised; it was raised in 1860 from a pod of seed of *A. tricolor* impregnated with *A. Criterion*; the shape is perfect, the form of the petals round, the colour a bright rosy-pink with deep crimson spots in the upper petals, – the edges of all the petals being white, and the pink colour of the ground being marked off in irregular bands. Messrs. Ivery and Son hope to let it out in the ensuing autumn.

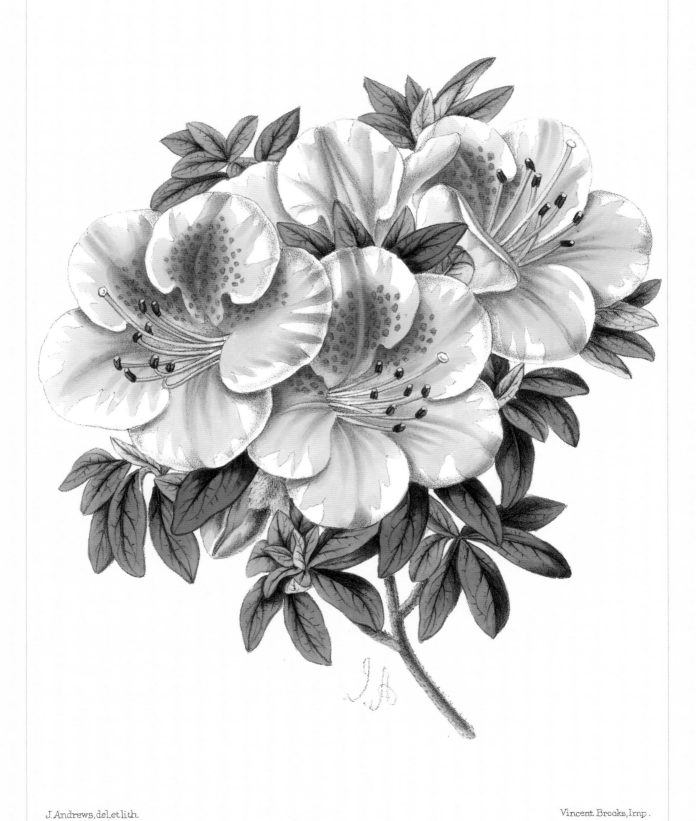

J.Andrews,del.et lith.

Vincent Brooks,Imp.

Azalea (Forget-me-Not, Ivery's)

Probably no English grower has been so successful in raising seedling Azaleas as Mr. Ivery, of Dorking, the many fine flowers which have proceeded from his Nursery holding a foremost place in all collections, for who can have a collection of which *Gem*, *Iveryana*, *Criterion*, *Carnation*, and other fine flowers, do not form a part? and we never see a good set of plants staged for exhibition in which some of his flowers are not to be found. That which we now figure will show that he has not forsaken their culture, but that in it and in others which he has already exhibited this season, he is prepared to maintain the high character which he has so long had as a raiser and grower of Azaleas.

This beautiful spring flower, which forms so prominent a feature at our various exhibitions, and both from its beauty and its fragrance is so generally admired, is by no means difficult of culture for those who are contented with ordinary cultivation. It of course, like every other plant, pays for the care bestowed upon it, and those moun-tains of bloom which are produced every year at the metropolitan shows are only the result of unceasing care and attention. The great enemy to their cultivation is the thrips, and we have observed, in a series of admirable articles by that well-known azalea grower, Mr. Barnes, of Camberwell, that he advocates fumigation in preference to any other process, for keeping this under, and considers that it ought to be repeated two or three times so as to ensure the destruction of this pest. Various other plans have been proposed, such as dipping them in a solution of Gishurst compound, and other preparations of a similar character; but independently of the discoloration of the foliage resulting from this process, he has not found it sufficient to kill the thrips.*

"Forget-me-Not" is described by Mr. Ivery as of "dwarf, compact habit, with small neat foliage, the colour a purplish-red, with rich markings in the upper segments, and quite distinct from any other kind." We do not hesi-tate to say that we think it will be a general favourite, for it is one of those flowers that keep a long time in bloom. We believe it will be sent out in May of next year.

*The process of fumigation is a very unpleasant one, and it is therefore with considerable satisfaction that we can recommend an improved fumigating bellows, recently brought out by Messrs. Barr and Sugden, of King Street, Covent Garden. The case to hold the tobacco is made of solid brass, so that there is no fear of its giving way with heat, and as it is supplied complete for a small sum, it will be acceptable to many amateurs. We have used it with much effect in our own greenhouses.

J. Andrews, del et lith.

Vincent Brooks, Imp.

There are many plants which, although they may not come up to the requirements of the connoisseur in those various little matters which are to him of so much importance, but which does not seem to be so to the general public, yet are exceedingly valuable for what is called decorative purposes. Such a flower is that so well re-presented in our figure, which, under the above name, and also, we believe, as *Madame A. Verschaffelt*, has been exhibited this season, and been commended, when exhibited by Messrs. Veitch, by the Floral Committee of the Royal Horticultural Society.

To be suited for decorative purposes, a flower ought to be vigorous in its growth, brilliant in colour, and very free blooming; vigorous in growth, because it must be an easy plant to obtain for the market, and unless it have bril-liancy and fulness of bloom, it will be no better for this purpose than other varieties; and as the Floral Committee have commended *Surprise*, we may presume that it comes up to their ideal of what a decorative plant should be.

The Azalea in general is admirably suited for all the purposes for which decorative plants are required; whether in the conservatory, hall, or boudoir, it cannot fail to attract, by its profuseness of bloom and variety. A well-managed plant will be so completely covered with flowers that no particle of foliage will be seen, while the delicacy of its perfume adds to its value. Hence, we were not surprised, during a recent visit to Paris, to see that it is so largely used there, although, as a general rule, the French are better contented with flowers of less value of which they are not required to take any special care.

One method of growing Azaleas has not met with much encouragement in England, that of having them as stan-dards, and yet, where there is a large conservatory, they make a fine display thus treated. When placed amongst fine-foliaged plants, the stem is hidden by the plants in front of it, and its bright colouring shows well at the back of the stage. Some excellently-trained plants of this description were exhibited by M. Margottin, of Bourg-la-Reine, at the Paris Exhibition of Horticulture, and were deservedly admired, although, from being placed on the ground, they could not be seen to that advantage that they would have been in the position we allude to. It may, of course, be said that we can grow large Azaleas, which will have all that effect; but for them we shall have to wait many years, while these plants are soon obtained, and moreover, they take up so very little room, in com-parison with large specimens, that it gives them an additional advantage.

151.

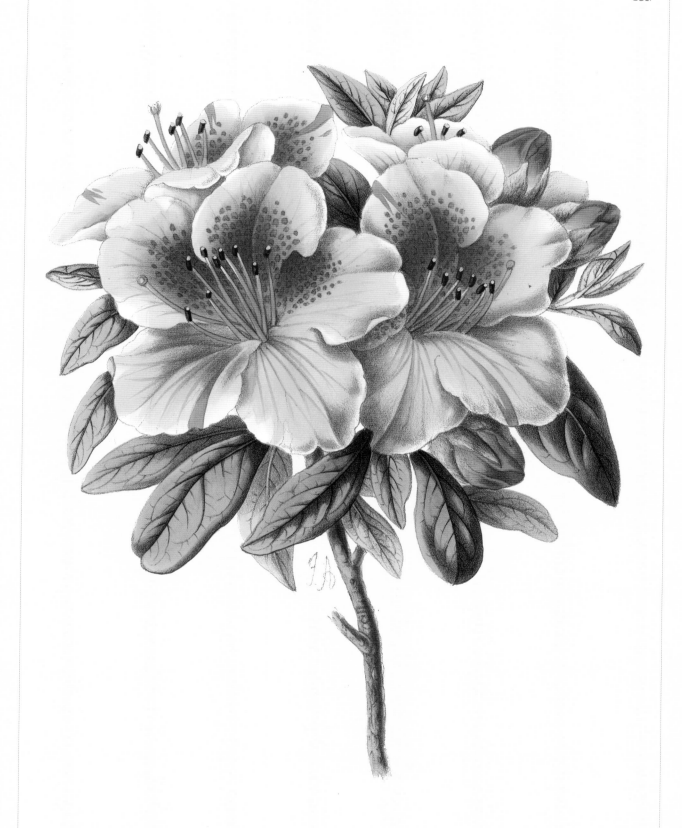

J. Andrews, del. et lith.

Vincent Brooks, Imp.

We live in an age of revolutions, and probably in no science have greater changes taken place than in horticulture, – one of the most notable and recent of which has enabled us to figure the very beautiful Orchid which forms the subject of our present Plate. Mr. Bateman, of Biddulph Grange, one of the most celebrated of our Orchid growers, forwarded to the Floral Committee of the Royal Horticultural Society, on the 25th of August last, a fine plant of *Epidendrum vitellinum*, together with a short paper as to the method of cultivation by which a result so unusual had been obtained. From that paper we condense the following remarks.

The first plants which came into his possession were received from Oaxaca about thirty years ago, and were in good condition at the time of their arrival, but perished shortly under the hot *régime* to which they were subjected. Dr. Lindley and Mr. Skinner (who found it growing in Guatemala, at an elevation ranging between 58° and 38°) advised that it should be subjected to cooler treatment, and showed the necessity of not subjecting all Orchids to the same treatment. Messrs. Jackson, of the Kingston Nursery, and Messrs. Veitch tried, in 1860, the effects of growing some of the Guatemala Orchid in a cool house, and were astonished at their success. Mr. Barker and Mr. Day, names well known amongst Orchid growers, tried the same with like success; and Mr. Bateman was induced himself to erect a house, about 20 feet long by 10 high, and he states that from this, erected at an expense of about £35, he had derived more enjoyment than he ever derived from houses of ten times greater dimensions. This cool house, he says, should always face the north, and must be kept damp as well as cool, particularly during the summer months, and while the sun is vertical ought to be shaded with tiffany for a few hours in the day; while means of heating it to the required temperature in cold weather ought of course to be at hand.

Barkeria Skinneri superba, the first of these cool-house Orchids that we have selected for illustration, is a very superior variety of the old and well-known *B. Skinneri*, – "in size of spike and flower," so writes to us Mr. Veitch, "and in brilliancy of colour, far surpassing it; it seems always to have branching spikes, which the old variety has not; it is also of strong growth and constitution. In the new field of Orchid-growing now opened to so many, it will be sure to occupy a conspicuous place.

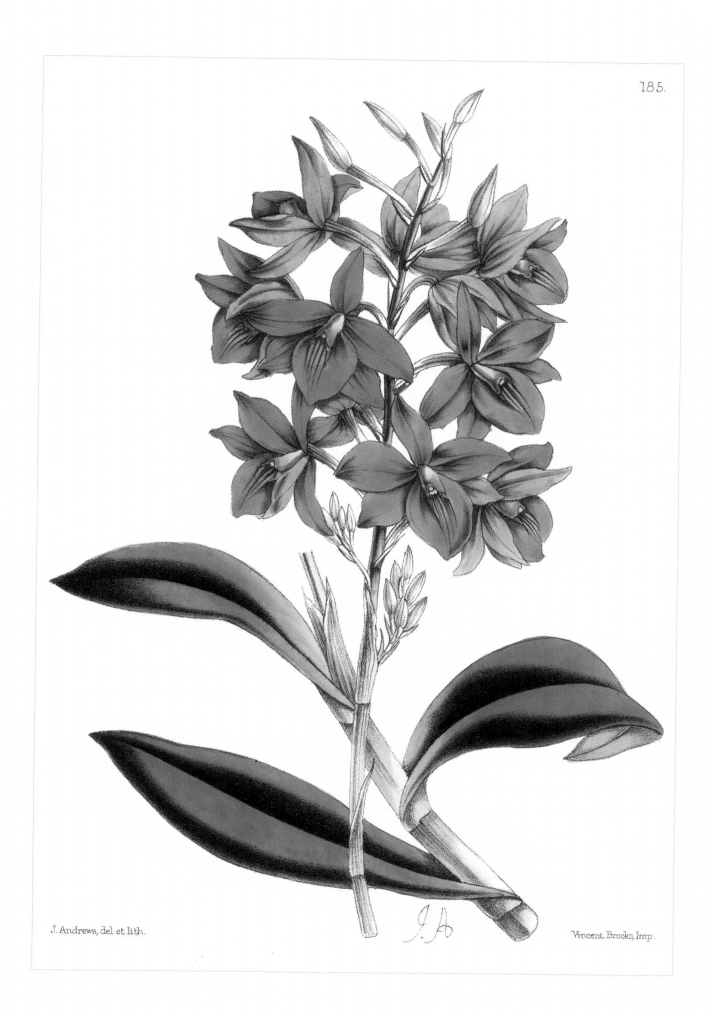

J. Andrews, del. et lith.

Vincent Brooks, Imp.

Flowers derive their value from various considerations and properties, some for their brilliancy of hue, others for their delicacy of perfume, others for the singularity of their forms, others for their hardiness, and some for the period of the year at which they bloom. When flowers are plentiful, and every parterre shines with the most brilliant hues, or when greenhouses are so filled that it is wellnigh impossible to display all to advantage, then it will happen that some flowers, which at another time might attract attention, are pushed aside; but when all out-of-doors is dreariness, and within scarcity of bloom prevails, then a flower which will adorn a house, even although it may lack the brighter hues of its summer rivals, is eagerly welcomed.

We have seen an immense change in the manner of decorating rooms; for fêtes of all kinds nothing now is of any service but natural flowers and plants, – the day for tolerating artificial flowers is past, and hence great demand is everywhere made for cut flowers and plants. Let any one but see the business that is transacted in Covent Garden for such things for decorative purposes, and the effect of this change is at once apparent: the flowering section of Begonias then is very useful for this purpose, – far more interesting, to our minds, than the ornamental-foliaged section, which was so much in vogue a year or two ago, but which has rapidly receded in public estimation.

The Royal Horticultural Society has attempted the plan of holding weekly exhibitions devoted to special plants, and amongst them the Begonia; but, like most of their plans, however well-intentioned, it seems to have been a complete failure. Thus, at the Begonia show, we are told, none were exhibited save a few from the Society's own garden.

The variety now figured is in the possession of Mr. B.S. Williams, of Paradise and Victoria Nurseries, Holloway; it is described to us by him as being of a dwarf and free-flowering habit, the colour being a light pink, the edges of the petal being deeper, and when contrasted with the deeper pink of the unopened buds, it forms a pretty object for the greenhouse or drawing-room, and makes it also useful for cut flowers for bouquets.

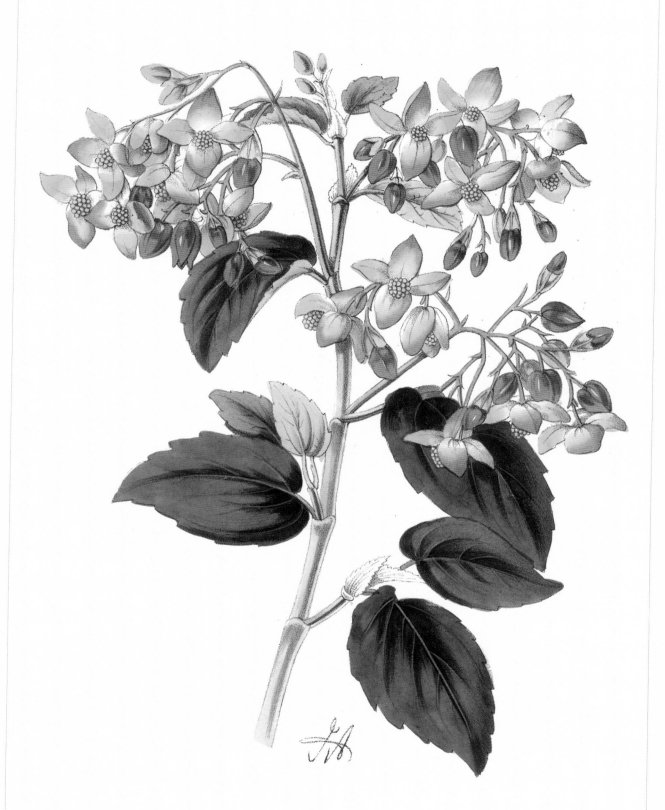

J. Andrews, del. et lith.

Vincent Brooks, Imp.

Flowering shrubs are always objects of interest, and few of those of late introduction have attained so much favour as *Berberis Darwinii*, the profusion of its bright apricot-coloured blossoms, and its pretty plum-coloured berries, making it at both the season of flowering and fruiting an interesting object; and therefore a hybrid like the present, which combines with its excellencies other good qualities, is well deserving of the distinction that it has obtained, wherever exhibited.

Berberis stenophylla was raised at the Handsworth Nursery, near Sheffield, by Messrs. Fisher, Holmes, and Co., and is a hybrid between *B. Darwinii* and *B. empetrifolia*, and evidently partakes of the character of both parents; the foliage is very distinct from *B. Darwinii*, the leaves being about half an inch long, and rolled backward on the edge, so as to give the appearance of being cylindrical, and the spines are not nearly so numerous or so strong as in *B. Darwinii*. The flowers partake of a good deal of the character of that species, being of a fine deep apricot, and produced in clusters of three to five at the axils of the leaves. The flowers are followed by small round berries about the size of black currants, of a deep purplish-black, and covered with a delicate bloom, as in the black grape. Surely these characters mark it as a very desirable plant; but besides this, the flowers are sweet-scented, and the plant itself is perfectly hardy. Moreover, as it grows in moist situations and soils, under trees, or in dry banks, and as its berries are likely to be as palatable to pheasants as its congener *B. Darwinii*, it will be seen how generally useful as well as ornamental it is likely to be.

We fear that the fine Japanese varieties, *B. Bealii*, *B. intermedia*, and *B. Japonica*, will hardly suit our climate, for, although not killed, their foliage is so much defaced by frost and wind, that they never present an attractive appearance. We are informed by Messrs. Fisher, Holmes, and Co., that the plants produced from seed of *Berberis stenophylla* do not come true, so that it must be propagated by cuttings in order to ensure its being true to character.

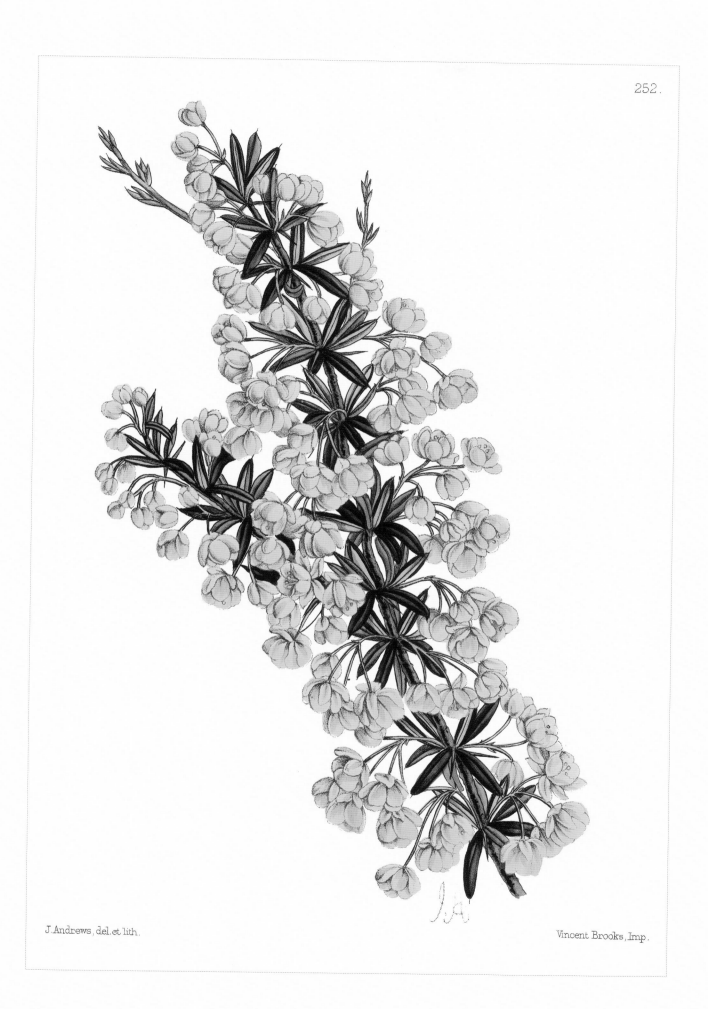

J.Andrews, del.et lith.

Vincent Brooks, Imp.

There can be little question that there is truth in the observation that the fashion which is now extending in horticulture is chiefly running in the direction of fine foliaged plants; "this commenced in the first instance with Ferns, British and exotic, until now it has extended in every direction, and plants with large leaves, metallic leaves, and, above all, variegated leaves, are now eagerly sought for;" and it has been said, "A species which would not be looked at for preserving the natural green of its foliage, became at once an object of interest for labouring under a kind of albinism, so as to make it appear mottled; but white and green, and yellow and green, were not enough to cause beauty, the eye wanted more, and during the last few years the whole of the inhabited and uninhabited world has been searched for plants with leaves having more than two colours, if possible all those of the rainbow."

During the present year we had the pleasure of visiting M. Linden's establishment at Brussels, and, from what we there saw, we are inclined to believe, that beautiful as are some of the foliaged plants which have been introduced by him, some that he has received and is receiving from his collector, M. Wallis, from the depths of the virgin forests of the High Amazon, will exceed in beauty anything that we have yet seen. Thus we know what a beautiful thing *Maranta Veitchii* is, but M. Linden has received one in which there is a broad, transparent band of glowing crimson, and has also one, which will be shortly introduced to the public, where the veins are of a bright, rich rose-colour.

Amongst the latest introductions has been the plant we now figure; it is a very pretty, ornamental stove-climber, introduced from South America. The leaves of this plant are very beautiful; when young they are of a purplish-green, with the midrib and veins bordered on each side with bright violet-rose, and as they become matured, changing to a bright green ground-colour, with borders on each side of the midrib and veins of silvery whiteness, the colour of the under-surface being bright purple-crimson. It has been exhibited by Mr. W. Bull, of Chelsea, and obtained a first-class certificate from the Floral Committee of the Royal Horticultural Society. It succeeds under the ordinary treatment of stove-climbers, to which class of plants it will form an interesting addition.

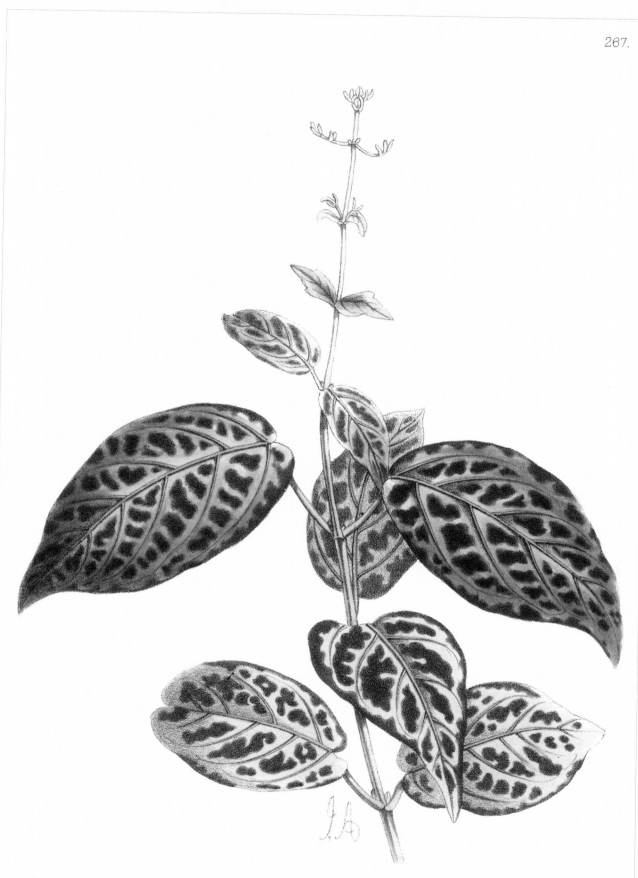

J.Andrews, del et lith.

Vincent Brooks, Imp.

There has not been a greater sensation in the horticultural world than that produced some four or five years ago by Mr. Daniels, gardener to the Rev. E.C. Ruck Keene, at Swyncombe House, near Henley-on-Thames, when he exhibited some sprays of the beautiful *Bougainvillæa speciosa*, loaded with its light magenta-coloured bracts, as, although that plant was a well-known one, it had not been so grown as to produce in any degree of profusion its flowers, and had consequently been but little thought of; we shall not readily forget the naïve question of an enthusiastic lover of the modern style of gardening, when it was first exhibited at the Royal Botanic Society, – "Will it do for bedding-out?" Happily all lovers of plants have not their ideas bounded by the modern *parterre*, and hence it has become largely grown and valued.

The treatment adopted by Mr. Daniels, and which was then considered the only one by which the plants could be induced to flower, was, to use his own language, "towards the end of January to plunge it in the driest and hottest part of the house, to give water sparingly for the first month, afterwards more frequently, and towards the end of February or beginning of March, it will begin to unfold its charms; it must have all the light and sun that can be given it while in bloom, or the colour will be found to be very faint. The large plant here is growing with its roots close to the boiler, which projects through to the inside of the house, this made the end of the house so hot that any other plant placed near it was destroyed with insect, as spider, scale, etc.; but it is a great recommenda-tion to *Bougainvillæa* to say that no insect except green-fly touches it. I believe too much dry heat cannot be given, and too little water." This opinion, however, must now be modified, as Mr. Fleming, of Cleveden, has caused it to flower freely under the more ordinary treatment of a warm greenhouse plant, and fine pot-plants of it have been exhibited by Mr. Turner, of Slough.

Bougainvillæa lateritia was exhibited by Mr. Charles Turner, of Slough, who obtained it from Mr. Daniels, and has received three first-class certificates; the entire stock of the plant was purchased from Mr. Turner by Mr. William Bull, of Chelsea, by whom it will be let out during the present autumn. The colour of the bracts, in which the great beauty of the plant consists, is a delicate salmony-pink, forming therefore a pretty contrast to the mauve-coloured bracts of *Speciosa*.

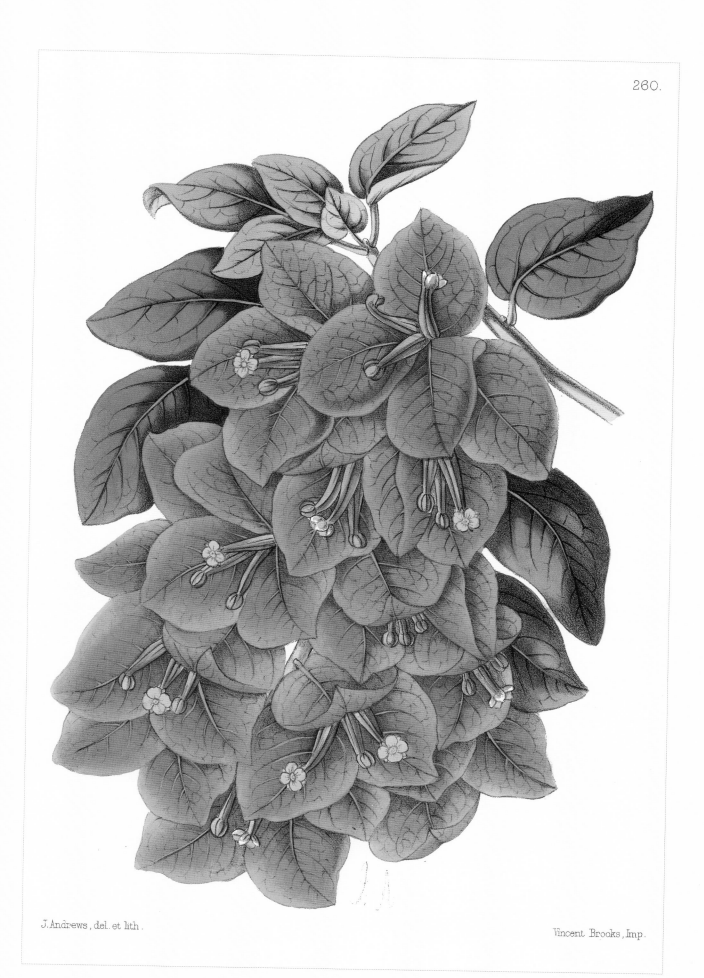

J.Andrews, del. et lith.

Vincent Brooks, Imp.

We figured, a short time since, one of the most beautiful of Mr. Dominy's results in the hybridizing of Orchids – for *Cattleya Exoniensis* may certainly lay claim to such a title; we now have the pleasure of adding another, which, if possible, is still more interesting, as combining so thoroughly the properties of both parents.

"It forms a tuft of flower-stems one foot and a half in length, loaded with blossoms of the richest rose-colour, of different degrees of intensity. Mr. Dominy produced it in the Nursery of Messrs. Veitch and Sons, of Exeter, by fertilizing *Limatodes rosea*, a rich rose-coloured beautiful Indian Orchid, with that variety of the white *Calanthe vestita*, which has a deep purple spot at the base of the lip. The result has been most curious: the hybrid, although completely intermediate between the two parents, yet shows a greater tendency to its mother than to its father; of the father it has exactly the manner of growth, and the peculiar four-lobed lip; but it has the rich colour of its mother, and some other peculiarities of her lip, along with an entire correspondence in form with her column."*

When we had the opportunity of seeing this very lovely plant at Mr. Veitch's, it was in the cold dreary month of November, and the fact of its being a winter-flowering Orchid gives greatly-increased interest to it. Amongst the properties of *Limatodes rosea* shared by *C. Veitchii*, is that of the flower-stem lengthening as the bloom expands, so that frequently it forms one of three or four feet in length. As the flowers at the base die away, fresh buds are formed at the tip, so that the period of blooming is greatly prolonged. This adds another advantage to the beautiful tribe of Orchids, that many of them remain so long in bloom; and as their cultivation is now better understood, their value and interest in this respect will be more appreciated, for no one can see the very beautiful groups of Orchids in any of our great plant establishments without admiring their singularity of form, richness of colour, and, in many instances, their delicate perfume.

*'Gardeners' Chronicle,' quoted in Botanical Magazine.

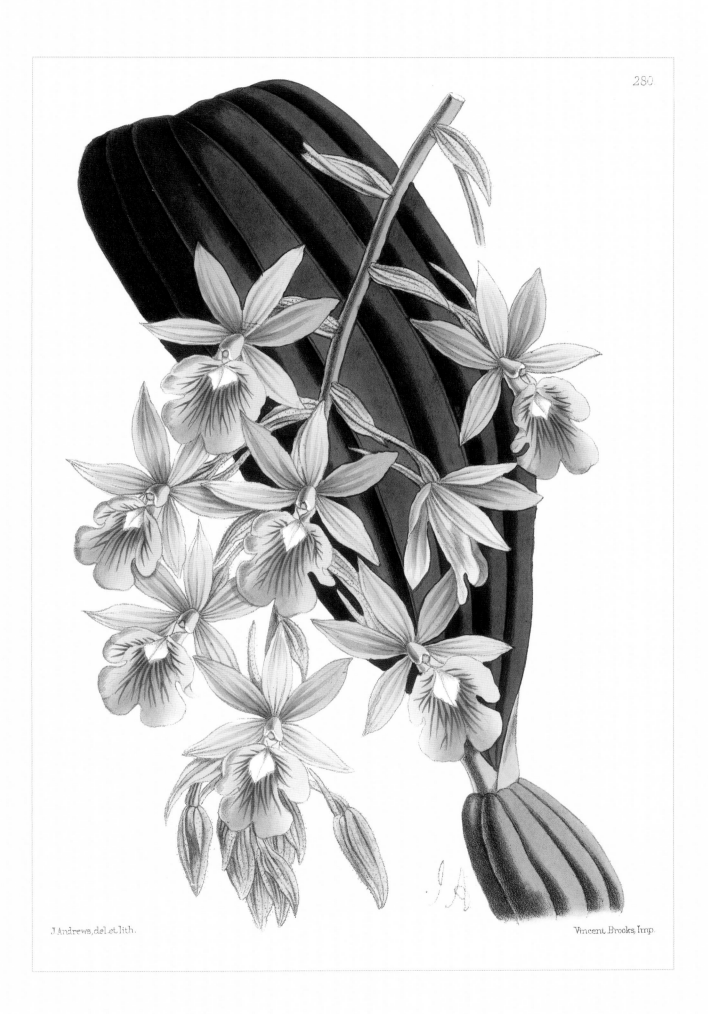

J.Andrews,del.et lith.

Vincent Brooks,Imp.

The modern style of gardening known as the bedding-out system has had a severe trial during the past season, the extreme dryness of the summer having in many cases entirely spoiled the effect, and especially where laid out in grass, as this suffered perhaps more than anything from the want of rain. Thus, at the Crystal Palace, where the system is carried out in perfection, the beds appeared as if set in brown soil, rather than in the bright green they usually do.

There are two methods in which this system is carried out; one, where the effect to be produced is obtained by the employment of large quantities of only a few flowers, arranged and combined in various methods. This we have seen in its perfection in the beautiful grounds of Lord Holmesdale, at Linton Park, under the able direction of Mr. Robson, whose skill in this department is unrivalled. His large and magnificent bed, which at once strikes the eye as the very perfection of colouring, is composed of only some six or seven different flowers. The other method is the employment of a large number of plants, with differing shades and tints of colour, giving greater beauty to the parterre, although perhaps not producing so good a general effect. Each system has its advocates, and, we may add, its advantages.

To those who adopt the simpler system, the flower which we now figure would be useless; for one rule connected with it is, never to employ those with two shades of colour; while to those who adopt the more complex plan it will be a great acquisition. Some years ago flowers of this shade of colour were raised by Mr. Cole, but, owing to their delicacy of constitution, they were found to be of little use. The flower which we figure is of a different character, being robust in habit, bearing large masses of bloom, and the individual pips of good size, the colour of a bright orange-red, with a margin of yellow, the whole flower being minutely punctured. As a pot plant also it will be found very useful.

Calceolaria Bird of Paradise is quite a new flower, and is in the possession of Mr. B.S. Williams, of Paradise and Victoria Nurseries, Holloway, by whom it will be distributed in the spring.

J. Andrews, del. et lith.

Vincent Brooks, Imp.

The frequenters of Flower Shows, and the readers of Horticultural publications in days gone by, will recollect the many beautiful varieties of Calceolarias which used, some ten or fifteen years ago, to be exhibited when Messrs. Kinghorn, Holmes, Green, May, Gaines, and others, used to bring them forward laden with bloom, and ever attractive, not only for the brilliancy of their colours, but the strangeness of their markings.

But these days passed away; it was felt that the difficulty of propagating and keeping them was so great that they were not worth the time, labour, and expense bestowed on them, so that gradually they went out of fashion; some well-known growers, however, still continued to save seed, and improve them both in size and brilliancy of colouring. It now seems as if their culture, under a different method treatment, is likely to become again fashionable; and as, notwithstanding the advance made in shrubby Calceolarias, the size, beauty, and variety of the markings have not been obtained in them which the herbaceous kinds can produce, we think them a flower eminently deserving of being cultivated by those who desire a brilliant display at little expense.

Amongst the most successful hybridizers, Messrs. Dobson and Son, of Isleworth, have for some years been noted for the very excellent *strain* of seed which they have obtained; and the flowers now figured were selected by our artist from a large number which they have bloomed during the course of the present year. The plan now generally adopted is to obtain from seed-growers seed saved only from their choicest flowers; and as they have a character to maintain, a grower will be anxious to save only from the best. When the plants have flowered and produced seed, it will then be at the option of the owner either to save seed from his own flowers or to procure a fresh supply from the original source; but in either case to throw away the old plants. This saves all the trouble and expense of endeavouring to keep them, with, after all, but little success, during the winter months. When they are in bloom, at once discard all worthless or indifferent flowers; and if you are particularly anxious about the seed, hybridize, selecting those of good form as the mother plants, and using the pollen of the more striking colours to fertilize with. Adopting this course, the house allotted to them will be in the month of June a blaze of beauty.

In order to avoid, on the one hand, the very inartistic notion of a Plate consisting of pips, and on the other the confusion that full trusses would make, we have given only three pips of each variety, but each plant produces a very large head of bloom, which would more than by itself occupy the space of our Plate.

J.Andrews,del.et lith.

Vincent Brooks,Imp.

Picotee, Colonel Clark, and Carnation, Lord Clifton

Although we have still to regret that so little favour is bestowed on this most beautiful and interesting tribe of florists' flowers in and about our metropolis, we still feel that it must ere long force its way into favour and recognition, and we have therefore figured the two beautiful varieties which form our present Plate.

When in a previous number we figured two varieties of different classes to the present, we made some observations on the neglect of this flower in this part of England, and ascribed it in great measure to the want of encouragement at our great metropolitan exhibitions, while not ignoring the difficulty, or rather the trouble, connected with its cultivation. In a friendly notice of the number in a contemporary, a somewhat strange reason was given for this neglect, viz. that it arose from the facility with which artificial imitations of it were made, and from the want of a handsome and striking foliage. In reply to this, we could draw attention to the fact, that other flowers, which are universal favourites, afford as easy an achievement to the paper-flower maker as the Carnation, – we may instance the Camellia, the Rose, and the Dahlia, many of the imitations of these flowers being so excellent as to deceive inexperienced persons, and that the florist and the flower-loving public generally take but little notice of the foliage, the excellency of the flower being the point considered; for even in the Rose, how often are the most beautiful blooms exhibited without any foliage whatever. We therefore still maintain, that if this flower received more encouragement at our exhibitions, it would speedily become popular; but no one must enter on its cultivation who is not prepared to undertake a considerable amount of trouble, for, unlike some other flowers which may be safely left to themselves for some months in the year, the Carnation and Picotee, like the Auricula, require constant watching.

The varieties now figured are Picotee, *Colonel Clark* (Normans), Fig. 1, a beautiful rosy-scarlet edge, heavily marked, without any bar, – the substance of the petal is also very good, – and the white, remarkably clear; Carnation, *Lord Clifton* (Puxley), Fig. 2, a pink and purple bizarre of great size and beauty. We saw it exhibited at the Alexandra Park Show during the past summer, and it struck us then as being one of the finest flowers we had ever seen, and that, too, in a class in which really good flowers are by no means numerous.

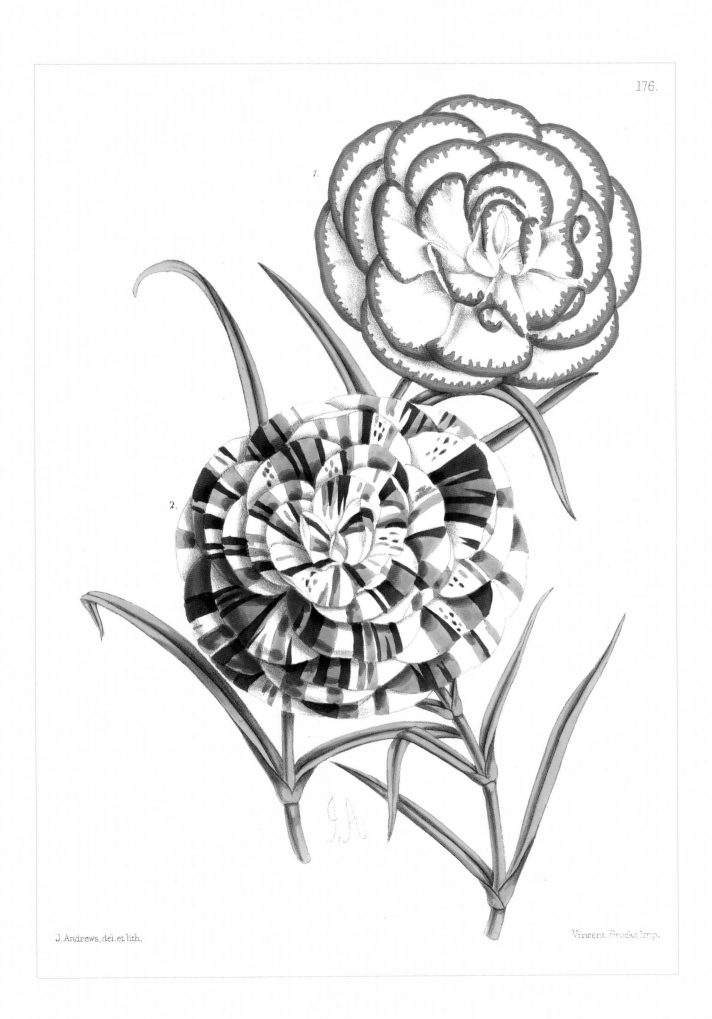

J. Andrews, del. et lith.

Vincent Brooks, Imp.

The production of flowers that will bloom during the dark and dreary months of winter has become more than ever an object amongst our cultivators, since no fête, whether public or private, is considered complete without a supply of natural flowers. Amongst those which have become valuable for this purpose, we know of none more worthy of a place in our greenhouses than the numerous varieties of tree Carnations and Picotees, three of which form the subject of our Plate.

Messrs. E.J. Henderson and Son, of the Wellington Road Nursery, have been the means of introducing this very desirable flower to our greenhouses, the greater portion of the varieties having been obtained from the Continent.

It will be at once seen, by a reference to our Plate, that they are very unlike in colour to the ordinary varieties of Carnations, although some varieties approach them very nearly, being regularly flaked, while others are as regularly picoteed. They are also very rough on the edge, as compared with florists' flowers of the same class.

We have found the following to be the best method of cultivation. As soon as the cuttings are struck, which should be about July or August, they should be potted off into small pots, in a good soil composed of loam and well-rotted manure and leaf-mould, in equal proportions, with a little road-grit, to keep it open; then gently watered, and placed in some cool place, either in the pot or out of doors. The flower-stems should be pinched off as soon as they appear, as we never allow them to flower during the first year, the object being to get them to make wood and to run up in a tree-like form. In the following spring we re-pot them into larger pots, and allow them to grow, which they will do rapidly. They should then be well staked, and brought into the conservatory as their flower-buds are produced. By this treatment good plants are obtained, which give a succession of flowers during the dreariest winter months.

The varieties which we now figure are all from the collection of the Messrs. Henderson, and are: — *Delicatissima* (Fig. 1), a very pretty pink flower, having the petals thickly barred with a deep pink or light-crimson; *Victoria* (Fig. 2), is a beautiful light-crimson flower, flaked with dark crimson, approaching to black; while *Princess Alice* (Fig. 3) is a bright yellow, with red bars and flakes, forming a very pretty and attractive flower.

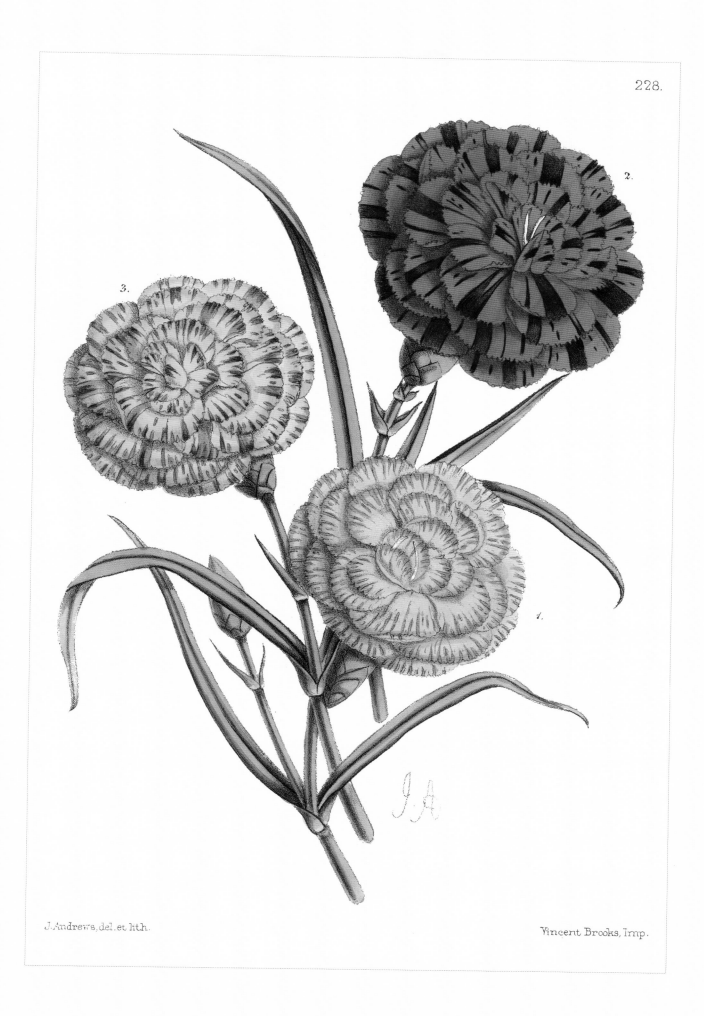

2.

3.

1.

J.Andrews, del. et lith.

Vincent Brooks, Imp.

It was a bold thought to submit the aristocratic tribe of Orchids to the same process which had produced such wonderful results in the more common and easily-managed classes, known as florists' flowers. And all honour be to Mr. Dominy, the intelligent foreman of Mr. Veitch, for the manner in which he carried out, so successfully and perseveringly, his plan. If he had done nothing else, this charming Orchid, which we now figure, is sufficient to attest his skill and success.

Cattleya Exoniensis was raised more than ten years since by Mr. Dominy, from seeds raised from *Cattleya Mossiæ*, impregnated with *Lælia purpurata*, and successfully unites the beauties of these much-admired Orchids. It must surely have greatly rejoiced the hybridizer, when, after years of long and patient watching of the little seedlings, he saw the expanding of this lovely flower, proving so conclusively that it was possible to produce varieties by the hybridization of our loveliest Orchids. "It proves to be an autumnal bloomer of fine sturdy and robust habit; the stems are one-leaved, and the spathes one- or more flowered; the sepal and petals vary in width, are of waxlike substance, and blush-coloured, the terminal half of the lip ranging from rosy-purple to a rich deep like crimson-maroon; the lateral part of the lip is white, and sometimes with a large purple margin, and a central portion of yellow streaked with purple. It obtained a first-class certificate from the Royal Horticultural Society, in September, 1864."*

We would take this opportunity of referring to a new Orchid-pot invented by Mr. Dominy, and which we saw in successful operation at Mr. Veitch's Nursery during the past summer. It is made with a false bottom with bars, like an ordinary drain, and is most useful for growing epiphytal Orchids, as it admits of the free circulation of air among the roots, which is of such great importance to epiphytal Orchids, and obviates the use of the objectionable potsherds for draining, which tend so much to harbour insects and produce fungi. The false bottom fits into the Orchid-pot about two or three inches below the rim, the whole of the part underneath being open to the air.

* So Mr. Veitch kindly writes to us.

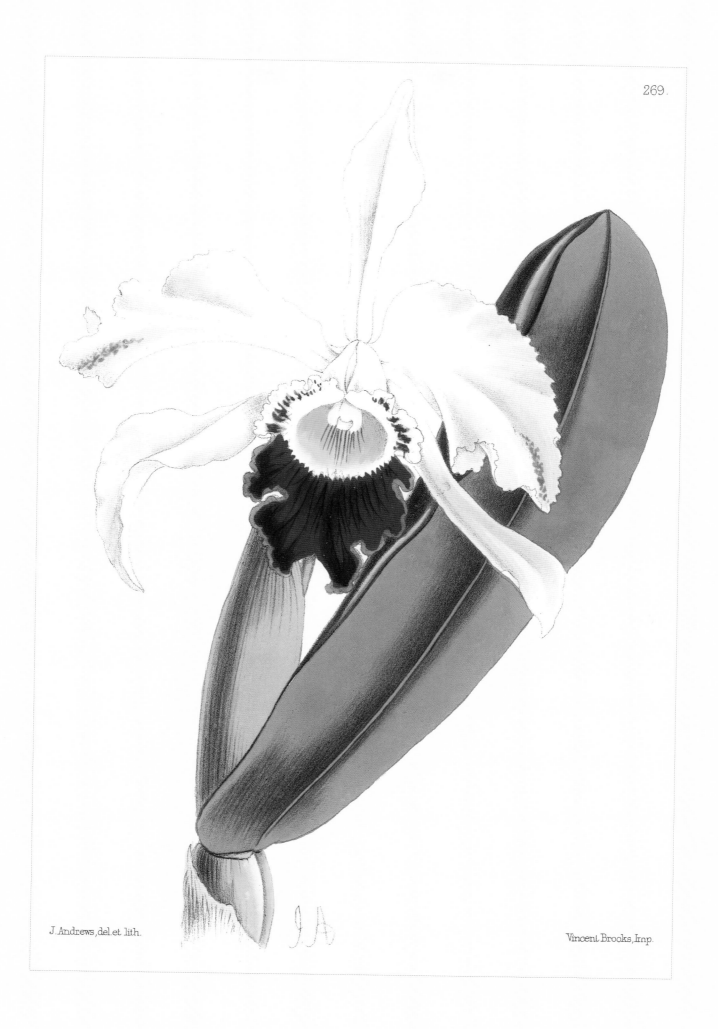

J.Andrews, del et lith.

Vincent Brooks, Imp.

The past season has seen a very greatly revived interest in this fine autumnal, and indeed we may say winter flower, the opening of the Amalgamated Chrysanthemum Society show at the Agricultural Hall, Islington, having brought together a large number of plants and cut blooms from the best growers about the metropolis, – a fact the more desirable because both the Royal Horticultural Society and Crystal Palace Company have abandoned their exhibitions, not finding, we suppose, that in the dreary month of November an exhibition will pay. We are also informed by Mr. Salter that he has never had so large a number of persons at his winter garden as this season, and he certainly never had a larger bill of fare to present to them, for independently of the older varieties, he had nearly three hundred seedlings, many of them of very great merit.

We question, however, after all, whether a Chrysanthemum show will be popular; there is a want of that decided colouring in them, which makes a flower show so attractive, and for ourselves we would sooner see Mr. Salter's collection than the best exhibition that could be got together, – for there is a greater mass of bloom, and the introduction of other plants gives that liveliness to them which their own want of brightness makes necessary, while there is ever the charm which attaches to novelty in looking at the new varieties coming forward.

In addition to the two figured in our Plate, the following will be found amongst the most novel and beautiful of the new varieties to be let out in April: – *General Bainbrigge*, bright amber; *Princess of Wales*, a very large white, with delicate pink margin; *Prince Alfred*, rosy-purple, a very large flower; *Robert James*, large bright orange-amber, with fine wide incurved petals; *Mr. E. Miles*, large bright yellow, with high centre and well incurved, this is one of the Ranunculus-formed flowers; *Saumarez*, fine dark-red; *Edward Landseer*, rosy-red, new colour, reflexed, fine flower for specimens; *Jupiter*, large dark chestnut-red; *Sir George Bowyer*, bright rosy-purple or violet, finely incurved, not large; *Rev. J. Dix*, red and finely incurved; *Donald Beaton*, salmon-orange, form of *Dupont de l'Eure*; *Belladonna*, delicate lilac, with blush shade.

Of the two figured, *Lord Clyde* (Smith) is a glowing crimson, very bright and fine colour, large, free-blooming, fine dwarf habit, and a most attractive variety for specimen plants; it is neither incurved or reflexed, but more of a rosette form, not unlike some of the French Asters. *Saint Margaret* (Pether's) is a bright orange-amber-anemone, with fine high centre, large and very distinct.

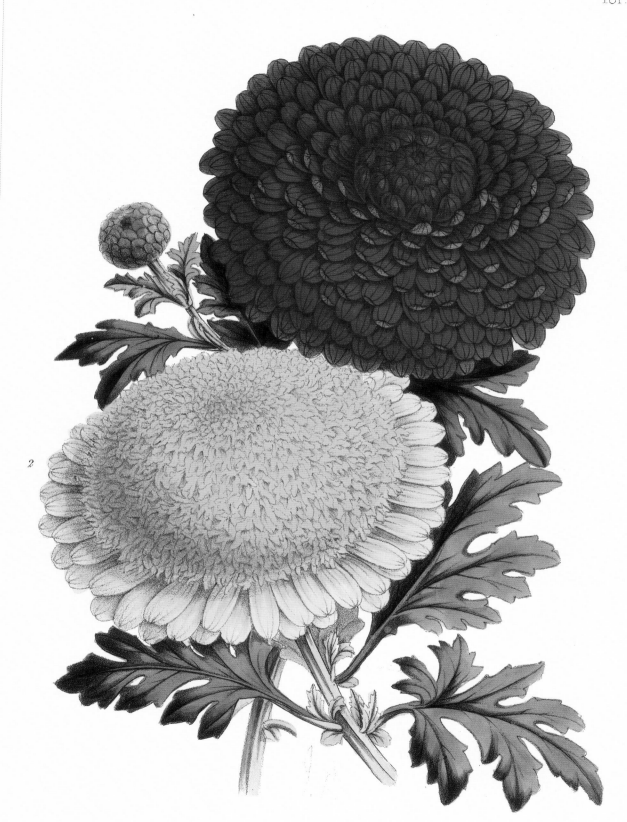

2

J. Andrews, del. et lith.

Vincent Brooks, Imp.

The past Chrysanthemum season has been, we are told, the very worst known in the neighbourhood of London for the last forty years; and it would almost seem as if the purveyors for the public in the way of flower-shows had foreseen this, for neither at the Crystal Palace nor the Royal Horticultural Society was there an exhibition.

Mr. Salter, of Hammersmith, who has now, for upwards of twenty years, held the first position as a Chrysanthemum grower, (nearly all the fine varieties now in cultivation having passed through his hands,) endeavoured to gratify the public with the view of a very extensive and unique collection, which he planted in the Royal Horticultural Society's Gardens at South Kensington, and the immense variety and great beauty of the flowers, sheltered as they were by canvas, were greatly admired.

The following interesting remarks in the Journal of the Proceedings of the Society (p. 702) supply some curious information on this flower: – "No plan or device by which he thought it possible to improve his flowers has been omitted, and no expense spared, by Mr. Salter. Finding that some climates were better adapted for maturing the seeds of his plants than others, he has made experiments in almost every quarter of the globe. Not content with Europe, he has sent plants to be grown for seed at the Cape of Good Hope, and had the produce returned to him; he has tried Algiers in the same way, also Canada and the United States; he has compelled this winter-flowering plant to flower in the summer-time, in the hope of making its seed ripen in our own country, but without success, – the plants refused to seed at all. He has watched the plants for years, to pounce upon a good sport from which to breed; for it is a curious fact with Chrysanthemums, that it is not from seed alone new varieties are obtained, they are also got from suckers. The great point at which Mr. Salter has been labouring is to obtain brilliant colour and good form for the flower, and a compact, dwarf, strong-growing habit for the plant. When we call to mind the dingy dull red with which Mr. Salter had to start, and remember that he has had no extraneous help from allied species, but that the brilliant and vivid colours now shown have been obtained by watching for a flower with a colour a little brighter than its neighbours, and breeding from that, and growing its seed in a climate which produces the most glowing colours (another point only learned by long experience), we cannot fail to accord our admiration to his skill and perseverance.

The varieties now figured are *Her Majesty* (fig. 2), and *Lord Palmerston* (fig. 1).

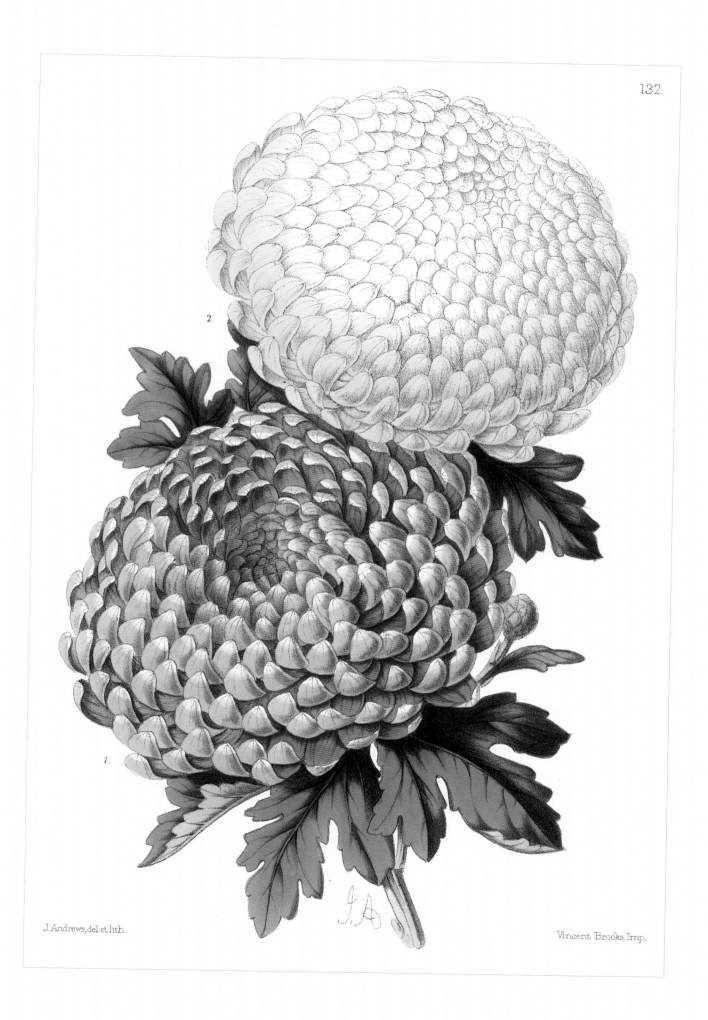

132.

2.

1.

J.Andrews, del.et lith.

Vincent Brooks, Imp.

While the large and brilliant flowers, which form what is called the section of large-flowering chrysanthemums, are those which are especially looked for, where either a striking display is desired or individual blooms required for single cut specimens, the neater and more compact varieties, which go by the names of Pompons or Lilliputians, (derived from the Chusan Daisy,) are those which are more especially admired for pot culture, neither requiring the room of the large ones, and being more available for bouquets; the former are the favourites with exhibitors, the latter with ladies.

It is mainly to the exertions of Mr. John Salter, of the Versailles Nursery, Hammersmith, that we are indebted for the large number of very beautiful flowers which comprise this section, and from his collection the subjects of the present illustrations were taken, although it is somewhat singular that during the past three or four years the greater proportion of new seedlings has been found amongst the large-flowered section, and so it is in the present year again: Mr. Salter has thirty-seven new flowers; of these only seven are Pompons.

The extreme docility, if we may use such a phrase, of the Pompon Chrysanthemum has led to its being very much tortured in the way of training, the ingenuity of many growers, many of whom concentrated their energies on this one class of plants, having been exercised to produce as ugly and tasteless plants as they could. We have never ourselves admired the curious forms and devices into which Yew and Box have been clipped, but where all was in keeping, and they formed the adjuncts of an Italian garden, they were just tolerable. Moreover being naturally stiff and formal in their growth, one does not feel that it is such a violation of taste; but when one used to see the Pompons grown on a single stem, and then trained like a round table, and sometimes three or four feet through, or else run up into a pyramid as formal as it could well be, suggesting more the idea of a floral bottlebrush than anything else, there was an instinctive feeling that this was entirely a mistake. We are happy to say that the death-blow seems to have been given to this system, and we believe that now generally the plan is adopted of training them more as the Pelargonium has been for so many years exhibited. For those however who wish to grow them merely for their own greenhouses, a much less amount of training is necessary, and a few stakes judiciously placed will answer every purpose.

Our plate contains *Fairest of the Fair* (Salter), fig. 1. *Mary Lind* (Smith), fig. 2. *Julia Engelbach* (Smith), fig. 3.

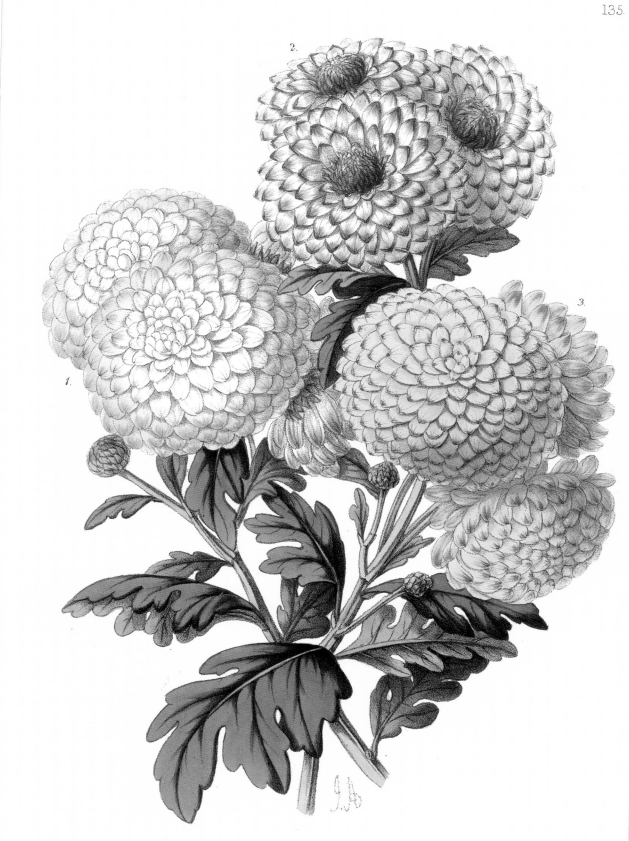

J. Andrews, del. et lith.

Vincent Brooks, Imp

Few flowers have so rapidly come into favour as the two varieties of Clematis raised by Messrs. Jackman and Son, of Woking, one of which, *Clematis rubro-violacea*, we have already figured; and, in accordance with wishes expressed to us, we now add that of its equally beautiful (and indeed, if possible, more beautiful) companion, *Clematis Jackmanii*.

Hardy climbers are evidently much wanted; and when any possessing the remarkable qualities of these new varieties of Clematis are produced, we do not wonder at the rapid sale they meet with. It will undoubtedly happen that the success which has attended these will stimulate others in the same field, so that we may expect additions to our lists from year to year. (It will not be easy, however, soon to surpass in size and brilliancy the splendid variety we now figure.) As a proof of this, we may mention that Mr. Wm. Bull has lately received from the Continent a pure white variety, called *Clematis lanuginosa candida*, and said to be a hybrid between *C. cærulea* and *C. lanuginosa*. It has downy leaves, while the flowers are open, of a pure white, and equal in size to *C. lanuginosa*. Another from the same source has been received by Mr. Bull, called *C. lanuginosa nivea*, but its character is not sufficiently determined.

C. Jackmanii has flowers fully expanded, and measuring from five to six inches across; the number of petals varies from four to six, the bloom figured in our Plate having five; the colour is a beautiful violet-purple, or, as it is now the fashion to call such colours, a bright mauve; the back of each petal is marked by three ribs, which show slightly through on the face of the flower, and tend in some degree to heighten the brilliancy of its appearance. It received equally with *C. rubro-violacea* a first-class certificate from the Floral Committee of the Royal Horticultural Society, when exhibited before them in August, 1863.

As we perceive by Messrs. Jackman's advertisement that their plants have been very widely distributed in all parts of the country, their merits are likely to be well tested during the ensuing year, and we have every confidence that they will give general satisfaction.

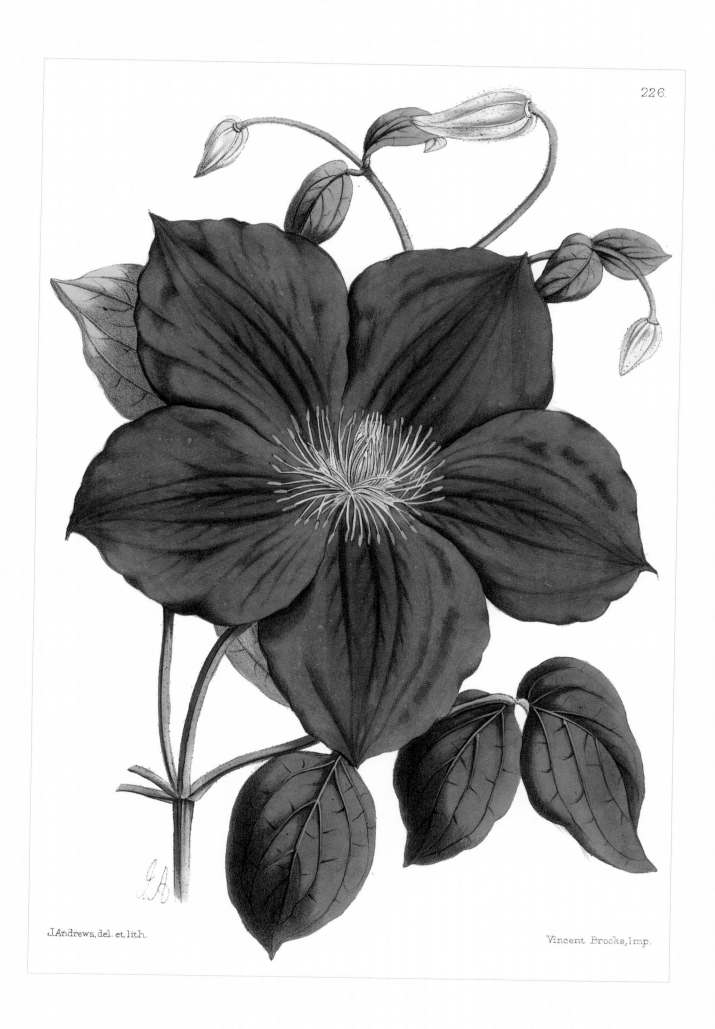

J.Andrews, del. et lith.

Vincent Brooks, Imp.

The appearance of this plant in our pages indicates a change in the character of our Magazine, which we hope will make it still more interesting to our numerous friends. We have hitherto confined ourselves to those plants which were cultivated in the open air or greenhouse, but we have felt for some time that as the efforts of the hybridizers were no longer confined to these, but had extended to the denizens of the stove and orchid-house, and that owing to the more wide-spread taste for horticulture a larger number of persons cultivate these flowers than formerly, we should meet their wishes and give a greater variety to our Magazine, by figuring from time to time such plants as were valuable for their decorative effect, and not mere botanical curiosities. In so doing we shall endeavour to avoid clashing with any other periodicals of a similar character.

Clerodendron Thomsoniæ has been exhibited during the present season in some of the collections of stove and greenhouse plants which have appeared at our great metropolitan exhibitions, but nowhere have we seen it so effective as in a small pit, at the establishment of M. Ambroise Verschaffelt, at Ghent, in Belgium, where it was trained along the rafter (in the same manner as we have seen the beautiful *Lapageria rosea* at Messrs. Henderson's), and the charming clusters of white and crimson flowers profusely borne on it made it a very lovely object, showing also that it is of easy cultivation and free habit.

"*Clerodendron Thomsoniæ*, var. *Balfourii*, now figured, is exactly like the normal form, excepting that its flowers are large, and being stronger the crimson and white are fuller and clearer. It was raised from seed by Mr. M'Nab, of the Edinburgh Botanic Gardens, who also raised *C. Thomsoniæ*." So writes Mr. Jackson, of Kingston, by whom the plant was exhibited during the present season, when it obtained a first-class certificate.

Mr Jackson has kindly given us the following notes on its cultivation: – "The cultivation of *Clerodendron T. Balfourii* is very simple. Pot in free rich mould. During the summer give strong heat, a liberal supply of water, and as much light as possible: keep the plant well spurred. In August ripen off the growth that has been made by withholding water and giving more air. During winter, if the wood is well ripened, it may be kept in a temperature of fifty degrees, and break stronger than if kept in greater heat."

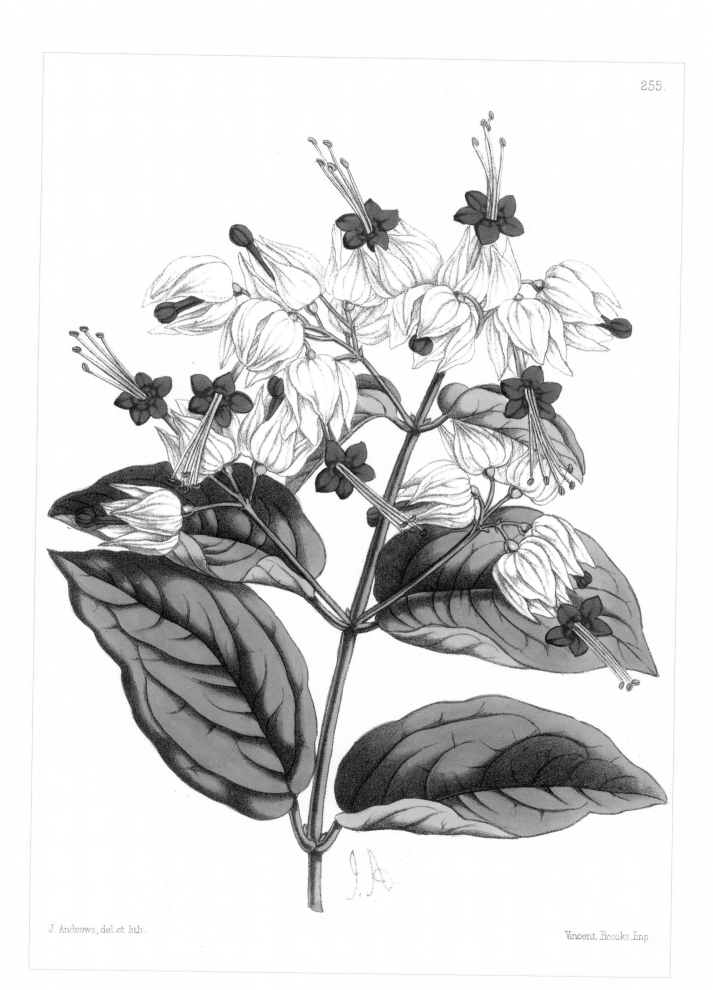

J. Andrews, del. et lith.

Vincent Brooks, Imp.

Clianthus Dampierii, var. Marginata

There are few flowers which make a more striking appearance than the beautiful *Clianthus Dampierii*, and we can well remember how much it was admired when exhibited by the Messrs. Veitch, at St. James's Hall, in the year 1858; its singular shape, bright glowing colour, and dark boss, giving it a most remarkable appearance. The plant itself is by no means a novelty, having been discovered in 1699, by Dampier (after whom it was named), in the dry sandy islands of Dampier's Archipelago, North-West Australia; but it had not adapted itself to the culture that it received, and so had all the charm of novelty when it was then exhibited.

Few persons who have visited the well-known establishment of Messrs. E.G. Henderson and Son, but could fail to admire the beautiful plants which were and are still grown in one of their long light pits, and would find it difficult to decide between the claims of this plant and *Lapageria rosea*, which was grown in the same house; it is impatient of damp, and requires careful management during the winter months, and is best treated as a biennial. It is to the Messrs. Henderson that we are also indebted for this new variety, which, if it at all corresponds with the Plate,* will be as great an addition as is the white variety of *Lapageria*; but as they regard it now as almost as sportive as a florist's flower, they will not, we believe, guarantee that it will come true, and of this we can only of course judge by time; in cultivation it will be found to succeed by the same method of treatment as the older variety, and is best planted out in a light and airy situation, no place suiting it better than such a pit as it is grown in by the Messrs. Henderson.

*Several gentlemen who have seen the drawing, and have at one time or other resided in Australia, have recognized the plant as one well known to them, and greatly admired in the colony; so that we have every likelihood of seeing not only this, but other beautiful varieties, produced from the imported seed which the Messrs. Henderson are sending out.

J. Andrews, del.et lith.

Vincent Brooks, Imp.

It is our province not merely to figure and describe such flowers as are new and popular, but also to endeavour to rescue from oblivion and to make popular those which though they may have been for a long while introduced into our gardens, are not as well known as we consider they ought to be; for it is surely unwise to cultivate worthless things because they are new, and reject valuable ones because they are old.

Amongst the flowers now adopted for the ornamentation of the conservatory, etc., hanging baskets (first introduced by the Crystal Palace Company, under Sir Joseph Paxton's guidance) are now become very much in vogue; and we were particularly struck, both at the Bishop of Winchester's and Lady Dorothy Neville's, with one filled with the plant which we now figure; and we have thought it well to give a figure of it in that condition in which it is most attractive, viz. when producing its exceedingly brilliant ultramarine berries, which it does in profusion during the autumn and winter months. We have been supplied, through the kindness of the Bishop of Winchester, with the following directions as to its cultivation by Mr. Lawrence, his Lordship's intelligent gardener: – "It is," writes Mr. Lawrence, "as most of our most beautiful things are, very easily cultivated. I find from experience that during the summer months it will do better in a close greenhouse, near the glass, and fully exposed to the light and sun's rays than in a stove, as might be supposed from its being a native of the West Indies; but on the approach of autumn it requires more heat, both to bring its flowers and its beautiful ultramarine berries to perfection, – the latter lasting in their brilliancy during the whole winter. It will thrive during the winter in any house where heat is used, such as a cucumber or pine pit, or intermediate house; the propagation, also, is very easy, as it grows equally freely by seeds or cuttings."

"When planting it in the basket, I first line it with moss, then fill it up with an ordinary compost of loam, leaf-mould, and sand; when the plant begins to grow freely, I peg the shoots over the surface until it is thoroughly covered, then it will throw enough shoots over the edges to make a fine mass, otherwise it will look straggling and poor."

We have little to add to the foregoing; its suitableness for the purpose named will be at once seen, and we consider it as far preferable to many more modern introductions, which have only the charm of novelty to recommend them.

J.Andrews,del et lith.

Vincent Brooks,Imp.

Few flowers are more graceful and elegant than the different varieties of Cyclamen, while their early-spring-blooming qualities add greatly to their value; and when combined, as in the case of *C. persicum odoratum*, with a delicious perfume, they are especially desirable, although no great diversity of colour is found amongst them.

The Cyclamen which we now figure, and which has been exhibited frequently by Mr. Holland, the intelligent gardener of R.W. Peake, Esq., of Spring Grove, Isleworth, besides the beauty of its appearance, both in foliage and flowers, has the additional recommendation of being evergreen, as will be seen from the following note, for which we are indebted to Mr. Holland, who has been most successful in the culture of this beautiful tribe of plants. "This very distinct variety was collected by R.W. Peake, Esq., in the South of Europe in 1859, and has been exhibited at all seasons of the year; and has obtained at the shows of the Royal Horticultural, Royal Botanic, and other Societies, first-class certificates. The remarkable features of this plant are its being evergreen, and in a constant state of efflorescence, while its blossoms are very fragrant, and continue for a long time. I have raised several seedlings from it, and they all maintain the character of the parent bulb."

It will be at once seen that there is, in many respects, a considerable departure from the character of *C. Europæum*, and that its qualities are such as to make it a very valuable plant. At present Mr. Holland is unable to say when it will be let out, but doubtless, during the coming season, there will be many opportunities of seeing it, together with those remarkably successful specimens of Cyclamen culture which Mr. Holland is wont to exhibit; a success which he mainly ascribes to giving the plant abundance of room, and not allowing the bulb to become too dry during its season of rest.

J.Andrews, del.et lith.

Vincent Brooks, Imp.

When Mr. J.G. Veitch went to the Philippine Islands two or three years ago, one main object of his voyage was to obtain plants of the beautiful and well-known *Vanda Batemanni*, and he had almost considered his voyage fruitless, so unsuccessful was he in procuring the Orchid he was in quest of. Happily, however, he one day landed in a bay in one of the small islands of the group, and there found his coveted treasure, growing in great profusion on the rocks of the coast; but more than this, he discovered at the same time growing on its roots this new *Cypripedium*. We saw it last spring, blooming in great beauty at the establishment of Messrs. Veitch and Sons, at Chelsea, and even amongst the curious and remarkable members of this group of Orchids it is a decided acquisition.

The plant was figured in the 'Botanical Magazine' of May last year (tab. 5508), but we were assured by Mr. Dominy that it had vastly improved in vigour and appearance since that figure was made; hence that by Mr. Andrews is much more effective, on account of the greater richness of colouring. We cannot do better than add Mr. Bateman's remarks upon it: – "It is most nearly related to *Cypripedium Stonei*, the only other species with glossy leaves, but differs from it in the form and colour of the lip, which is small and of a dirty yellow, while that of *C. Stonei* is large, with a pink front on a white ground. The petals, too, of *C. Stonei* are not twisted, and only twice the length of the sepals, while in *Cypripedium lævigatum* they are much twisted, and at least four times the length of the sepals. Again, in *C. Stonei*, the dorsal sepal is striped on the outside with crimson, but is white within, whereas in *C. lævigatum* the crimson stripes are all on the inside."

When we saw the plant in flower at Chelsea, it was blooming in an intermediate house; but as *Vanda Batemanni*, on which it was found, flourishes in the heat of what is called an East Indian Orchid House, we believe that *C. lævigatum* will do best in a similar temperature.

J. Andrews, del et lith.

Vincent Brooks, Imp.

The past season witnessed, as indeed every season does, the introduction of a large number of seedlings of this fine autumn flower; and, in the opinion of a good many growers, some remarkably fine flowers were amongst them. One of them, the subject of our present Plate, has been greatly admired, and we have therefore gladly given it a place in our Magazine.

Since we last figured Dahlias, the question of exhibiting them in their present classes has been largely mooted, and considerable desire has been evinced to effect an alteration. The class of fancy Dahlias, it has been felt, is very arbitrary. Why a flower with a dark ground and a white tip should be placed in this class, while one with a light ground and dark tip is not, is one of those anomalies which are at once recognized; and yet, like many other things, it is easier to see the error than to amend it. The discussions connected with the subject were commenced in a contemporary more or less connected with the Royal Horticultural Society, but the Autumn Show of the Society has been now abandoned, so that there is no opportunity of their initiating any change; nor do we think the Crystal Palace Company is likely to do so, so that the present system is likely to continue: and unless the change were generally recognized and agreed to, it would be worse than useless to attempt it. In the 'Florists' Guide' (a new aspirant for favour amongst those who cultivate florists' flowers, and promising well under its able editor), we find a writer has criticized the Dahlias of last year very severely, and notwithstanding the high promise of some of them, hardly seems to consider any of them worth preserving. This is very disappointing if it be so, but we have always to consider how much difference locality makes in all florists' flowers; and as he is a northern grower, perhaps the flowers are more suitable for southern growth and tastes. Dahlia *Princess Alexandra* was raised by a grower who has contributed not a few excellent flowers to our lists, Mr. C.J. Perry, of the Cedars, Castle Bromwich, near Birmingham. Among them, *Earl of Shaftesbury*, *Model*, *Delicata*, and *Mauve Queen*. He is also well known as a most successful exhibitor. It is difficult to give in a drawing an idea of the pearly whiteness that characterizes the ground, while the tip is of a very delicate lavender colour, quite different from any Dahlia in cultivation. The contour of the flower is good, and well up in the centre, so that we believe it will prove a desirable acquisition. It obtained, we may add, a certificate from the Floral Committee of the Royal Horticultural Society in September last.

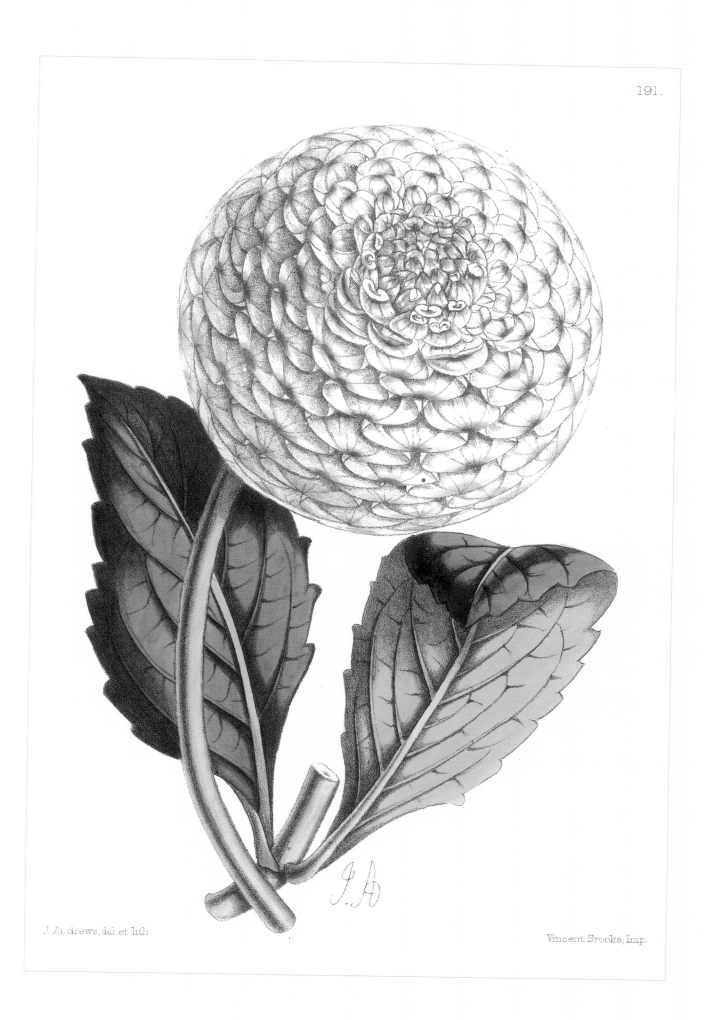

J. Andrews, del. et lith.

Vincent Brooks, Imp.

The changes which have been effected by the skill and energy of the horticulturist, in the entire character and appearance of the various plants which have been the subjects of his enterprise, are such as to startle those who are unacquainted with them, and who can hardly credit the marvels which he has to point to in proof of the success of his efforts.

Few could imagine that the magnificent double Dahlias, which year after year seem to attain to still greater perfection of form than before, are the progeny of the single variety which used, many years ago, to be considered merely as a greenhouse plant, and few we think would recognize, in the curiously beautiful subject of our Plate, any affinity to the Larkspurs, which either as annuals or perennials have been so long cultivated in our gardens. Such at least were our own thoughts, when, on visiting Mr. Fraser's garden, at Lea Bridge, in the summer of the present year, we perceived the plant growing amongst a collection of Delphiniums of home and foreign production, from which it was remarkably distinguished in many respects. Some years ago, a variety, which received a first-class certificate, named *Alopecuroides*, was exhibited by Messrs. Wheeler, of Warminster, but it was very different from *Triomphe de Pontoise*, being very confused, and of much deeper colour; it also, however, was a curious departure from the normal form, but we have not heard of any further advance upon it.

Triomphe de Pontoise is distinguished by the great regularity and button-like appearance of the individual flowers, the florets being regularly laid over one another so as to present a semi-globular appearance, and they are sufficiently numerous to present the appearance of a good spike of bloom without being confused; the colour is of a very bright and pretty azure-blue, and a good deal of white being present in the flower, it has a singularly delicate appearance. We are informed by Mr. Frazer that it was raised in the south of France, and that it blooms continuously from May to October, hence we think it will meet with the approbation of all lovers of herbaceous plants.

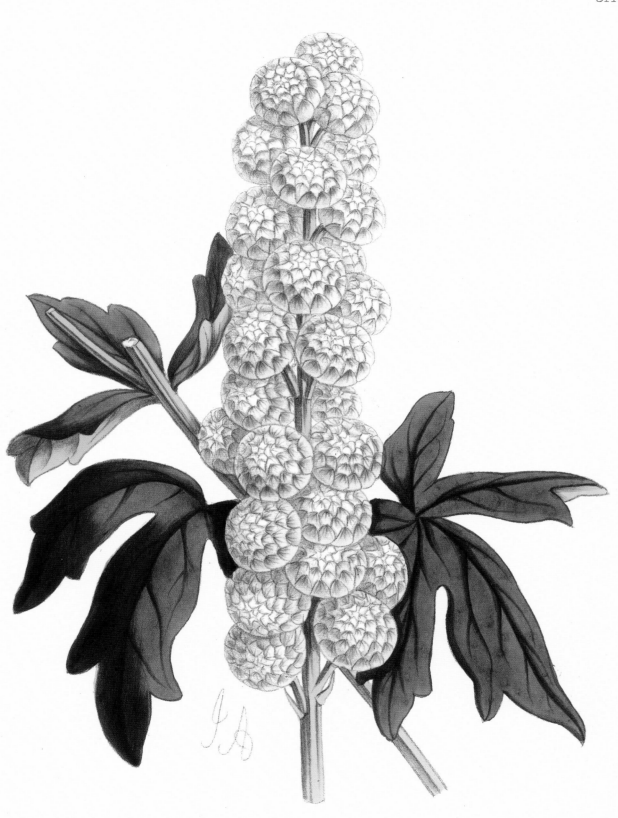

J. Andrews, del. et lith.

Vincent Brooks, Imp.

The species of Dipladenia already in growth are well known for their great beauty, freedom of flowering, and for the facility with which they form good plants for exhibition purposes, so that in most collections of stove and green-house plants, either *D. splendens*, *crassinoda*, or *Houtteana* are to be seen; that which we now figure under the name of *Dipladenia amabilis* will be found equally valuable for either the decoration of the stove or for exhibition. The Dipladenias are stove shrubs of climbing character, and grow and flower freely under the following treatment: – pot them in a compost composed of turfy loam and peat in about equal proportions, and with some pieces of charcoal about two inches square; during the early part of the year they should be encouraged to grow in a moist stove freely exposed to light; they will afterwards form a second growth, and should then be placed in a drier and cooler place in the stove; if it is required to grow them for exhibition, they should be shifted into large pots, plunged in the tan-bed, and their growth greatly encouraged; the wood should be very frequently stopped, so as to encourage a bushy habit; when they have done flowering and made their growth, they should be removed to a cooler position (an intermediate house would answer), and more fully exposed to the influence of the light of the sun; the wood will be thus ripened, and be in a better condition for the next season's growth.

Dipladenia amabilis has been frequently exhibited during the past season by Messrs. Backhouse and Son, of York, and Messrs. Veitch and Son; to the former of these gentlemen we are indebted for the flower from which our drawing has been made. It has obtained, and deservedly so, first-class certificates both from the Royal Horticultural and Royal Botanic Societies; has been universally praised by the gardening press, and will no doubt supersede some of the older varieties of the same colour.

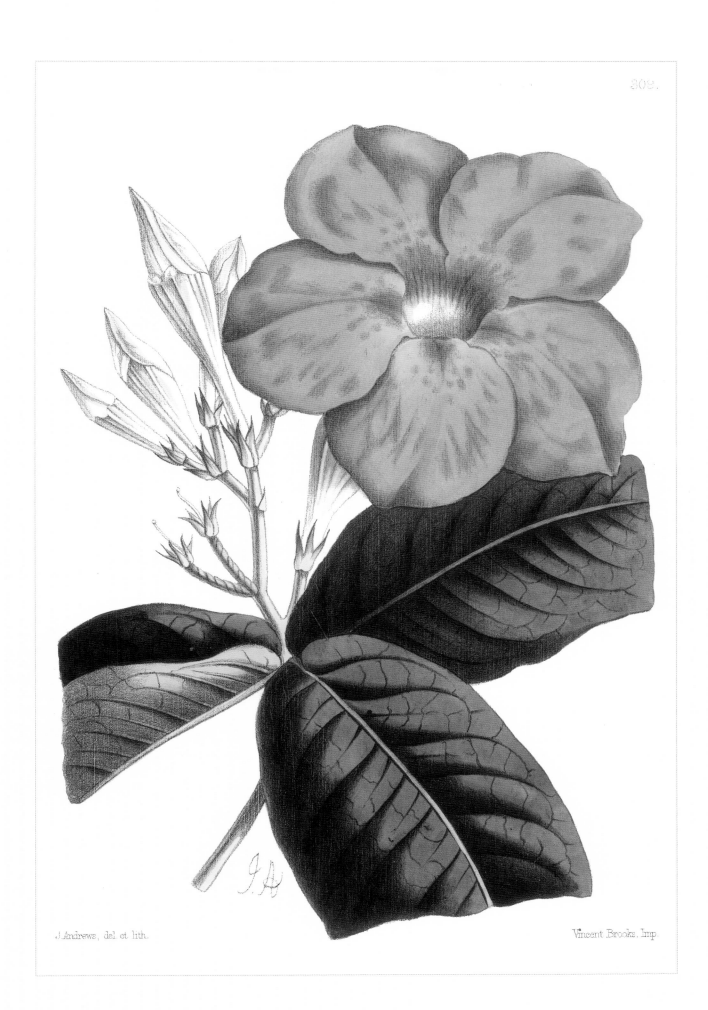

J. Andrews, del et lith.

Vincent Brooks, Imp.

Disa Grandiflora, var. Superba

It is now upwards of three years since we figured this beautiful Orchid in its normal condition, when indeed it was not known that there was any variation in the colouring. At that time it was so scarce that not only was it not in any catalogue of our leading firms, but none of our amateurs (save one) who spare neither trouble nor money in adding to their collections had it in their possession.

Since then, the liberality of the gentleman who first showed how this lovely plant might be successfully treated, our friend Mr. Charles Leach, of Clapham Park, and the enterprise of one of our leading nurserymen, Mr. James Veitch, of Chelsea, have combined to make it better known; the former has presented it to many of our best Orchid-growers, and also to the Royal Horticultural Society, through whom it has been distributed amongst the Fellows, and the latter has imported a quantity of it from the Cape of Good Hope, and has now a good stock of it in various-sized plants, ranging in price, according to size, from one to three guineas; and in accordance with the wishes of many of our friends we have given a figure of the more beautiful variety, named *superba*.

We had the pleasure the other day of seeing Mr. Leach's stock of this Orchid, comprising upwards of a hundred plants in various stages of growth, and on inquiring of him whether the past three years had led him to suggest any alteration in his method of treatment, he said, "No; some had spoken of giving the plants rest; mine appear to require none; at all events they do not get it, if by rest be meant diminution of watering: mine are syringed over two or thee times a day all the year round, young fry being in their several stages always in a growing state, and the young plants, the offsets from the parent bulbs, being generally an inch high before the old flower-stems have died down. I finished my repotting and taking off offsets or runners about a fortnight ago, and should no mishap befall me during the winter, I shall be almost driven to plant them out in the spring and make a bed of Disas instead of or beside a bed of Geraniums;" – thus bearing out the anticipation we formed three years ago, that it might hereafter be used round small pieces of ornamental water in gardens.

The variety now figured has larger and better-proportioned flowers than the ordinary one, while the colour in all the parts is much richer, and the green tips which exist in the lateral sepals of *grandiflora* are wanting in *superba*. We should add, that the Plate gives a very inadequate idea of the beauty of the plant, as six, seven, and in some instances eight flowers are produced on a single stem.

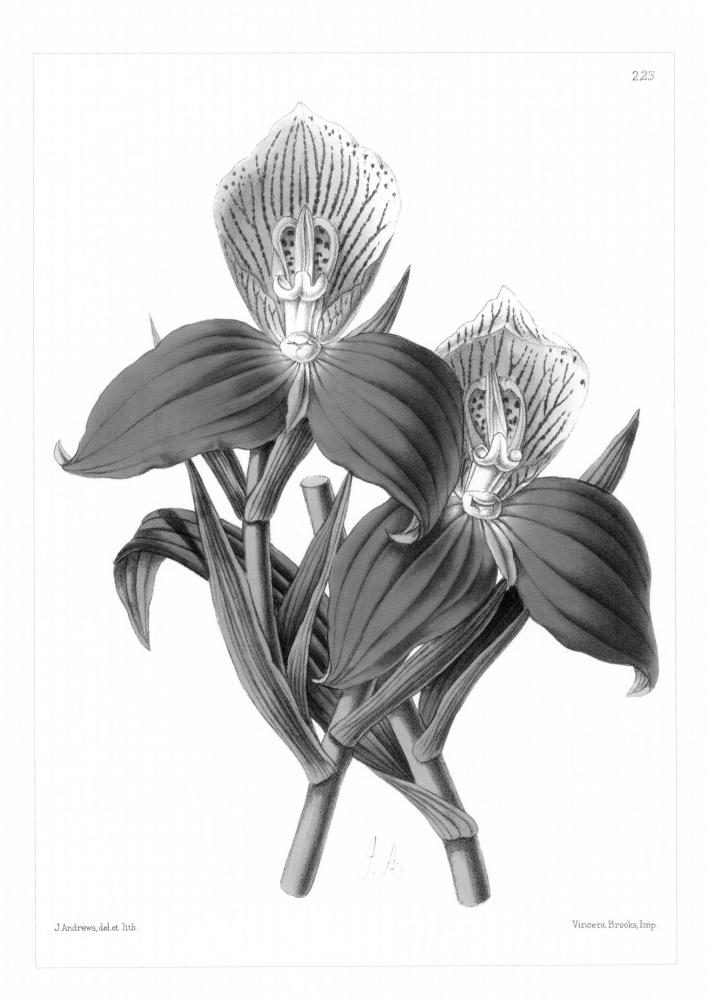

J.Andrews, del.et lith.

Vincent Brooks, Imp.

Few subjects have increased more in interest during the past few years than what is commonly known as the cool treatment of Orchids; large importations of the varieties most suitable for this purpose have been made, a ready sale has been found for them, while houses have (we have been informed) been erected in large numbers for their reception. Amongst those which were earliest subjected to this treatment, and successfully, was the well-known *Epidendrum vitellinum*, and the far handsomer one which we now figure is equally suitable for that purpose.

We have had an opportunity during the present season of seeing at various times the cool Orchid-house of Mr. James Veitch, and have been surprised to find what a continuous bloom was kept up in it, from earliest spring, or rather winter, until late on in autumn, and will still be maintained for some time to come, – the permanence of bloom of these Orchids making them most desirable objects for this purpose. Beginning with the Lycastes and Barkerias, on through several species of Odontoglossums, and then with Epidendrums, it was always gay. We had also an opportunity of seeing Mr. Rucker's houses of a similar character at Wandsworth, where two divisions of a long pit-like house were devoted to this purpose: in the first the temperature was kept at from 45° to 50°; here the flowers above-named flowered in great vigour; while in the second division, where the temperature was kept about five degrees higher, Cypripediums, Calanthes, Dendrobiums, Leptotes, and Cattleyas were doing well: and thus the idea heretofore attached to Orchids of a steaming East-Indian temperature (and still applicable to many species) is being gradually dispelled, and some very beautiful and remarkable flowers are now within the powers of the multitude.

Epidendrum vitellinum majus is, as its name implies, a larger variety of the well-known *Epidendrum vitellinum*, and the colour is much brighter, and in every way an improved form. We are indebted to Mr. Veitch for the opportunity of figuring it; and in a note received from him, he confirms the statements above made, and also adds that the cut blooms of this Orchid last for a very long time in bloom.

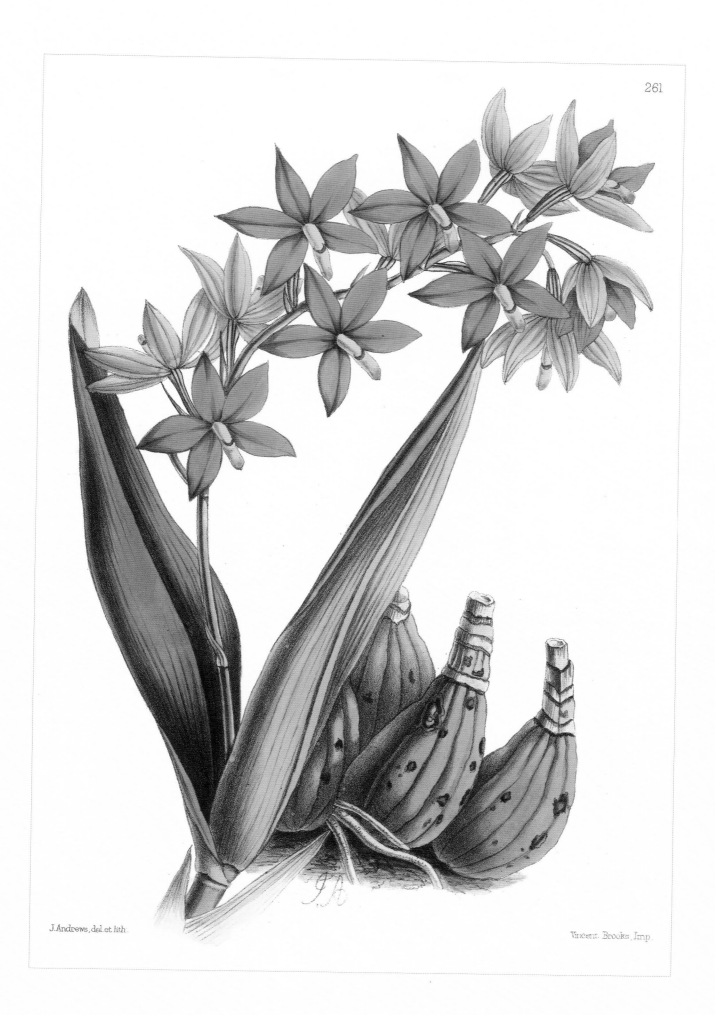

J. Andrews, del. et lith.

Vincent. Brooks, Imp.

Amongst those plants which have been forced to give way to the rage for novelties, and to the exigencies of providing room for bedding-plants in small establishments, Cacti of various sorts may be enumerated. In our younger days, we remember when they were the almost necessary adjunct of every warm greenhouse; and even now, on the Continent, where the modern system of gardening does not so much prevail, they are much more largely cultivated. We have ourselves seen, at some of their exhibitions, collections containing from 100 to 150 species, attracting considerable attention.

It is true that prizes have been for many years offered for Cacti at our great exhibitions; but the mistake has, we think, been made of regarding more the size of the plants than the number of varieties, and consequently very little attention has been paid to them; whereas, had a larger number of their very curious forms been constantly brought before the public, we doubt not they would have been much more appreciated.

Amongst the sorts most in vogue on the Continent, the various varieties of *truncatum* are perhaps in as great favour as any, and, formed into standards, they are admirable plants for table decoration, the heads drooping gracefully down, covered with their brilliant scarlet flowers. One of the newest of this class is *Epiphyllum truncatum tricolor*, figured in our present Plate, and sent out from the establishment of Mr. W. Bull, Chelsea. The blossoms are of a brilliant orange-red, having the centre of a rich purple, and being in all respects, perhaps, the very best of its class ever sent out. It has received the highest award that can be made to a new plant, and is a most desirable acquisition to our winter-blooming plants. In order to give, more clearly, a representation of the bloom, our artist has represented one of the branches in a semi-erect position; but the plant has the drooping character of the class.

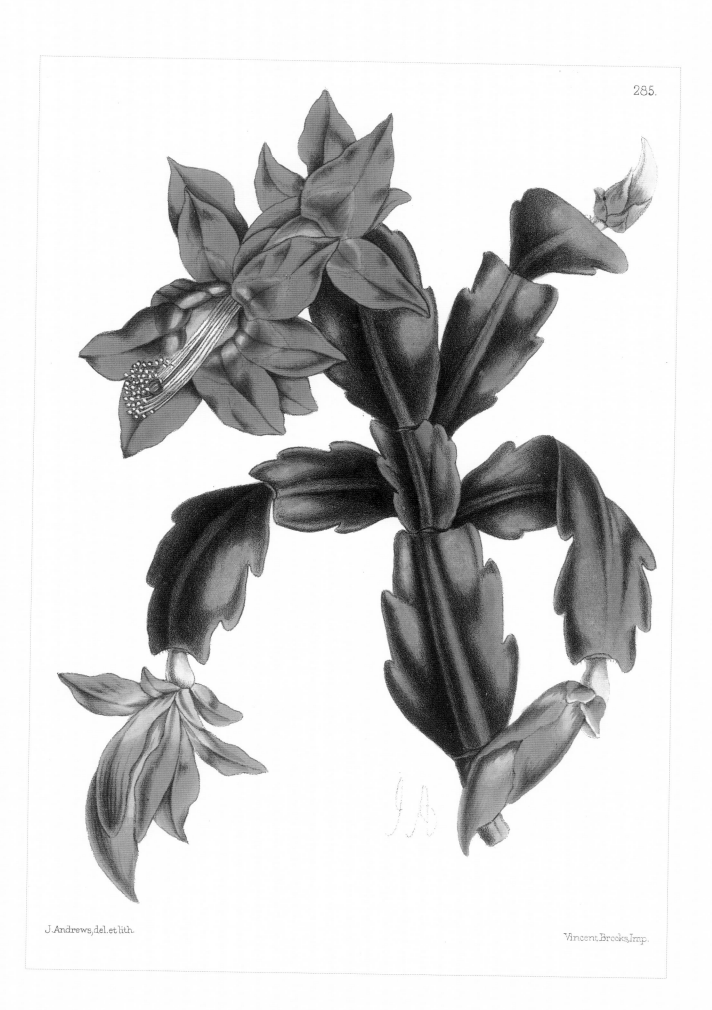

J. Andrews, del. et lith.

Vincent Brooks, Imp.

We are indebted to the Messrs. Veitch, of Chelsea, for the opportunity of figuring this new and desirable plant, from whom we learn that it was forwarded to them by Sir Daniel Cooper, Bart., from New Caledonia in 1862, and was exhibited by them at a meeting of the Floral Committee of the Royal Horticultural Society in September of last year, when it obtained a certificate.

Plants are now required for so many and such various purposes, that anything new is likely to be of service in some form or other; and although the subject of our present Plate has no pretensions to be a showy plant, yet its extreme freeness of flowering, and the dwarf and shrubby character of its growth, make it probable that it will be a very effective plant for decoration, more especially if (as we suppose it not unlikely, from the period of the year at which it was exhibited) it be an autumn bloomer. In the earlier part of the season there is no difficulty in obtaining flowers for decorative purposes, but as the summer denizens of the greenhouse have finished their blooming, it becomes no easy matter to supply their place, and hence a plant like this *Eranthemum* is a great acquisition, more especially to the owners of small greenhouses, if its cultivation be easy. Mr. Veitch says that as far as they can see, the temperature for growing it will be such as is to be had in a greenhouse, and it will thus be placed within the reach of most growers.

As the plant has been figured in the 'Botanical Magazine' (t. 5405), we cannot do better (as so little is known of its habits, etc.) than give Sir Wm. Hooker's botanical description of it. "Apparently a small *shrub*, copiously branched, with opposite or subverticillate slender tuberculated branches. *Leaves* copious, half to three-quarters of an inch long, elliptical or subobovate, very shortly petiolate, entire, obtuse, or more generally emarginate at the apex. *Flowers* very numerous, pure white, almost concealing the foliage by their number, axillary, solitary, scarcely peduncled (*almost* sessile). *Calyx* small, sparsely piloso-hispid on the subturbinate side; *limb* of fine, erect, linear subulate segments. *Corolla* with a very long, narrow, slightly curved, almost filiform *tube*, slightly dilated upwards; *limb* an inch across, oblique, scarcely two-lipped, the 5 *segments* ovate, very patent. *Anthers* small, purple, scarcely exserted. *Stigma* biglobose.

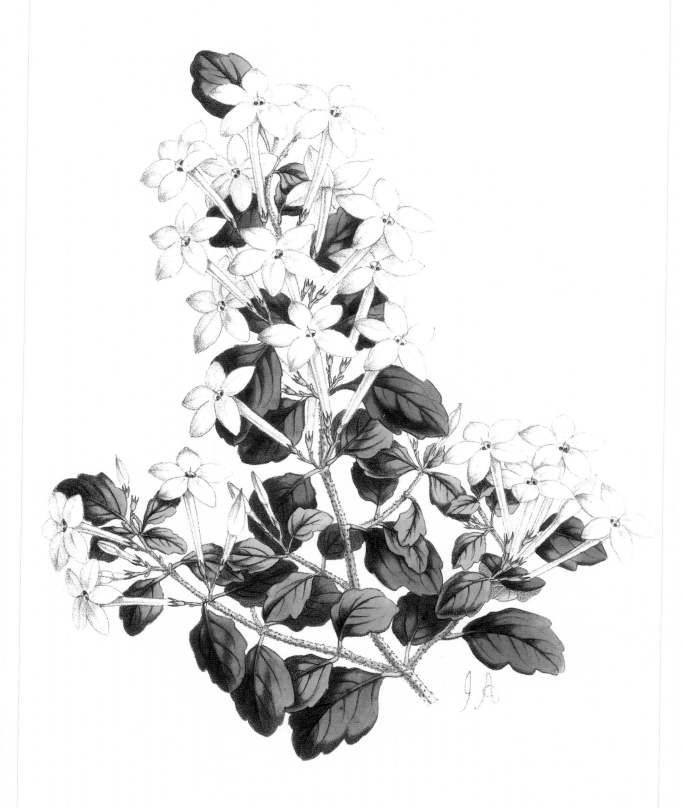

J. Andrews, del. et lith.

Vincent Brooks, Imp.

Fuchsias, Lucrezia Borgia and Fantastic

There seems to be really no limit to the variations that take place in the very simple flower which is seen in every garden and which bears the most opposite extremes of climate, for we have seen it during the past year, luxuriating as large shrubs twelve and thirteen feet high, in the wild and stormy mountains of Mayo and Donegal, and adorning in immense quantities the park and squares of Paris; and we may well ask, who would recognize in the curious and beautiful forms that now adorn our greenhouses the same plant that years ago they had cultivated originally with its narrow yet pretty flowers, its crimson sepals and darker tubes? See what changes either hybridizing or chance have wrought in it. We have it attaining a size which a few years ago would have been deemed chimerical; its sepals, from being pendent, have become reflexed like a Turk's cap; and in lieu of flimsiness, we have now great substance, the tube has increased in size and substance in proportion as the sepals have increased, the corolla has instead of being closely folded round become expanded, like a parachute or crinoline, or has become doubly increased in the number of its petals, while, as in the variety figured in our Plate, it appears in another and most curious form. An equal variation has taken place in the colouring: we have had white sepals, and corollas of crimson, violet, and purple; we have had, on the other hand, dark-crimson sepals and white corollas; and we have in *Lucrezia Borgia* a tendency to produce striped flowers which may yet create a revolution in the colouring and marking; and, as we have given evidence in our pages, the foliage has also added variety, and in such flowers as *Meteor*, *Pillar of Gold*, and *Cloth of Gold*, we have another remarkable class of plants.

Lucrezia Borgia (Fig. 1) is a flower raised by our friend and neighbour, Edward Banks, Esq., of Sholden, and is of great size and substance; the sepals are broad and well reflexed, the corolla is also large, of a rich violet-purple, with blotches and stripes, of light crimson-pink, these markings are irregularly produced, but are indications of a change in colouring which may yet produce some further novelties; it received a certificate from the Floral Committee of the Royal Horticultural Society. *Fantastic* (Fig. 2) is a flower raised by Mr. George Smith, and well deserves its name; the sepals are reflexed in the ordinary way, but it is in the corolla that the curious change has taken place; instead of being pendent, it opens out nearly horizontally, while underneath is what has the appearance of a second corolla, with the petals folded round in the ordinary manner, the colour being a deep-lavender: a reference to the Plate will at once show the very curious and fantastic appearance that this produces.

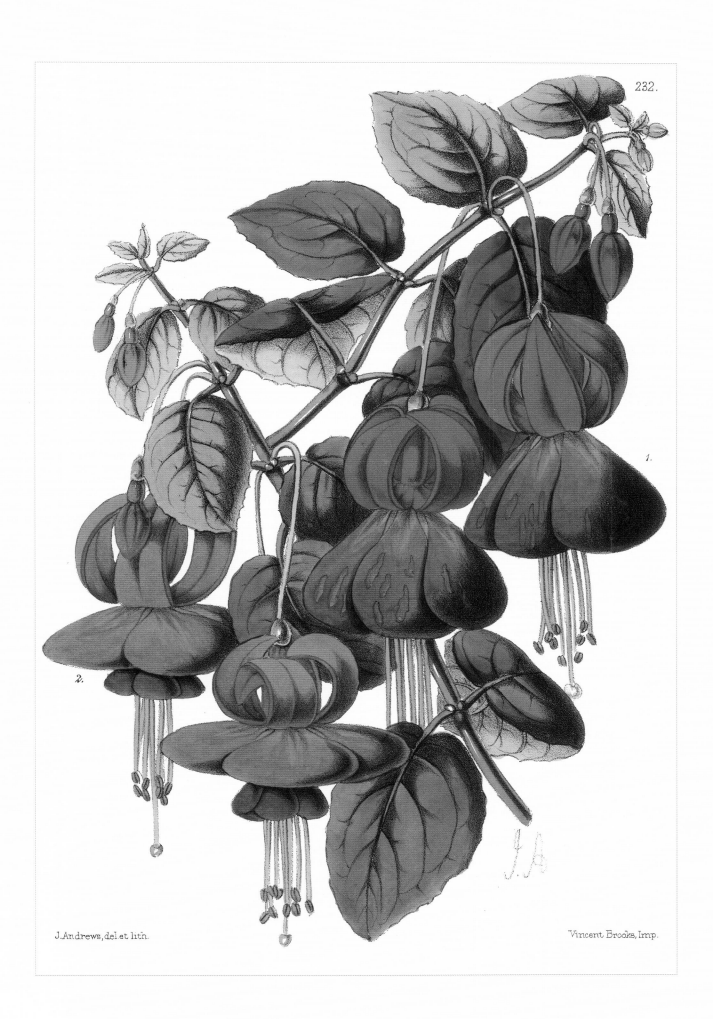

232.

1.

2.

Never has the maxim that "demand creates the supply" been more thoroughly exemplified than in the present taste for variegated plants; a few years ago and they were comparatively unknown, or, if known were in out-of-the-way places, where no one cared to look at them; now, not only has many an old plant been brought to light, but variegated forms of very many of our garden favourites are being continually introduced; and, stranger still, we have found, from the researches of Mr. Fortune and Mr. Veitch, in Japan, that the inhabitants of that kingdom have been far in advance of us, and that they have variegated forms not only of plants and shrubs, but even of trees, for we find *Thuiopsis*, *Retinosporas*, etc., with either gold or silver variegation, amongst those fine collections sent home to enrich our gardens and parks.

The whole question of variegation has given rise to opposite opinions, especially as to its cause; the opinion that it is the result of disease is now generally held by practical men, and is borne out by the fact, that when the departure from the normal condition is extreme, it is impossible to propagate the plant. Thus, when zonate or bedding Geraniums produce, as they sometimes do, entirely white leaves, it invariably follows that the attempt to perpetuate such a plant fails; if the cutting be taken off and planted it is certain to damp off. We may, however, say that as there are some forms of disease which give additional beauty to the human face, brightening the eye, and giving a lovely but treacherous colour to the cheek, so in the plant (especially in such a one as that in our Plate), we may say that the additional colour, and the varied hues which it acquires, greatly increase its beauty.

In *Pillar of Gold* not only is the variegation beautiful (the bright crimson midribs and the sulphur-marking on the leaves giving it a very bright appearance), but the flower is really a very tolerable one, the petals reflexing well, and the colour bright. We may also add, that as plants are now so much in requisition for dinner-table decoration, it is a most suitable one for that purpose, the play of light on the various colours producing just the effect which is required.

Pillar of God is the property of that well-known firm, the Messrs. Smith, of Dulwich, and will be let out by them in the spring; and we feel sure that with the present taste for variegated plants, many persons will desire to possess one so easy of cultivation, and useful as it is.

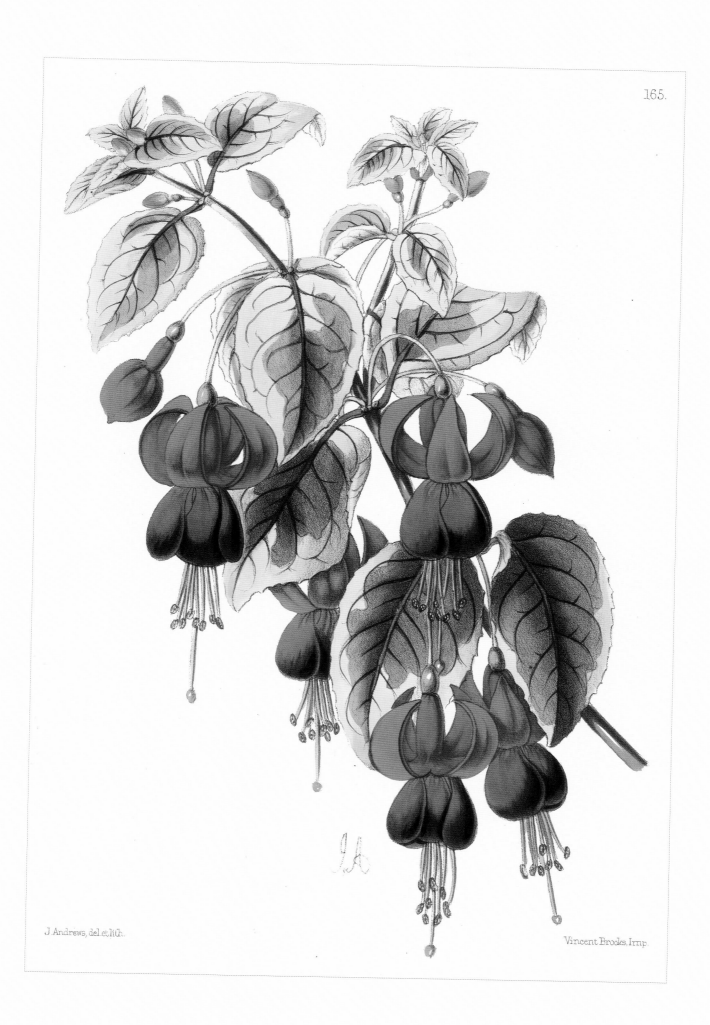

The difficulty of transit, when flowers are so easily separated from their flower-stalks and so numerous as in the Fuchsia, materially affects the bringing of them forward, before the recognized courts of appeal, for adjudication on their merits; and thus it has only once happened that our neighbour Mr. Banks, of Sholden Lodge, has been able to send any of his fine strain of seedlings to the Floral Committee, and then the result of the experiments did not (although his flowers received several certificates) make him anxious to do so again. Those fortunate raisers in the neighbourhood of London are not so disadvantageously situated, – the distance is short, the plants can be carried in the hand, and are little the worse for the journey; among these, Mr. George Smith, of Tollington Nursery, Hornsey Road, has been long known as a successful raiser and two of his flowers form the subject of the present Plate.

The subject of Fuchsias as objects for exhibition, has been considerably mooted during the past season, general dissatisfaction having been (and we think justly) expressed against the very artificial manner in which they have generally been placed upon the exhibition table; they have been grown very tall, elaborately trained out, and the whole character of the plant destroyed. Now there are certain rules of taste which we think ought never to be violated, and amongst these one ought to be, never to overtrain a plant which is naturally graceful. We say *overtrain*, for it would be quite impossible to show them without some support, but let any one notice the gracefully pendent character of this tribe, and say whether it would not at once strike an observer that such plants ought to be left in their natural state as far as possible, a single stake in many cases being ample. We believe it has arisen in a great measure from the desire to have over-large plants, no restriction being placed on the size of the pots, and the great endeavour being to have as large and cumbersome plants as possible, and consequently instead of growing yearly plants, old bushes have been exhibited. One exhibitor did last year break through the trammels, and the reward that he met in being placed first, will we hope, be a lesson that will not be thrown away on exhibitors during the present season. Amidst the gay and brilliant crowd of flowers, the Fuchsia does not shine pre-eminent for richness of colour; it ought then to have in perfection that quality which so essentially belongs to it as a plant, gracefulness and neatness.

Sanspareil (fig. 1) was exhibited at the Royal Botanic Society in July last, and considered the finest white-corolla Fuchsia ever offered. *Hercules* (fig. 2) is an extra large flower, free-flowering, and of good habit.

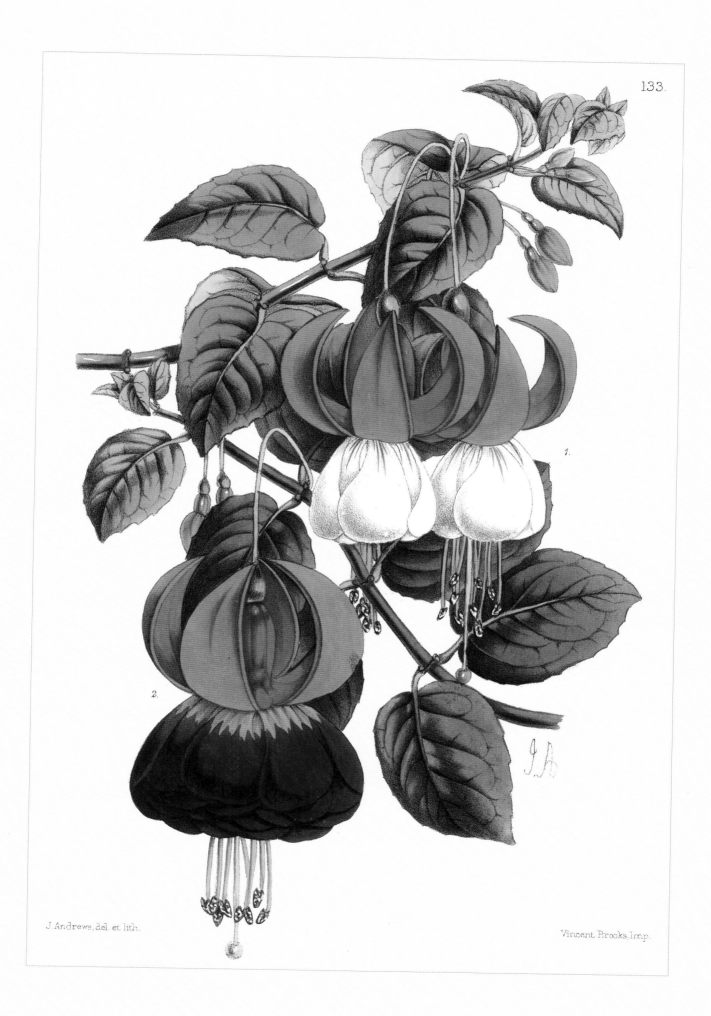

1.

2.

J. Andrews, del. et lith.

Vincent Brooks, Imp.

The Cape of Good Hope (and indeed South Africa generally) has furnished us with so many beautiful bulbs, and has been so well ransacked by collectors, that we must consider the introducers of this beautiful little bulb as peculiarly fortunate in having obtained so charming an addition to our already abundant treasures from that quarter of the globe.

When we run over in our mind the many gorgeous and beautiful bulbs which are furnished to us from thence, from the stately *Brunsvigia Josephinæ* down to the slender yet beautifully-marked and graceful Ixias, we may well call it the "paradise of bulbs;" moreover, from the character of the climate, they are of such a character, as in many instances (the gladiolus for example) to be perfectly hardy, and in nearly every instance, if not all, requiring at most the protection of a cool house, where they may be kept from frost.

Gastronema sanguineum, scarlet-flowered Gastronema (Lindley), was introduced by the well-known firm of Messrs. Backhouse and Son, of York. "The flowers are borne" (so they have described it to us) "on single stems rising from six to twelve inches high from the bulbous root, and are from three to four inches across, resembling the expanded bloom of a large-flowering Crocus, but of a clear apricot scarlet, varying to pure scarlet or orange-red, and with the addition of a broad, pale (sometimes white), Amaryllis-like tube." Being a native of the same country as *Gladiolus psittacinus*, it will no doubt prove hardy. Dr. Lindley, who first named and described it, says, "It is a very handsome plant, deserving general cultivation even in the most select collection." This description is well borne out by our figure, and we have no doubt that it will find a place wherever Cape bulbs or other ornamental greenhouse plants are grown, for in such situations it will, at any rate for a time, be found; its rarity will no doubt prevent any experiments as to its hardiness being tried for the present. Should it ultimately prove hardy, we can readily conceive what a valuable root it will be found for our flower borders, which are once more working their way into favour, threatening to reoccupy some of the ground which the bedding-out system has ousted them from.

We have only to add, that it obtained a first-class certificate from the Floral Committee of the Royal Horticultural Society when exhibited before them, and that it is now being distributed by the Messrs. Backhouse, who, as we have said, were the introducers of it, and to whose courtesy we are indebted for the opportunity of figuring it.

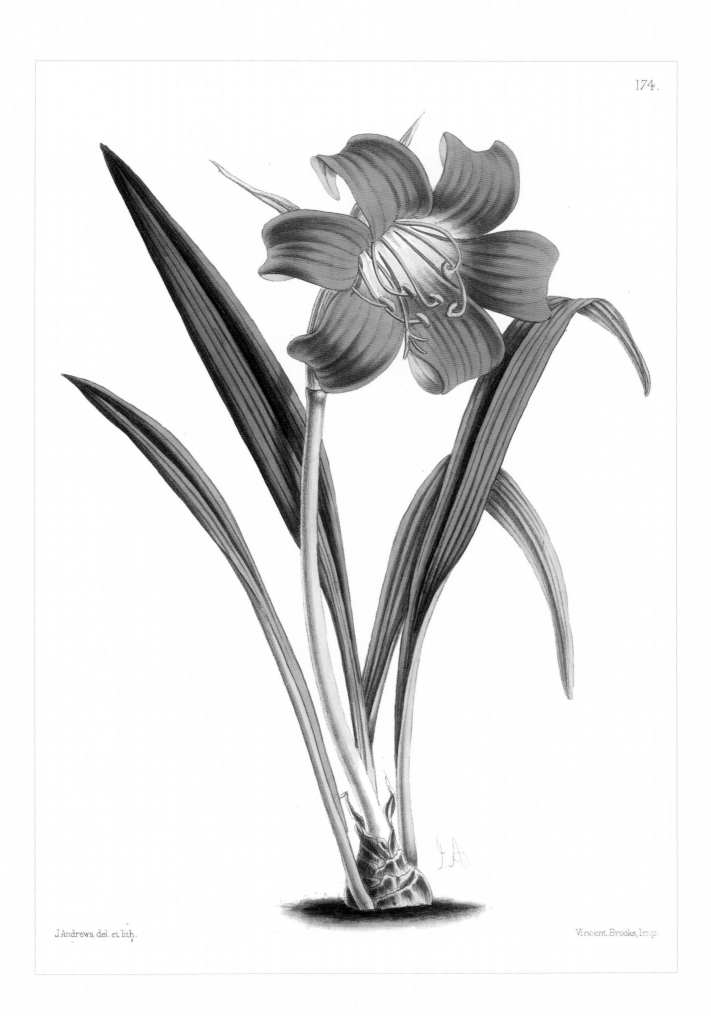

J.Andrews, del. et lith.

Vincent Brooks, Imp.

The popularity of this beautiful autumn flower has received a rude shock during the present season, owing to the disease which has appeared amongst the roots, in some cases sweeping off entire collections, in others depriving the growers of any bloom, and in many more, injuring it very materially. We think therefore that we cannot serve the interests of our friends better, than by submitting to them a few observations upon this point; for although we have not been sufferers ourselves, having had no symptoms of the disease, yet we have paid a good deal of attention to it, have conversed both with English and French growers, and have formed our own conclusions, which indeed may be wrong, but which nevertheless have commended themselves to many experienced growers. We have noticed that the disease has been most prevalent in heavy soils, – the growers about London, on the London clay, and in the loamy districts of Hertfordshire, having suffered the most, while in the light soils of Ascot and Great Yarmouth, neither Mr. Standish nor Mr. Youell have found it prevalent, and in our own rich but light and well-drained soil it has also been absent. Coupling this with the fact of our having had so very wet a season last autumn, when the bulbs ought to have been maturing, we are led to think that excess of moisture has been the cause; that owing to that, the bulbs were not sufficiently ripened last autumn; and that when they were planted in damp and close soils, they very soon became affected with the disease.

The course which we have ourselves adopted, and which we intend to continue this year, is to cover over the beds *now*, with old sashes or any suitable covering that will protect them from heavy rains, and when taken up, which they will be about the middle of November, to dry them well indoors, to manure the beds well at this season, so as to allow it to get well incorporated with the soil during the winter months, and not to plant too early in the spring. The beautiful variety now figured is one of those raised by Mr. Standish, of Ascot and Bagshot, and received a certificate at the September show of the Royal Horticultural Society, but it is quite impossible to find any pigment that will do justice to its glowing richness and beauty. We have had the opportunity of testing his flowers this season, with some of the best and newest of M. Souchet's, and to our mind, there can be no doubt as to the superiority of the English seedlings, their form and substance being better than the French ones.

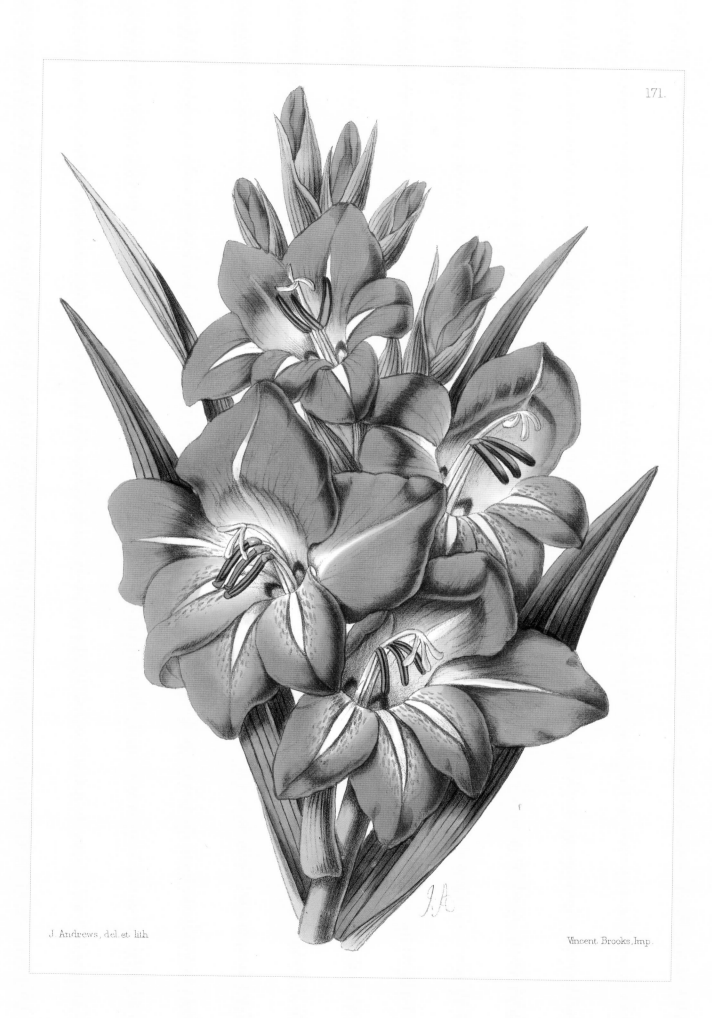

J. Andrews, del. et lith.

Vincent Brooks, Imp.

Although but scant favour has been shown to autumnal flowers this season around the Metropolis, – the exhibition at the Crystal Palace being the only one worthy of the name, for the miserable display at South Kensington did not deserve to be called an exhibition, – yet in various parts of the country where autumn shows are always popular, fine collections of beautiful Gladioli have been staged. We had ourselves the pleasure of carrying off first prize at Brighton in a class open to all England, and amongst the spikes then so much admired was one of the very beautiful variety figured in our present illustration, one of the numerous fine seedlings produced by the successful hybridization carried on my Mr. John Standish, of the Royal Nursery, Ascot. We have again taken the trouble to compare some of the finest of Mr. Standish's seedlings with those which have come to us from the Continent, principally raised by M. Souchet, of Fontainebleau, and we do not hesitate to say that the English flowers are quite equal to the foreign ones; and as so many new flowers are raised every year, we think it is time that there should be more discrimination practised as to what should be let out and grown than formerly. There can be no question that those varieties which produce their flowers on opposite sides of the stem are very inferior in effect to those which present but one face, and hence, as we have so much variety, all these "winged flowers," as they have been called, ought to be discarded, – a process which we are about to begin in our collection, they having been simply tolerated until the same colour was produced in the better-arranged flowers.

Again has the question been mooted as to the best way in which the Gladiolus should be exhibited, – the discussion having arisen from the fact of one of the exhibitors at the Crystal Palace placing his flowers in the concave leaves of the Aloe, and thus showing those flowers which were double-faced to a single front. We think that they ought to follow the example of all florists' flowers, and be shown without any foliage, for we believe that then the true character and value of the varieties would be better seen.

Eleanor Norman is a flower of great delicacy of colour, and indeed quite unique. The ground colour is white, but so largely suffused with pink and flaked with pink stripes as to leave very little of it to be seen; in the centre of each of the lower petals is a bright crimson feather, while in the throat there are semi-circular spots of deep crimson. It obtained a first-class certificate from the Floral Committee of the Royal Horticultural Society, and has been greatly admired wherever exhibited.

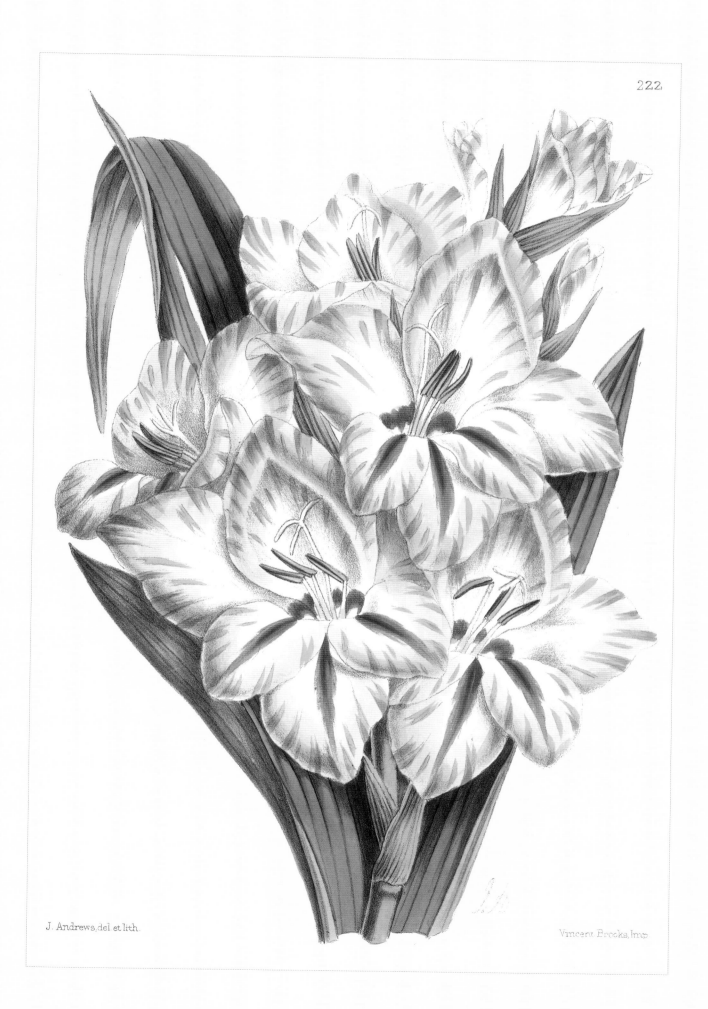

J. Andrews, del et lith.

Vincent Brooks, Imp.

Godetia Rosea Alba, var. Tom Thumb

The varieties of *Godetia*, closely allied to *Oenothera*, are well known in our flower gardens, and many of them are used as hardy annuals for the purpose of filling up herbaceous borders, especially in those smaller ones where the bedding-out system has not been extensively used, – a system much more applicable to large gardens, and where large means are at command, than to small ones.

It has been well observed by the Messrs. Carter, to whom we are indebted for the opportunity of figuring this new variety, that "the original *Godetia rosea alba* is well known as one of the prettiest of the so-called Californian annuals, its only demerit consisting in its now being sufficiently dwarf; this objection is overcome by the *Tom Thumb* variety now offered. The colour of the flower is pure white, with a brilliant rose blotch towards the base of each petal; its height of growth is not more than twelve inches; and the blooms are produced in great profusion." There is but little to be said as to the cultivation of this, or indeed of any of these hardy annuals, which, it is well known, is of the very simplest character; so simple, indeed, that they are oftentimes treated on this account with much neglect. A little trouble is not thrown away on them, and we know from experience that where they can be sown in seed-pans, and then pricked out, the trouble is amply repaid by the great business of the plant and the profusion of bloom; and where so much of this branch of gardening is practised by ladies, they can easily manage to bestow this additional trouble, which, we can assure them, will be amply rewarded.

We may take this opportunity of mentioning that several novelties amongst annuals are announced this season. Mr. Thompson, of Ipswich, sends out his new *Rhodanthes*; Messrs. Barr and Sugden announce new *Celosias*, etc.; while the Messrs. Carter have, in addition to the flowers now figured, the *New hybrid Mimulus*, *Clarkia integripetala*, *Swainsonia splendens*, and *Gilia laciniata*; so that in these, as well as in what are called florists' flowers, the lovers of novelty are likely to have their tastes gratified.

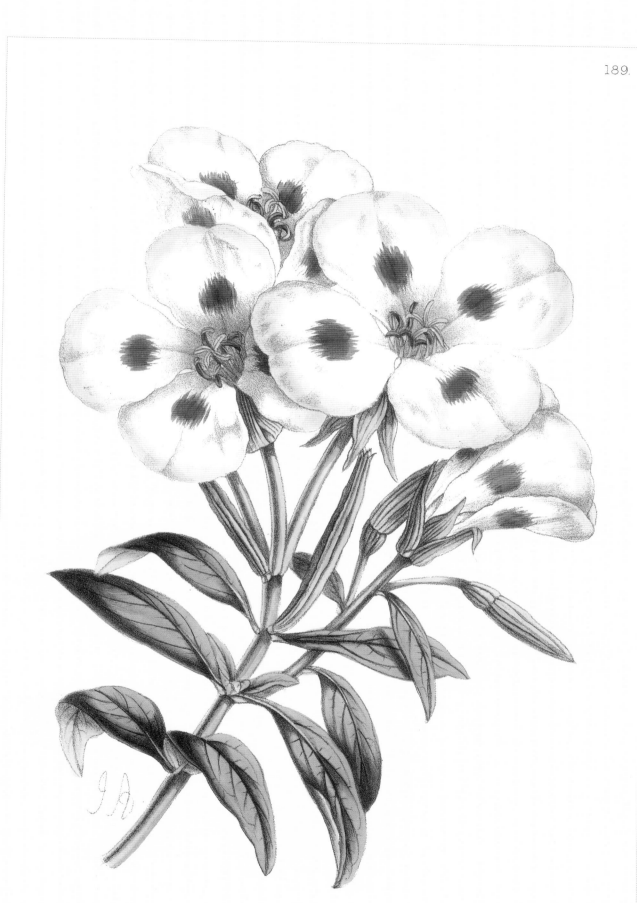

J Andrews, del et lith.

Vincent Brooks, Imp.

Amongst the early recollections of our flower-loving days, succulent plants hold a place: in those days, ere foliaged plants and ferns were so extensively grown, when Orchids were considered to present almost insurmountable difficulties, and the world had not been so thoroughly ransacked to satisfy the insatiable appetite of the horticulturists, collectors of these plants, so curious many of them both in their foliage and their flowers, were by no means uncommon; *Aloes* and *Mesembryanthemums* from the Cape; *Cacti* from Mexico and Central America; and curious forms from other parts of the world, tending to make an interesting, if not a brilliant display. The taste seems to have survived in France longer than here, for at their great Floral Exhibition in May last, we noticed several collections of them from some of the large growers there.

"A plea for succulents" has lately been made in one of our contemporaries, and their points of interest very forcibly put; and as the curious plant which we now figure has received a first-class certificate from the Floral Committee of the Royal Horticultural Society, we have endeavoured to encourage, so far as lies in our power, the attempt to bring them once more into favour. Although the plant was exhibited by Mr. W. Bull, of Chelsea, it came from the collection of Miss Hibbert, of Clapham, and to her intelligent gardener, Mr. Lloyd, we are indebted for the following particulars.

"*Greenovia aurea* was introduced in 1815 from Madeira by Dr., afterwards Sir James Edward Smith, and named *Sempervivum calyciforme*, by Haworth. The genus *Sempervivum* was broken up subsequently (I believe by Webb), when our plant obtained a new specific as well as generic name; it was afterwards nearly lost, and the first time I ever saw it was in Cambridge Botanic Garden, whence I procured a plant for W.W. Saunders, Esq. Since then that gentleman has received plants of it, as well as *G. fallax* and *G. dodrantalis*, from either Madeira or the Canary Islands.

"In cultivation, I may say that it is triennial; when it has once bloomed it dies, and the only method of reproduction, except by seed, is to cut out the centre of the plant with a sharp knife, after which operation it will produce offsets which take root freely; in texture it is so very compact as well as concave, that full-grown plants will hold and retain a wineglass-full of water, without its filtering through between the leaves."

We have but to add, that the exigencies of our Plate will not admit of our giving to it more than half its natural size, and that a very small portion of the large head of flowers (which are of a bright yellow colour) has been introduced.

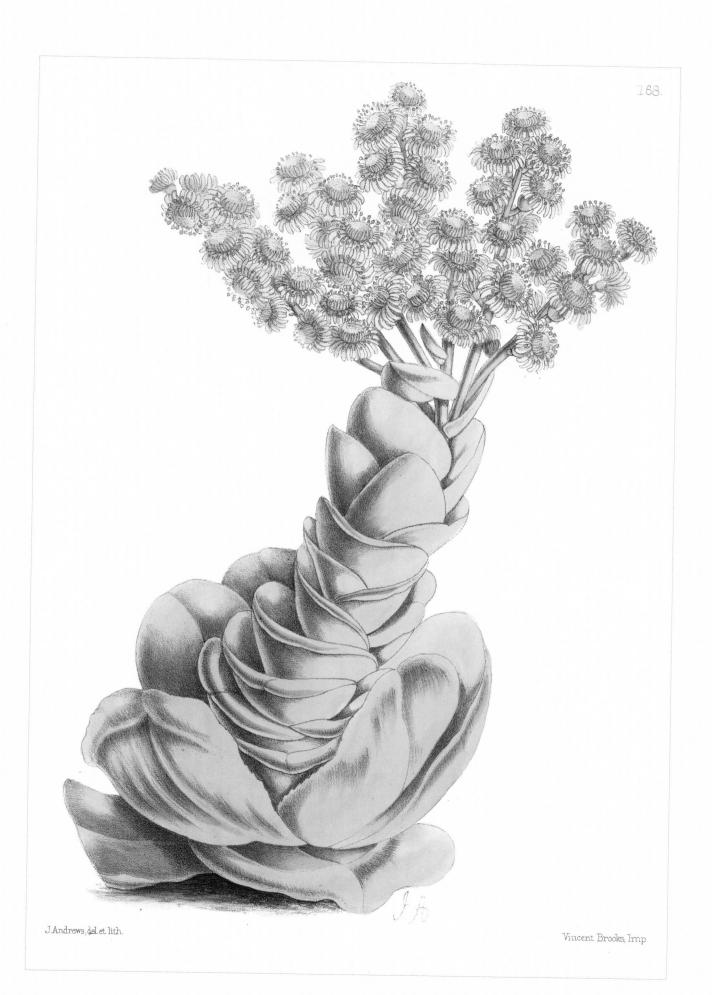

J. Andrews, del. et lith.

Vincent Brooks, Imp.

There are few persons who have of late years visited our spring exhibitions who have not admired the very striking plant which, in a reduced form, is the subject of our present plate; its broad and ample lily-like foliage, surmounted by a large scape of its brilliant orange-coloured blossoms, making it a conspicuous object; and its early-flowering habit, in which it resembles may others of the Amaryllids, will make it a plant most desirable for a season of the year when flowers are so much appreciated.

Imantophyllum miniatum is a native of Natal, and possesses the most desirable quality of being an evergreen plant, unlike in this respect many of its congeners, which produce their large and brilliant flowers some time before the foliage appears, and consequently lack a charm always acknowledged by a lover of flowers – bright foliage to throw off the colours; it was, as we learn from the 'Illustrated Bouquet' (published by Messrs. E.G. Henderson and Son, in the December number of which work it is figured), sent to this country by Mr. James Backhouse, of York. Like many other allied plants, it likes a warm temperature during its period of growth, and thrives best in a compost of loam and peat, with the addition of a little leaf-mould and sand. When the plants have thrown up their scape they may be removed to a cool portion of the house, and will thrive during the summer months in a cool greenhouse, where they can have abundance of air and light; and by this means, a good healthy plant is secured for the next year's blooming-season.

Mr Andrews has felt considerable difficulty in accommodating the plant to the size of our Plate, and has adopted the plan of showing a few of the flowers the size of life, – also giving a leaf of natural size, and in a small outline figure, showing the general habit of the plant; thus both the great beauty of the individual flowers, which some-times number as many as twenty on one scape, is seen, and the character of the plant itself shown.

A plant so desirable and so easy of cultivation will not be long in finding its way into the collections of those who appreciate beautiful and early-flowering plants; and in the hope of aiding in its cultivation we have included it in our illustrations.

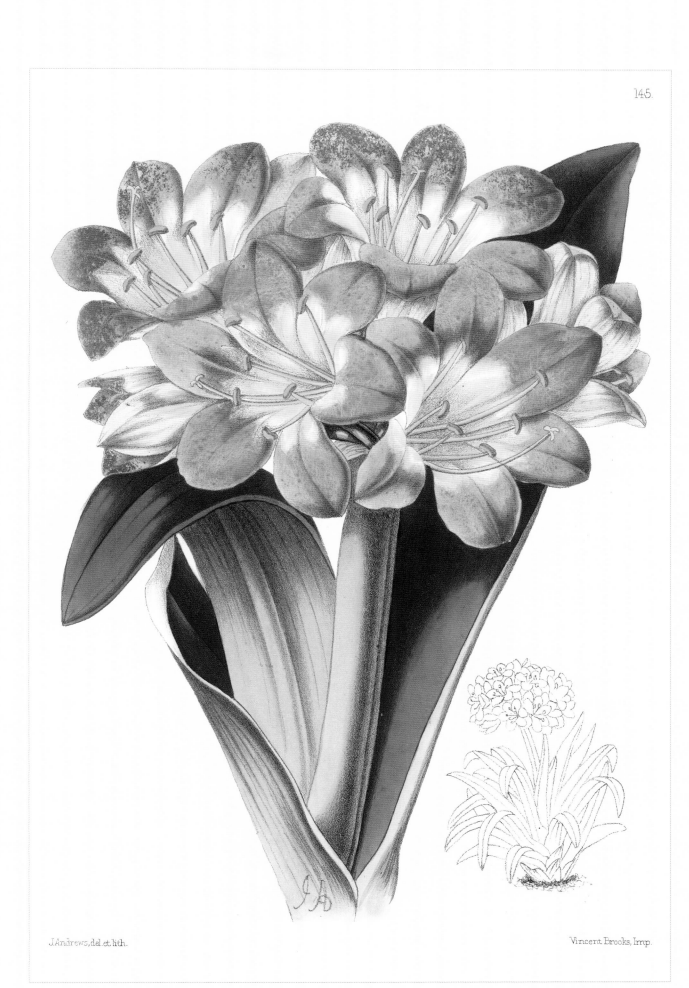

J.Andrews, del. et lith.

Vincent Brooks, Imp.

The desire of making variety in those brilliant flower-gardens which are now so much in vogue, and especially of contrasting something more sombre with the bright and glaring reds and yellows that predominate, has led to the introduction of many plants with dark foliage, such as *Perilla Nankinensis*, *Coleus Verschaffeltii*, and *Amaranthus melancholicus ruber*, – the latest addition being the plant which we now figure, introduced from Brazil by Mr. Herbst, of the Kew Nursery, to whom we are indebted for the following account of it: –

"This plant forms a soft-wooded shrub of from twelve to eighteen inches high, and is without any trouble grown into a perfect specimen of the most globular form, as it produces a branch from the axil of every leaf. In a house too warm and close it no doubt would grow taller, but even then the stopping of the terminal shoot would make it branch very easily. The stem and branches are of a most beautiful almost transparent carmine, while the leaf itself, strongly bilobed, is of a purplish-crimson underneath, dark maroon on its upper side, with its many broad ribs of a very prominent carmine. There is not a green spot on the whole plant, and whether placed in the shade or in the most brilliant sunshine, it produces a most admirable contrast with plants of a lighter colour. It has neither the gloomy appearance of the Perilla nor the woolly leaf of Coleus, and is by no means so susceptible of cold and dampness combined as this latter plant. Another advantage it has is, that it does not flower either out-of-doors nor in a warm greenhouse, where I have introduced several strong plants on purpose to induce it to flower."

"The Iresine was introduced by me from the River Plate, and Sir W. Hooker possesses a native specimen from Peru, gathered by Matthews; but incorrectly, he says, placed in his herbarium as *Iresine diffusa*; I am at a loss to find how I deserve the compliment paid me by Sir William by naming the plant after me, unless he meant it as an acknowledgment for the many contributions in plants which I sent to Kew Gardens during my eight years' stay in Brazil."

"The plant coming both from Peru and the River Plate will no doubt stand our climate better than the Coleus; in my nursery-ground, in close vicinity to and almost on a level with the Thames, open to all winds and weathers, without trees or protecting walls, it stood uninjured in the slight frost which occurred in August last, while the leaves of *Coleus Verschaffeltii* were entirely spoiled, and those of *C. nigricans* dropped off."

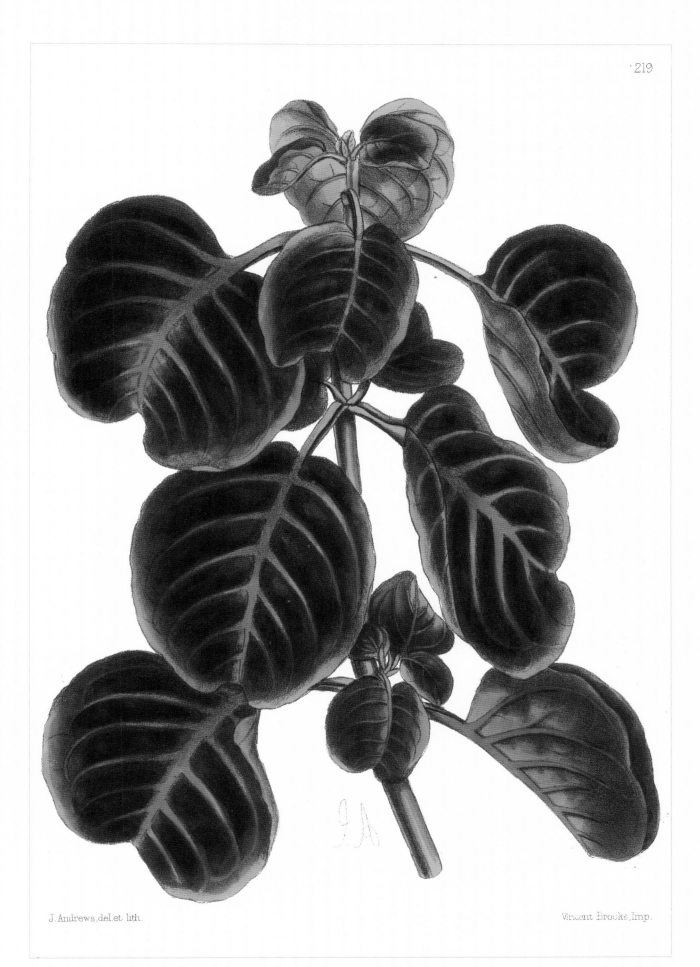

J. Andrews, del et lith.

Vincent Brooks, Imp.

Among the many plants with variegated foliage which have been introduced from Japan, this form of the old and well-known Kerria of our gardens is likely to attract special notice, and we have therefore added it to our illustrations. A plant of it was exhibited at one of the spring shows of the Royal Horticultural Society by Mr. Charles Turner, of Slough, and was much admired.

The whole subject of variegation and its causes has lately been a good deal ventilated, and with it also that of double flowers, Professor E. Morren maintaining that variegated leaves and double flowers never co-exist, although his theory was somewhat disturbed by this very plant being figured in 'Illustration Horticole' with double flowers; it was found, however, that the artist had made up the figure with the variegated leaves of one plant and the double flowers of another!

A writer in a contemporary, in speaking of this subject, says, "One of Fortune's variegated Camellias which has lately flowered in Mr. Bull's establishment and has been figured in the 'Journal of Botany,' is also calculated to strengthen Professor Morren's position. Until now, few of the plants of *Camellia Japonica* in our gardens have been known to produce flowers in the strictly normal condition, namely, with five petals only; and Dr. Seemann, when publishing his monograph on Camellia and Thea, was compelled to state that, though we had thousands of representations of the different varieties of *Camellia Japonica*, we did not possess a single plate exhibiting its normal condition, – even Siebold and Zuccarini, in their 'Flora Japonica,' having figured a form with semi-double flowers. Bull's variegated Camellia, with its five petals, is therefore as happy an illustration as Professor Morren could wish to have to prove that variegated leaves and double flowers – weakness and strength – never, or, as we would rather put it, seldom, go hand-in-hand."

This, then, is the present state of opinion, and the single-flowered variegated form of the plain-leaved double Kerria is another proof in the same direction.

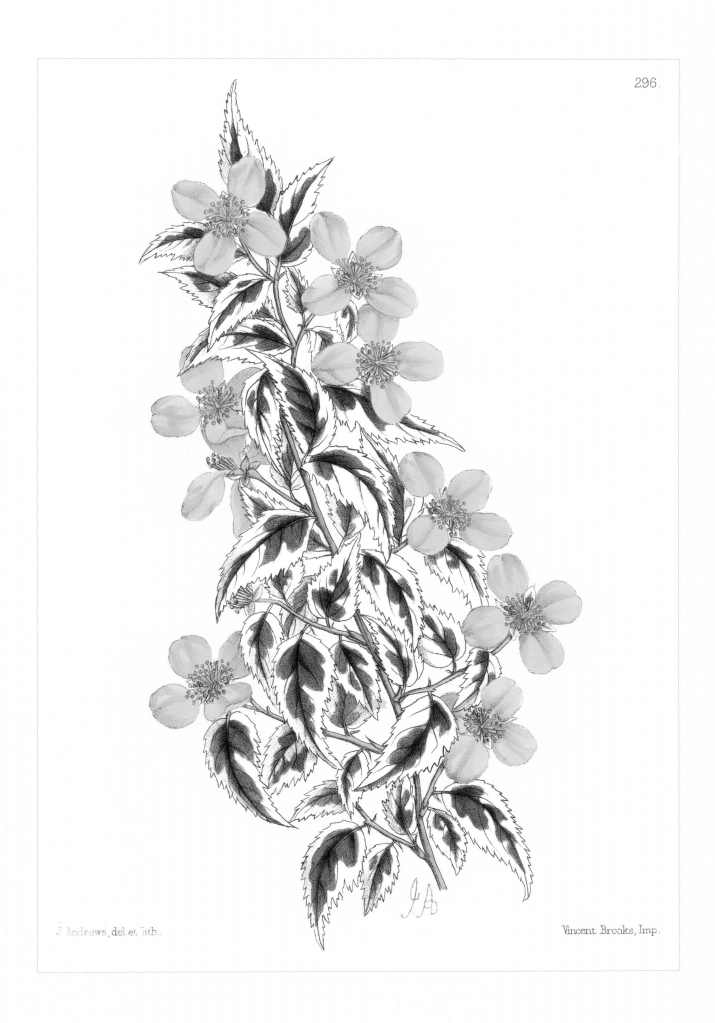

J. Andrews, del. et lith.

Vincent Brooks, Imp.

Amongst the many collectors sent out by our chief nurserymen, few have had the good fortune to send home prettier and more generally useful plants than Mr. Pearce, the indefatigable collector of Messrs. Veitch and Son, of Chelsea. Our pages have already been enriched by drawings of some of his plants, *Ourisia Pearcii*, *Mimulus cupreus*, etc., and we now have the pleasure of adding another to the list, in the very pretty orange-yellow *Linum* which, under the name of *L. Chamissonis*, he sent home in 1860.

Many collectors visit the warmer portions of our globe; and although in grandeur of foliage and singularity and splendour of flowers, Borneo, Madagascar, and Brazil may justly claim the pre-eminence, yet their productions are such as only the wealthy can hope to cultivate; not so, however, such countries as Japan, North China, and the higher ranges of the Andes, – there, owing to the low temperature, their flora is such as will either bear transferring to our gardens, or at most will require the protection of a greenhouse, so that all persons of moderate means may be benefited by the researches of those who visit them; hence their much greater value in the eyes of the floricultural public. Take, for example, the very curious *Ouvirandra fenestralis*, or Lattice-plant of Madagascar, – in how few places is that to be found! while *Lilium auratum* will in a very short time find a home in every greenhouse in the kingdom: one is the plant of the select few, the other, that of the many.

Many of the species of *Linum* are exceedingly ornamental. The little Alpine Flax is a very pretty plant; even the common Flax of commerce is highly ornamental, with its delicate foliage and pale-blue flowers, amongst annuals there are few more effective things than the beautiful crimson *Linum grandiflorum*; and we think that the plant now figured will be also a very pretty addition to the already known members of the family. Mr. Veitch says of it: "We received it from our collector, Mr. Pearce, who sent it from Peru in 1860. He describes it as a beautiful species, with large flowers about an inch in diameter, and growing in a good loamy soil. It is a very free bloomer indeed, and the plant we exhibited in the summer is still in bloom (September), and will, we think, be a capital greenhouse decorative plant. We have not yet sent it out, but shall be able to do so, we hope, next season."

We have only to add, that it has received a certificate from the Floral Committee of the Royal Horticultural Society, when exhibited before them during the present year.

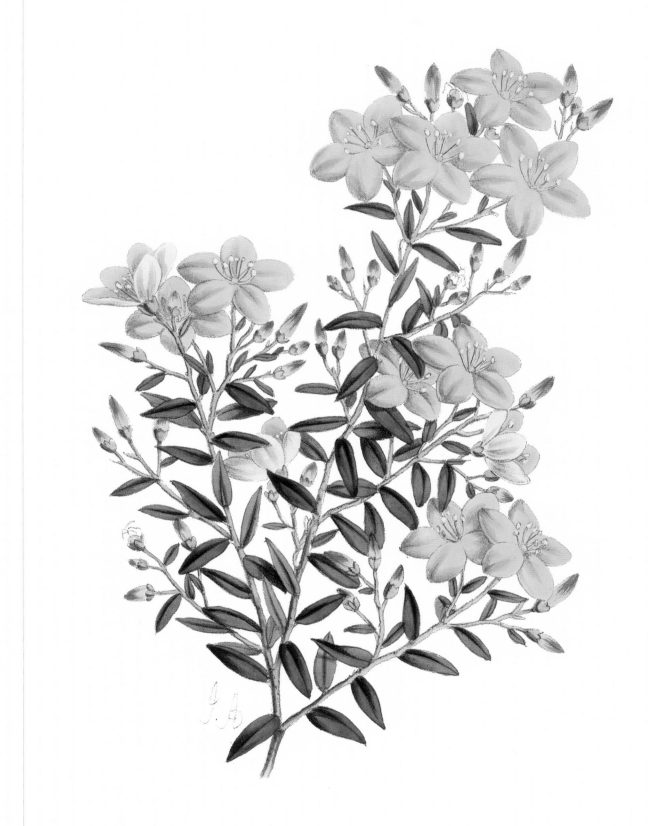

J. Andrews, del et lith.

Vincent Brooks, Imp.

We are indebted to Messrs. Backhouse and Son, of York, who have introduced so many valuable and beautiful herbaceous plants, for the opportunity of figuring the very beautiful Lobelia, which forms the subject of our present Plate.

At a time when every one who cultivates flowers is seeking to have them, not merely for the decoration of their gardens in summer, but also to ornament their houses and conservatories during the whole year, any plant that will effect this must be considered an acquisition, and when that flower is a blue one, the acquisition is all the greater; and such is the character given to this showy Lobelia by Messrs. Backhouse. They received it, as they inform us, "from a correspondent in the interior of Caffraria; when grown out-of-doors during the summer months, it forms a dense tuft, with spreading shoots, each terminating in an ascending rosette of leaves; from each of these shoots and their branches a flower-stem rises, of from four to six inches in height, bearing three to five or six large and lovely blue blossoms, having a faint tinge of violet, *each of which remains in perfection many weeks*, so that the plant is gay with flower throughout the whole range of the winter months, – a time when so much beauty has a double charm."

The character of the plant has been very admirably delineated by Mr. Andrews, and it remains for us but to say a few words on its cultivation. Like many herbaceous plants, it flourishes well in an open but not too rich soil; sandy loam, peat, and leaf-mould forming an admirable compost for it; it should be kept in a greenhouse during the winter months, and when increase is desired, this may be obtained by dividing the roots or suckers in spring, after the growth has commenced.

Lobelia coronopifolia is not by any means a new plant, but, like a great many old and valuable things, it has passed out of notice to give way to other things which have nothing more than novelty to recommend them, and hence there is often now a "hue and cry" raised for some long-forgotten flower. We hope herbaceous plants are again coming into favour, and we may expect to see many more old plants brought forward.

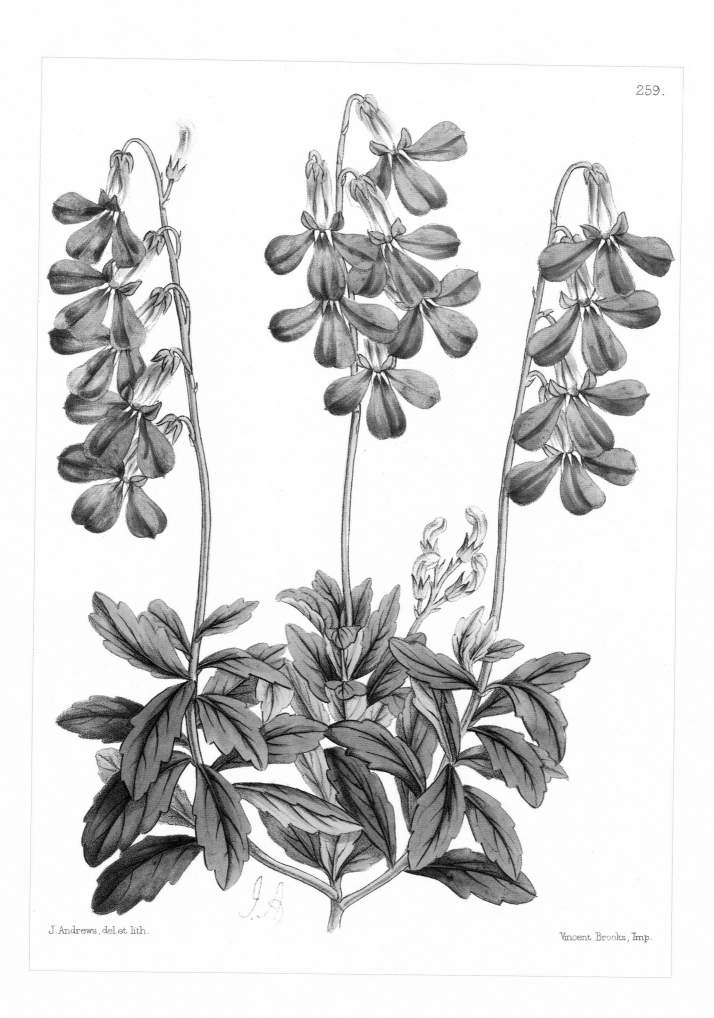

J.Andrews, del.et lith.

Vincent Brooks, Imp.

Amongst the flowers which used in bygone times, before the bedding-out system drove everything else out of the field, and banished to our kitchen gardens or expelled altogether many of our favourite flowers, the old scarlet *Lobelia cardinalis*, in the latter part of the summer and the early part of autumn, used to be much valued for its decorative character, and it was often a matter of surprise, that while many much less showy flowers had been submitted to the skill of the hybridizer, the Lobelia had been left unnoticed. This can no longer be said to be the case, many very handsome varieties having been of late years raised, one of which we now figure from the collection of Mr. William Bull, of the King's Road, Chelsea.

The ease with which these plants are cultivated is one great recommendation; they require none of that excessive care which the florist is obliged to bestow on his favourites, and are quite independent of the cold wintry weather, from which all the denizens of the parterre must be carefully guarded. They flourish in any good garden soil, and indeed, the only care they require is that of preventing them from becoming too large and taking up too much room; where room can be obtained, it will be surely worth while to reinstate some of these old favourites in public favour, especially when so much variety of colour is now being obtained.

We had an opportunity, during the past summer, of inspecting Mr. Bull's fine collection; unfortunately they were in pots, and so could not be seen in the perfection that they would have been, if planted out. Besides the variety now figured, we noticed, *Ruby*, a very rich ruby Nonsuch violet rose, *Peach Blossom*, beautiful peach colour, *Excellent*, bright magenta, *Glitter*, glowing scarlet, *Distinction*, rose cerise, *Matchless*, rich purple.

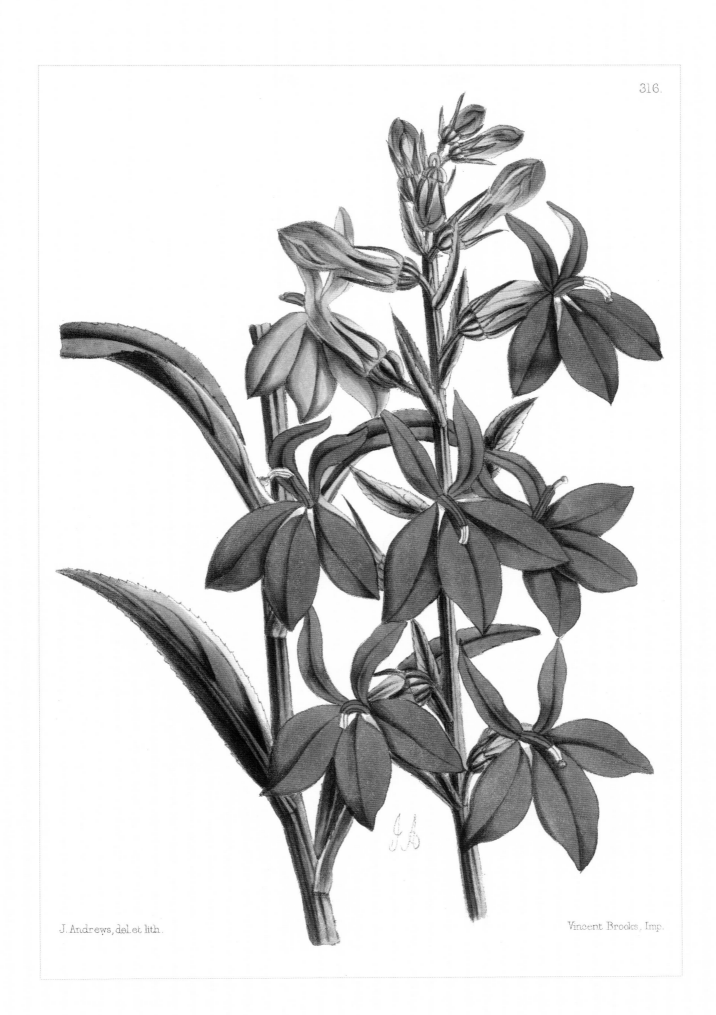

J. Andrews, del. et lith.

Vincent Brooks, Imp.

Among those Orchids which have flourished so admirably under the cool treatment, none have exhibited a greater readiness to adapt themselves to it than the varieties of *Lycaste Skinneri*. Beautiful as it is in any circumstances, it derives a greater interest from its easiness of culture, and also from the fact that it exhibits almost as much variation in its markings as any florists' flower, and indeed, taking the ordinary definition given to them, it might well be classed as such.

Mr. Bateman, of Biddulph Grange, to whom we are indebted for so much valuable information upon this interesting point of floriculture, has drawn attention to the fact that not only will *Lycaste Skinneri* flourish under this cool treatment, but that he has had it in flower for several months in his drawing-room, where it has produced its ivory-like flowers in rapid succession. When we consider how the Orchid has been considered the exclusive privilege of the wealthy, and that now many a flower of this interesting tribe of plants may adorn our sitting-rooms, we cannot but rejoice at the change that has taken place. Mr. Robert Warner, of Chelmsford, the accomplished editor of 'Select Orchidaceous Plants,' has also cultivated it in a vinery, where, under the shade of the foliage, it had produced its large flowers perfectly pure in their white ground, of exquisite shape, and fully as fine and large as when grown in heat; while we have ourselves seen, at the Messrs. Veitch's, many plants of it in their cool-house flourishing in the greatest vigour and beauty, and it was from several that we then saw that the beautifully-marked variety was selected for illustration by our artist.

In the cultivation of Orchids we are aware that several of our friends have adopted cocoa-nut fibre refuse, and when used in combination with peat, it is likely to be very useful, as it retains moisture so very well, although it has not, as we think sufficient substance in it, when used alone, either for this or other plants. We have tried it with Ferns, and certainly think that, while nothing can exceed the vigour with which they root and grow in it at first, they require something stronger when they have become established.

We think it right to mention that the very beautiful variety of *Lycaste Skinneri* now figured is still in Mr. Veitch's hands, and will not as yet, at any rate, be offered for sale.

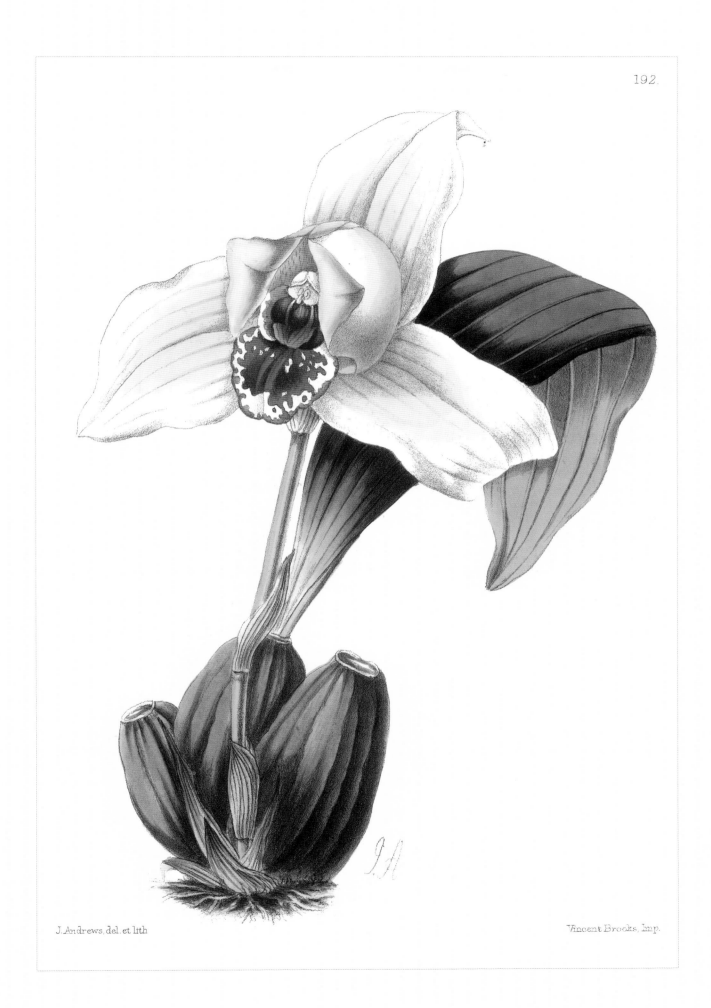

J. Andrews, del. et lith.

Vincent Brooks, Imp.

While flowers at all seasons are welcome guests, and are sure to receive their due meed of attention, there can be no doubt that those which greet us in early spring, whether indoors or in the open air, are of all others the most welcome. There are other flowers as pretty as the yellow Primrose or the drooping Snowdrop; there are other flowers as sweet as the Violet; but there are none more welcome, either for their appearance or their fragrance, than these early favourites; and so with the less hardy denizens of the greenhouse. The *Primula* is eagerly welcomed, not because of any special beauty, as we imagine, but because it and other plants are readily induced to flower in the dreary months of winter. When, therefore, we saw a plant covered with its pretty mauve-coloured flowers at the February show of the Royal Horticultural Society, we felt convinced that it was one which deserved a place in the record of popular flowers.

The Free-flowering Monochætum was exhibited by Messrs. Smith, the well-known nurserymen of Dulwich; and as the plant was entirely new to us, we asked them for some information on it, and have been most courteously furnished with the following particulars: –

"The plant exhibited by us is a Continental hybrid, (or, as botanists call them, 'garden variety,') introduced by us last summer. It differs from its parent, *Monochætum sericeum*, in its foliage being narrow and less glaucous, and its habit being close and dwarf, and, what is of great importance, in its profuseness of flowering; it is a greenhouse variety, growing, indeed, in pots when dry and kept warm during frosty and cold weather; but, like all this class, during the early months, a warm temperature with moisture is essential to rapid growth. It thrives also with the same treatment required for *Pleroma elegans*, *Genetyllis*, and kindred plants. We find it quite at home on the swing-shelf in the greenhouse during the winter months; and doubtless this is the most suitable place at that season for the whole class referred to above."

"We consider this variety by far the best yet introduced; even late and small plants struck last August have flowered with us this spring."

It remains for us but to add that we think it will make a most desirable spring-flowering plant, the pretty mauve-coloured blossoms being produced in great profusion, and the curious barbed stamens giving it a very distinct appearance; while, as a dwarf-growing plant for a pan or basket, it will, we think, be much esteemed.

141.

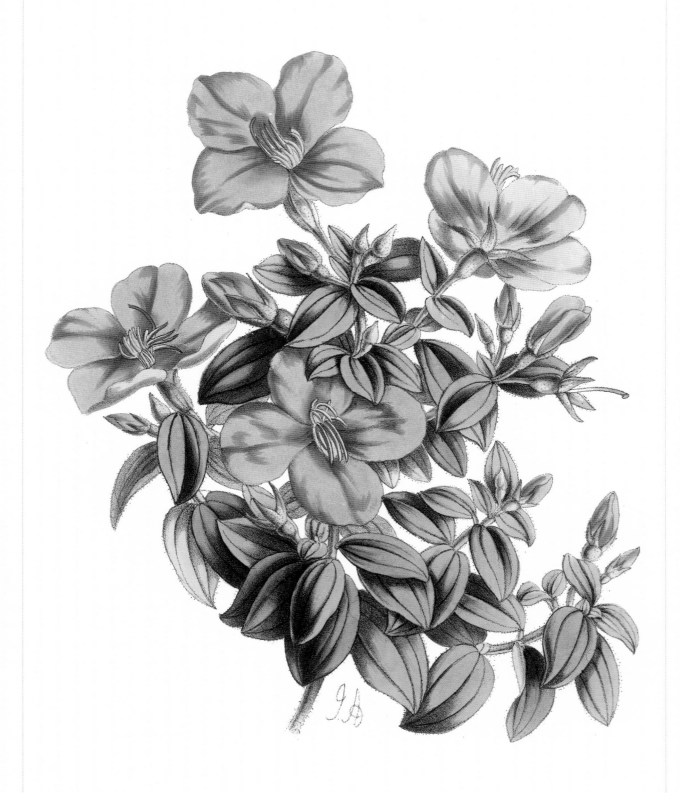

J. Andrews, del. et lith.

Vincent Brooks, Imp.

We have had the opportunity of figuring some desirable varieties of this very pretty and well-known annual. The very elegant *N. discoidalis elegans*, sent out by Messrs. Charlwood and Cumins, has been greatly admired; and now the well-known firm of Carter and Co., of High Holborn, have added the sterling variety figured in our Plate. Whatever may be thought of the relative value of bedding-plants and annuals, there are few, if any, who would be willing to neglect the different members of this neat-growing and free-flowering family, and consequently in every garden, both small and large, they are to be found; the bright and clear blue of *insignis* producing a charming effect in the early spring months, varied as it now may be with the many additions which have been made from time to time; and we imagine that this new variety will be as much esteemed as its predecessors.

Nemophila discoidalis vittata, as it has been described by Messrs. Carter, the raisers, was obtained from seed amongst the large quantities of the various kinds grown by them at their seed farms in Essex. These varieties are doubtless due to the visits of insects, especially the smaller moths, who, in endeavouring to rifle the flowers of their nectar, carry away with them some of the pollen adhering to their proboscis, and in inserting it into another, effectually impregnate the plants. This Mr. Darwin has shown to be the case in Orchids, and there is no doubt that this is also the way in which many of the smaller flowers, such as Verbenas, (as clearly shown by Mr. Miller in the 'Companion to the Floral Magazine' last month,) have their varieties so multiplied. It would be almost impossible for the hybridizer to effect this artificially, where the organs are either so small or so awkwardly situated as to make the operation one of great difficulty, and consequently then it is absolutely necessary, where it is hoped to obtain valuable varieties, to grow only such sorts as are of real merit; for it too often happens, that as "ill weeds grow apace," so the pollen of worthless flowers has often apparently a vitality denied to more highly refined ones. In the case of Auriculas, we know that growers will positively refuse to grow a single alpine, when they are desirous of saving seed, as, if they do so, they find that a very large proportion of the plants produced are of an alpine character. The colour of this new and striking variety is a dark-chocolate, or black, broadly margined with pure white, the colour not being laid on in a broad band, but passing off into minute hair-like strokes; and we hardly think that the raisers have exaggerated its merits when they describe it as probably one of the most desirable of the many new variations of this universally-grown annual.

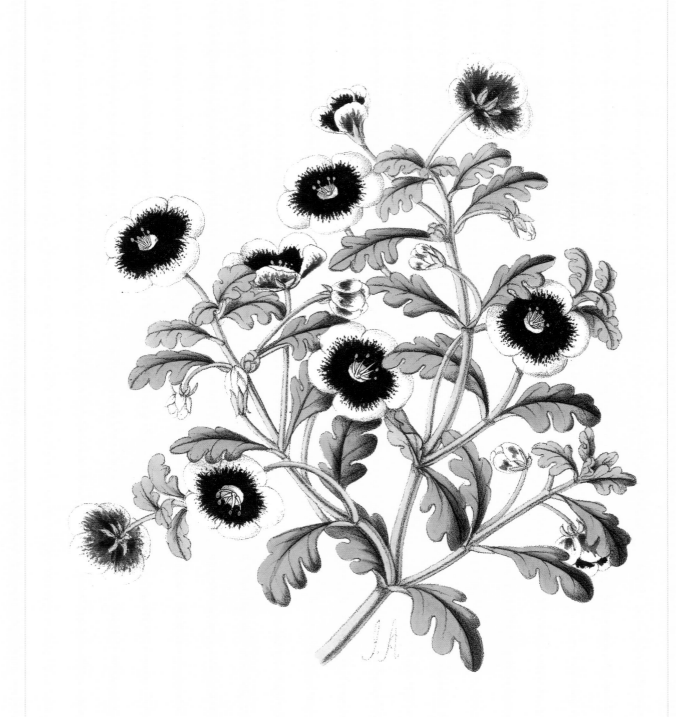

J. Andrews. del. et lith.

Vincent Brooks Imp.

Although our object is to introduce new plants and flowers to our readers in each of the various departments of horticulture, there are times when we think it well to remind them, that in the search for novelties and love of new things, there are oftentimes some of very old date which have been so utterly neglected and put on one side, and yet which are of such excellence, that it is worth while now and then to bring them into notice, and it may be into favour. Amongst these we must number the beautiful tribe of Nerines, and having recently met with examples of the old and favourite bulb, *N. Fothergillii*, which exhibited some departure in colour from their normal condition, we have thought it well to figure it, certainly not as a novelty, but as an interesting decorative plant which ought to receive more attention than it has met with.

That Cape bulbs, as they are generally called, should have been so little cultivated of late years, does not speak well for the taste of our horticulturists. The gorgeously beautiful tribe of Amaryllids are much more in favour on the Continent than they are with us, and we saw last summer, at M. Louis Van Houtte's, at Ghent, tens of thousands of these lovely flowers in every state of progress, and heard from him, that they are very much in request in France and Germany. Collections are sometimes exhibited by Mr. Parker, of Tooting, and Mr. Cutbush, of Highgate, but as a rule, they are very unfrequently seen. At one of the floral meetings of the Royal Horticultural Society in September last, Messrs. Paul, of Cheshunt, exhibited a collection of this very bulb, and the remark was then made that it was a great pity that it was not more generally cultivated. Then how gracefully delicate is the pretty *Nerine undulata*, remaining as it does so long in bloom, and at a season of the year when flowers are scarce. *Nerine coruscans* and its improved variety *coruscans major* are also very beautiful, while, when we diverge into the Brunsvigias, we have in such as *Brunsvigia Josephinæ* the very king or queen of bulbs. We hope, then, that our figuring of this old flower may induce some to commence the growth of a tribe which affords great variety of character and colour.

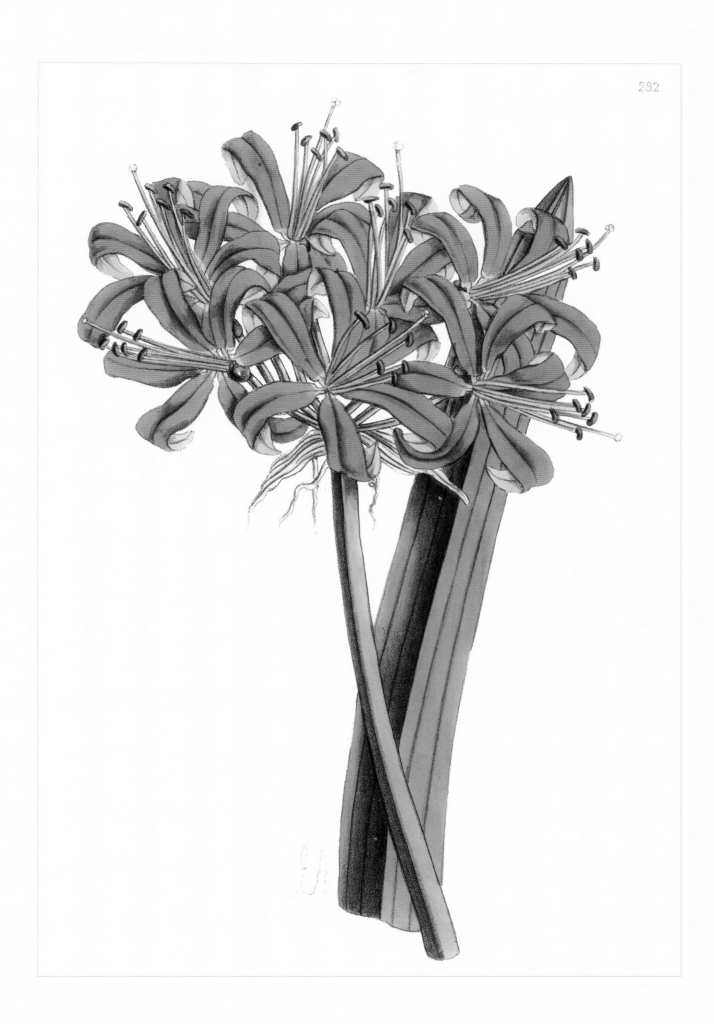

The many species of English Orchis, although they cannot vie with their gorgeous congeners of the tropics, are yet many of them of very great interest, and are always sure to attract the notice of those who, perhaps, without much knowledge of botany, are yet admirers of our English wild-flowers. Various attempts have been made to cultivate them, but not with any great amount of success, while the desire to possess them, and attempt their cultivation, has led in many flowers to the complete extermination of species once abundant. We remember in our early days that in the county in which we reside (Kent), an old gipsy was in the habit of gathering Orchids of various sorts and taking them round the country, and so persistent were her labours in this direction, that several species are now not to be found; amongst others, the Spider Orchis was tolerably abundant, but is now hardly ever to be met with.

The normal type of the plant we here figure is by no means rare, but the variety *superba* has only been lately brought into notice; we learn, from the firm of Messrs. Osborn and Son, of Fulham, by whom it was exhibited, that "it was found growing wild in Ayrshire, but where and by whom we do not know, it having passed into our hands through the respected firm, the Messrs. Samson, of Kilmarnock. It is perfectly hardy, and easy of cultivation; at the same time, the size of the spike of flower, and beautiful marking of the leaves, makes it quite worthy of pot culture. The plant we flowered so finely was potted in peat soil in the month of November, and kept in a cold south pit all the winter and spring, until the flower-stems made their appearance; it was then placed outside and exposed to all weathers, until it expanded its blooms as exhibited at the scientific meeting of the Royal Horticultural Society, where it was awarded a first-class certificate."

We can add nothing of importance to this statement, but would express our opinion that there are many plants which find a place in our greenhouses not so worthy of cultivation as this beautiful hardy English Orchid.

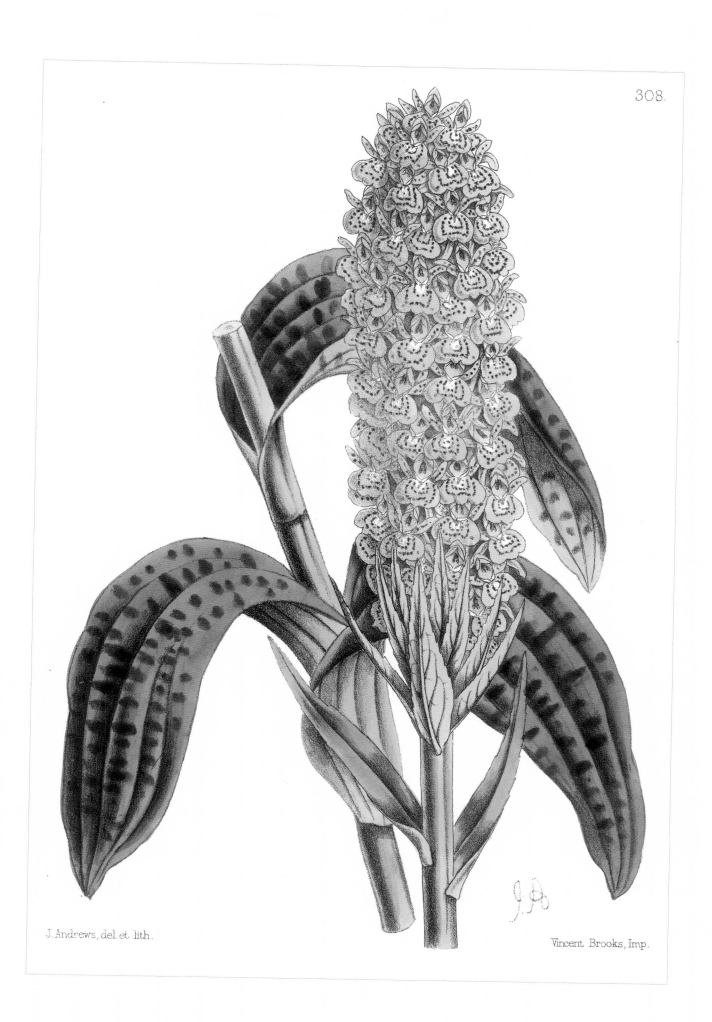

J.Andrews, del. et lith.

Vincent Brooks, Imp.

We are indebted to the kindness of Mr. James Veitch, of the Chelsea and Exeter Nurseries, for the opportunity of figuring another of the interesting plants which he has been the means of introducing from the Chilian Andes.

At the first great show of the Royal Horticultural Society held in May last year, an allied species was exhibited, and awarded a Silver Knightian Medal; it was thus described in the report of their proceedings: – "*Ourisia coccinea*, a dwarf hardy perennial of great beauty, introduced from Chili." But this, though so glowingly described, is far inferior to the very beautiful one now figured.

Mr Veitch, in a communication kindly sent to us, says, "*O. Pearcii* promises to be one of the best of this interesting genus. It was sent home by our collector, M. Pearce, from its native habitat in the Andes of Chili. I treat it as a herbaceous plant, and as far as I can see, it seems to be of easy culture, and altogether a valuable addition to this interesting class of plants." When exhibited at the meeting of the Floral Committee on the 5th ultimo, it was greatly admired, and received a first-class certificate; its character has been faithfully depicted by Mr. Andrews, and we feel confident that it will be appreciated by all who admire both novelty and excellence.

We cannot forbear noticing how great is the enterprise exhibited by so many of our leading firms in thus catering for the ever-increasing wants of the flower-loving public. Japan and South America have thus both been lately visited on the behalf of the Messrs. Veitch. Mr. Standish has received the botanical treasures of Japan, and the magnificent tree-ferns of New Zealand. Mr. Low receives fortnightly consignments of Orchids and other exotic plants, from Borneo and other tropical climes, and other firms are engaged in the same work, and all as a matter of purely commercial speculation, without the aid of either societies or the Government; it speaks well for the wide-spread love of flowers that exists amongst us, and testifies quite as much as do our magnificent exhibitions to the fact that nowhere does the real love of flowers exist in so remarkable a degree as in our own island, and nowhere, albeit the many disadvantages of a climatic character for which we suffer, is their cultivation carried out with such great success. Few sciences have made greater progress during the last fifty years than that of Horticulture, and none minister more to the enjoyment and elevation of all interested in the pursuit.

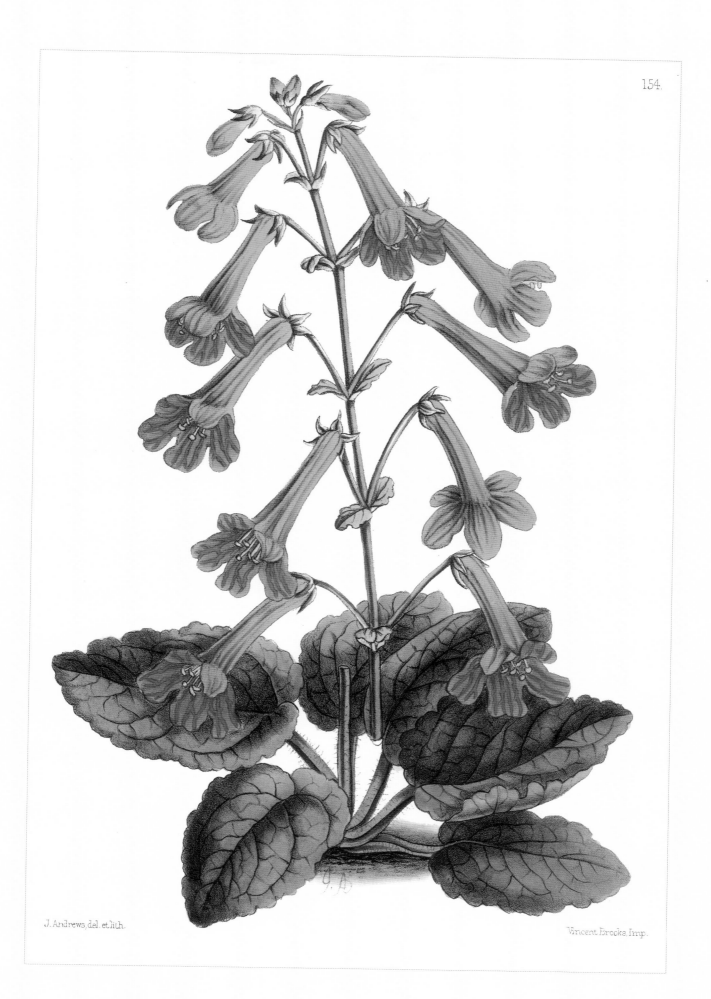

J. Andrews, del. et lith.

Vincent Brooks, Imp.

The advance which we long ago predicted would be made in the Fancy Pansy has been more than realized, and we do not hesitate to express our conviction that in a few years it will have obtained, not only increased popularity, but also a recognized place amongst florists' flowers.

Some twelve years since, M. Miellez, of Lille, and Messrs. Salter, of Hammersmith, and Downie, of Edinburgh, commenced their cultivation, and may be considered as the pioneers in the vast improvement that has taken place in them; although Messrs. E.G. Henderson and Son, of the Wellington Nursery, St. John's Wood, ought to have the credit of determining to bring them prominently before the public. London air, however, proving prejudicial to their growth, they induced Mr. William Dean, of Shipley, near Bradford, to cultivate them. Although first ushered into notice by him as Belgian Pansies, they are in truth of English blood, and will be known as Fancy Pansies.

Mr. Dean, to whom we are indebted for the opportunity of figuring them, says: "I venture to predict for the Fancy Pansy an immense popularity with ladies. It is peculiarly a ladies' flower; for, in addition to its rich colour and great variety, it is more easily cultivated than the florists' section of pansies, being of a more robust constitution, and requiring more room; a moderately light soil, made up of leaf mould and old potting stuff, mixed with garden soil, suits it best, pegging down the shoots to preserve them from being broken down by the wind, and occasionally surfacing the plants with a little light soil, to induce them to throw out side shoots for a succession of bloom. The seeds were sown in November, 1861, in a cold frame, and the young plants were planted out early in April. By the beginning of June they began to flower, and continued in beauty all the summer. It is so cold and damp here in winter that we are obliged to give Pansies frame-shelter, not because they are not hardy enough to stand any amount of cold, but they do not like so much moisture. Therefore, in the north it is better to winter them under glass; but in the south they can be left out all the year, and seedlings can be planted out in the autumn."

Our illustration comprises *Impératrice Eugénie* (fig. 1); *Harlequin* (fig. 2), a greatly improved *Dandie Dinmont*; *Admiration* (fig. 3); and *King of Italy* (fig. 4).

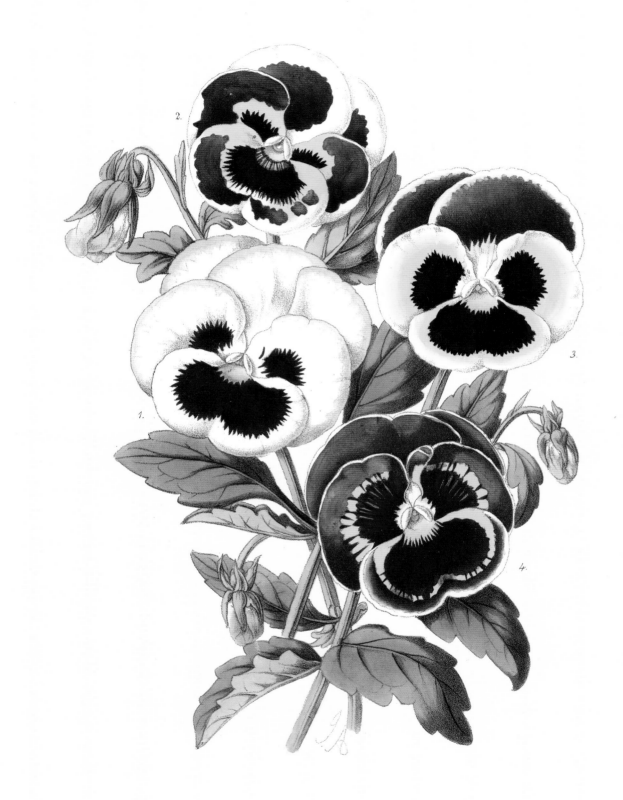

J. Andrews, del et lith.

Vincent Brooks, Imp.

The great improvement that has taken place in the form, size, and colour of this universally admired flower was admirably shown at the Great International Exhibition, where Mr. Hoyle exhibited blooms of some of his most remarkable flowers together with a sheet of dried blooms of the Pelargoniums of sixty years ago. It was hardly possible to conceive that the beautiful, symmetrically rounded flowers with their brilliant colouring could ever have been the descendants of such narrow-petaled and starry-looking flowers as our forefathers cultivated then; no greater proof could be given of the change that skill and careful hybridization can effect than they did; and few, we think, can deny the statement that no one has so largely contributed to this result as Mr. Hoyle, of Reading. The flowers which we now figure have been selected by us from a number of seedlings, which will be, as usual, sent out by Mr. Turner, of Slough, in the autumn, as they seemed to us to be, where all were excellent, the best. In this opinion we have been strengthened by the fact that they have both received first-class certificates. They are both flowers that will sustain the high position that Mr. Hoyle has deservedly attained.

Favourite (Fig. 1) is a very brilliant-looking flower; the upper petals are a brilliant crimson-maroon with a narrow fiery crimson border; the lower petals are deep rosy-crimson, with a dark spot towards the base of each, while the centre of the flower is pure white.

Lord Lyon (Fig. 2) is a very large, noble-looking flower; the upper petals are bright rosy-crimson, with a dark blotch; the lower petals are rosy-pink, slightly veined, and the throat is pure white. We have no doubt that this flower will take a high place as an exhibition variety. This white centre is a striking characteristic of the flowers that Mr. Hoyle has of late introduced, and adds very much to their purity and beauty.

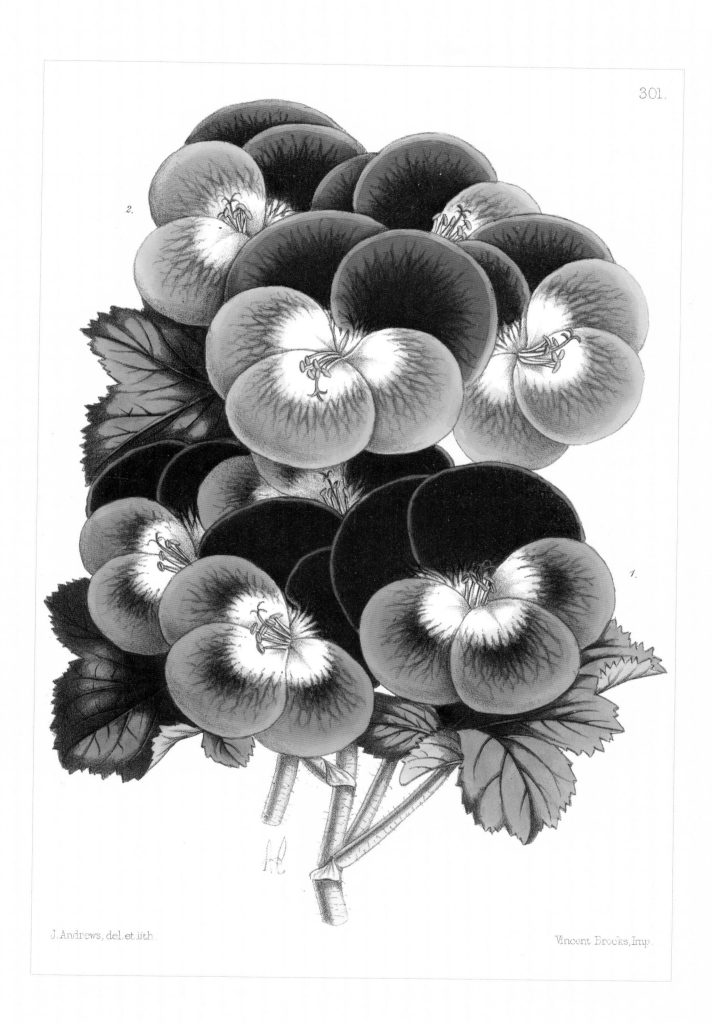

301.

2.

1.

J. Andrews, del. et lith.

Vincent Brooks, Imp.

We have for a long time maintained the superiority of the bedding Pelargoniums known as "Zonal," to those which have claimed the designation of "Nosegay," but as the general taste of the horticultural public seems to be inclined towards this latter section, we have selected one of the most beautiful of the novelties that are coming out next season, for our illustration.

The character of the flower of the true Nosegay is essentially distinct from the Zonale; the petals are more pointed and narrow, and are entirely deficient in that beauty of form which now marks so many of the Zonale varieties, and have generally the habit of dying away in the centre of the truss, leaving a blackened space, which detracts greatly from the beauty of the bed, when viewed closely; on the other hand, it cannot be denied that there are colours, and shades of colour, to be found amongst them, such as in *Cybister*, *Stella*, *Lord Palmerston*, *Amy Hogg*, etc., which we in vain look for amongst the Zonals, and when great variety has to be introduced amongst the beds of a flower garden, this is a matter of some account. What we are anxious to see, and indeed what has already been to some degree effected, is a class intermediate between the two sections – hybrid Nosegays, which shall retain the colouring of the one with the perfect shape of the other. The more nearly they approach the circular form of such flowers as *Clipper* and *Dr. Lindley*, the more we are sure they will be appreciated; for we are convinced, that however much persons may decry the florists particularity, their views are formed on sound judgment, and will eventually commend themselves to the general public.

Duchess of Sutherland was raised by Mr. Fleming, the well-known gardener, at the equally well-known seat of her Grace the Dowager Duchess of Sutherland, at Cliveden; the colour is a beautiful crimson-cerise, and the truss is very large. The flowers partake more of the character of the Nosegay varieties than some other sorts, and the plant is very free-flowering; it is in the hands of Mr. Charles Turner, of Slough, and will be sent out by him, with several others, in the spring of next year.

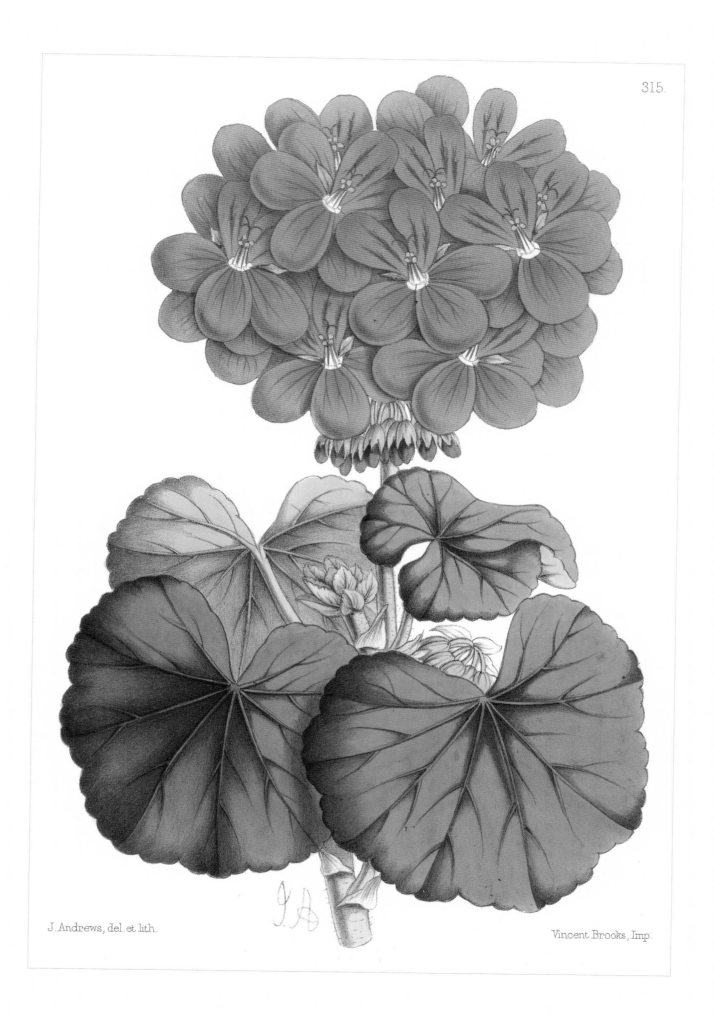

J.Andrews, del. et lith.

Vincent Brooks, Imp.

Pelargoniums, Queen of Whites, and Monitor

The concurrent testimony of all who saw the very varied collection of seedling Pelargoniums exhibited last season at the Royal Horticultural and Royal Botanic Societies, was that they far exceeded the productions of any previous year, and that as far as florists' flowers were concerned, 1862 might be noted as the *Pelargonium* year.

It was feared that when Mr. Edward Beck, of Isleworth, and Mr. Forster, of Clewer Manor, died, the number of Pelargoniums would be greatly decreased, as it apparently only left Mr. Hoyle, of Reading, to carry on their cultivation; in this, we are happy to say, our fears were not realized; in both establishments, under the care of their intelligent gardeners, Messrs. Wiggins and Nye, the raising of seedlings has still been carried on, and never, we believe, have Worton College and Clewer Manor been so conspicuous in their results as last season, while, as will be seen, Messrs. Dobson, of Isleworth, have also distinguished themselves by producing the best white flower of the year. It is some corroboration to the truth of our statement, that Mr. Charles Turner, of Slough, announces in his catalogue that the varieties he sent out last autumn have obtained forty certificates, and that of these, the Floral Committee of the Royal Horticultural Society have awarded fourteen first-class and seven second-class.

It is often said that when long wars, as in India, are carried on between two apparently unequally-matched antagonists, the one teaches the other to fight, and however inferior at first, after a time the difference is not so discernible. We may notice the same in the friendly contests of Flora's battle-ground; we remember when Mr. Charles Turner was so far ahead of any of his competitors, that it required very little time for the judges to decide, Messrs. Dobson and Co., Gaines, Fraser, etc., being far behind. It is not so now; the contests continued year after year have stirred up the *esprit de corps* of the others, and now not only does Mr. Dobson run him on many occasions very close, but has, during the past season, carried off the first prize in two instances. This is as it should be; when we have the matter all in our own hands, we are apt to become careless, but when we occasionally are discomfited, we are taught that a little more exertion and watchfulness is needed, the result of which we shall, no doubt, see in the present instance. Besides *Queen of Whites*, Messrs. Dobson have some other new varieties of which they speak highly, *Startler*, *Sanspareil* improved, and *Commandment*, being considered especially good.

Monitor (Foster, fig. 1) received a first-class certificate at the Royal Botanic Society and a certificate at the Royal Horticultural Society. *Queen of Whites* (fig. 2) received a first-class certificate at the Regent's Park.

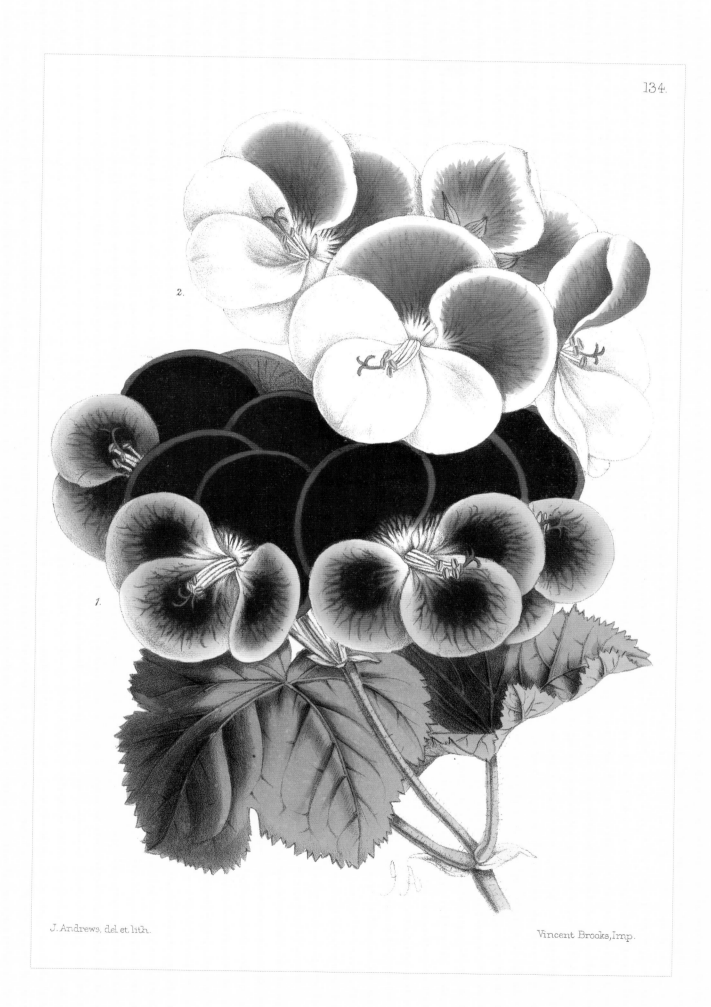

2.

1.

J. Andrews, del et lith.

Vincent Brooks, Imp.

No class of flowers is more popular at the present time than that which is commonly known as the bedding Geranium (the term *scarlet* Geranium being now clearly incorrect, inasmuch as colours of all hues, pure white, salmon, pink, rose, crimson, as well as scarlet, are to be found in them), and whether for the adornment of the flower garden or conservatory during the summer months, they are especially valuable, combining great brilliancy of colour, easiness of growth, and profusion of bloom.

This popularity has induced the promoters of our great flower-shows, during the present season, to offer prizes or collections of both the plain-leaved and variegated kinds; but we must express our decided opinion that the plants exhibited were, with very few exceptions, quite unworthy of the class and of the skill of the exhibitors, – that terrible love of formality which has so hindered the natural, and consequently beautiful, growth of many of our exhibition plants having completely spoilt the effect. In many cases they were trained, or rather tortured, into flat table-like shapes, like the specimen plants of Pompon Chrysanthemums we have seen formerly. In one instance the flowers were tied across, so that the eye was arrested by a series of sticks and stalks, and all for the purpose of getting the blooms into their proper place. Thus fine plants were entirely spoilt by the love of formality.

Amongst the plants which are most suitable for pot culture, the tricoloured-leaved varieties are very conspicuous. These are now divided into two sections; those with the edges of the leaves of a golden hue, as *Mrs. Pollock*, which has had a greater run than any other variety of the tribe; and those with white or light-sulphur edge, such as *Attraction*, *Picturata*, etc.; to this latter section *Italia Unita*, or *United Italy*, – for it has been called by either name, – belongs, and is one of the most attractive of the number. It was exhibited both last season and this by Messrs. E.G. Henderson and Son, of the Wellington Road Nursery, and has been greatly admired. The margin of the leaves is of a delicate sulphur-white, within that a broad zone of bright crimson-pink, marked with bronze, and the centre of the leaf green. The habit of the plant is dwarf and compact, and as a pot plant is unsurpassed in its class, but, like a good many of the silver tricoloured-leaved varieties, it loses much of its beauty in the open air. The flower is small, of a dark-crimson colour.

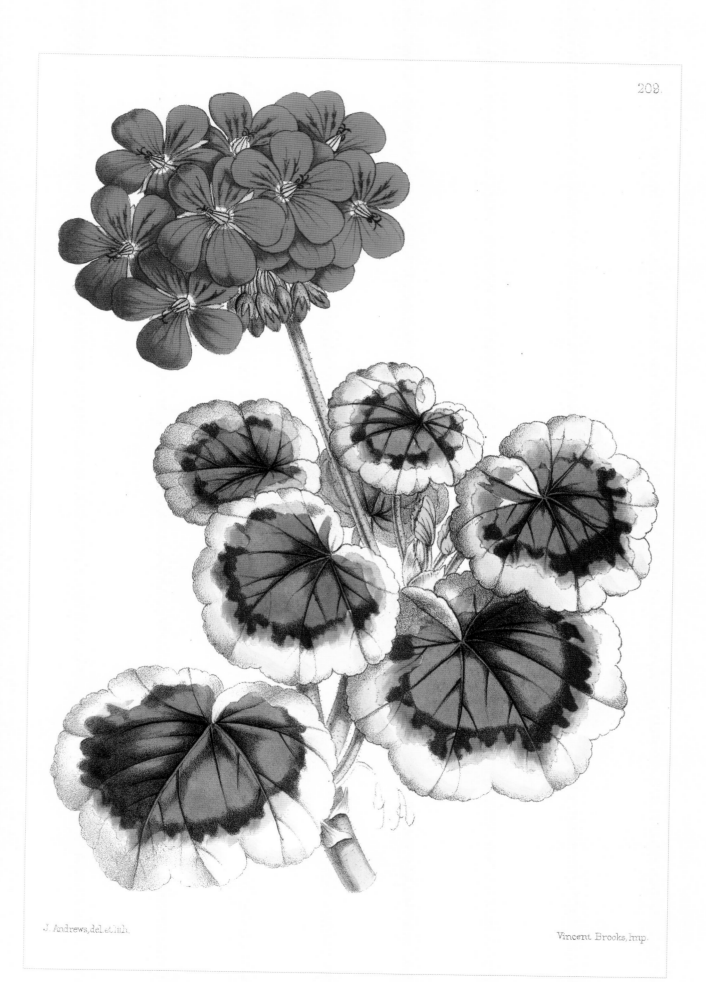

J. Andrews, del. et lith.

Vincent Brooks, Imp.

The favour with which double Petunias were regarded in the horticultural world a couple of years ago, seems to have been of a very short-lived character, as we find that they are now but very little sought after; and in a collection which we saw at the Paris Exhibition in the spring, which was brought forward by the well-known raiser M. Rendatler, there was so little of novelty, and no improvement upon kinds already well known, so that this neglect is sufficiently accounted for. The same may be said, we think, of the Phlox. All the ingenuity of the floriculturist does not seem to have been able to impart any novelty to the tribe; and although M. Lierval still industriously pursues his task, we fancy that neither as a garden plant nor an exhibition flower it is likely to be much longer in favour.

Under these circumstances, single Petunias are much more likely to be sought after, and we therefore have thought it desirable to figure this very beautiful variety, raised by Messrs. Smith, of Dulwich, and named by them *Mrs. Smith*. Its character, as will be seen, is quite novel, entirely distinct from such flowers as *Madame Ferguson*. It is distinguished by having a white margin to the very beautiful magenta-coloured petals, and also in the centre of each segment a broad white space, giving the flower a very star-like appearance, and on the plant, making it very remarkable. From the specimens we have seen of it, it also seems to be very constant, although it must be expected that in this, as in all flowers of a similar bizarre character, irregularities in the markings will occasionally show themselves; any one who has grown flowers in any class where these singularities of markings occur can bear witness to this.

We have but little to add relative to the culture of the Petunia, which has been so often referred to in our previous volumes. We may however add, that besides their adaptation for bedding purposes, many of them make admirable plants for the greenhouse in autumn, when treated as climbing plants and trained to a trellis; this variety will be, however, hardly suited for this purpose, as we are informed by the Messrs. Smith that its habit is dwarf and rigid, so that it will have to be treated as such when grown in pots.

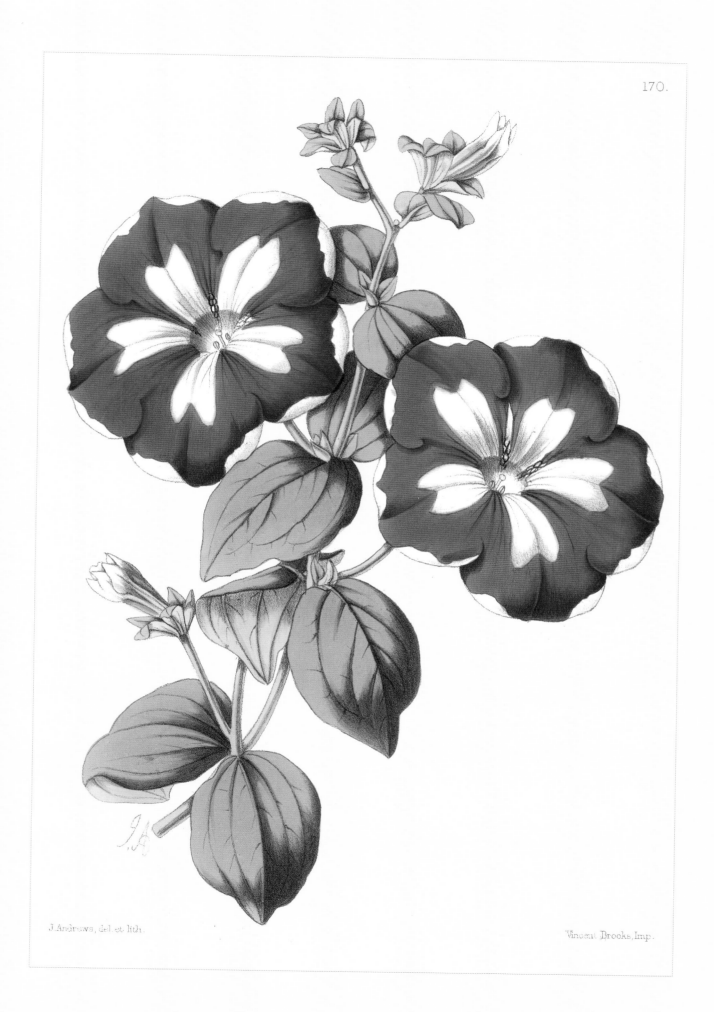

J. Andrews, del. et lith.

Vincent Brooks, Imp.

There are many herbaceous plants which, although not perhaps so brilliant in colour as many of the more fashionable bedding-plants, are yet exceedingly useful in the flower-garden, and are, we believe, gradually winning back their way to public favour. Amongst these we think we may class the hybrid or mule Pink, as it is sometimes called, some new and desirable varieties of which form the subject of the present Plate.

The habit of the plant is dwarf, the height to which the flower-stems rise being about sixteen inches; and so very free are some varieties in flowering, that in order to increase them it will be necessary either not to allow them to flower so continuously as they do, or even in some cases to cut out the flower-stems altogether, so as to induce them to throw out late summer shoots; but we believe this is not needed in these later varieties, where the greater vigour of the plant ensures the formation both of "grass," as it is technically called, and also of flower-stems. These latter they produce in succession for several months in the year; and as the flowers are not so easily injured as many of the more tender varieties of bedding-plants, in a climate like ours this is a matter of great consequence, as we all know how very soon after a heavy fall of rain the appearance of the most brilliant beds is destroyed, from the delicate character of their blooms; but with these more substantial flowers such is not the case, and after a few hours they appear in their previous brilliancy. Another advantage of these plants is, that they afford portable and easily-cultivated plants for the greenhouse or conservatory during the winter months, blooming freely from December to March; and their cut blooms, mingled with those of the Tree Carnation, another most useful and valuable winter plant, add fragrance to the winter bouquet, that much-coveted object; and thus, by a little judicious management, the owner of the small greenhouse may be able to procure that which has generally been considered only the privilege of the wealthy.

Fig. 1, *Striatiflorus*, is distinctly marked with crimson flakes on a light rosy-crimson ground. Fig. 2, *Marie Paré*, is a very clear and good white, and has been in bloom with us during the summer, and now again in the depth of winter. Fig. 3, *Rosette*, is a very pretty salmon-pink, and will be sent out in the spring by Messrs. E.G. Henderson and Son, of the Wellington Road Nursery, St. John's Wood.

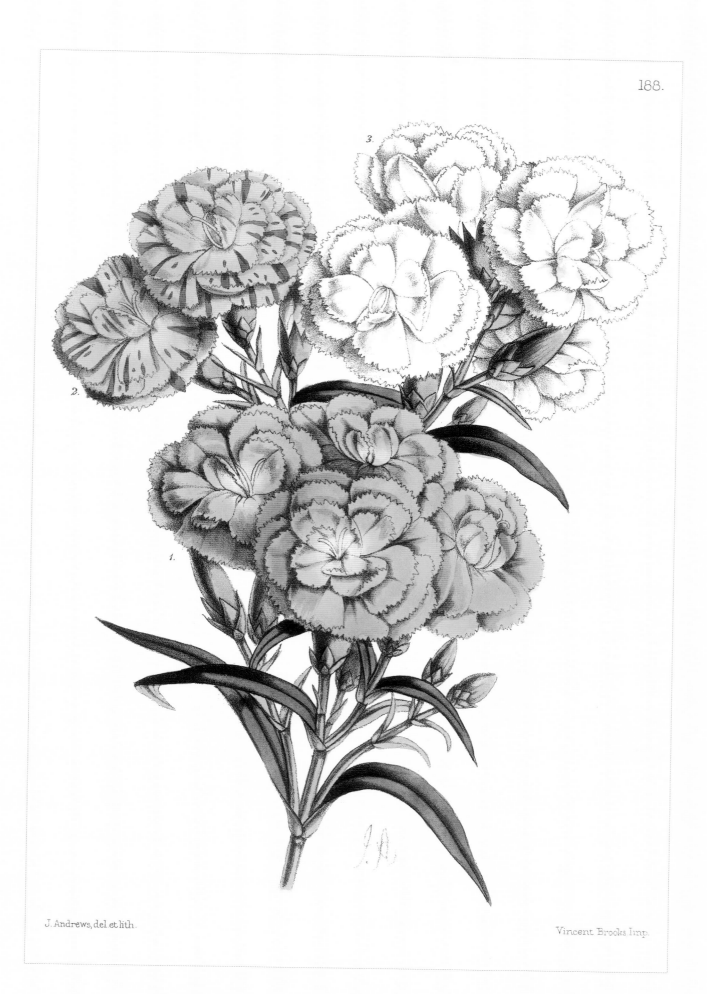

Pinks, the Rev. George Jeans and Lord Herbert

Scant indeed is the encouragement given to exhibitors of Pinks in the neighbourhood of London, the only prizes offered being, we believe, at the Royal Botanic Society. They are sometimes, indeed, brought forward by Mr. Charles Turner and others, at the Royal Horticultural Society's exhibition, and perhaps awarded an extra prize in the miscellaneous class, but no regular entries of them are made, and yet they are surely deserving of a little more attention than they have received. It is indeed true that they do not exhibit that diversity of colouring which is so conspicuous in other florists' flowers; but then the beautiful build of the flower, and its exquisite perfume, compensate for the defect, if defect it be.

It is almost impossible for those who have not seen the wonderful stands of blooms brought forward by Mr. Turner, to imagine the perfection to which this flower is brought under his care and management, for not only must the blooms be large, clean, and well-coloured, but they require to be carefully manipulated, or "dressed," as it is technically called, afterwards; and hence it is not to be expected that under ordinary culture, blooms such as those which Mr. Andrews has so faithfully represented are to be obtained, and this often leads people ignorantly to say that the drawings are exaggerated.

The present time is the most favourable one for obtaining plants of Pinks, for when planted out early, they are much more certain to produce flowers well and evenly laced, than when the planting is deferred; they like a rich, open, and friable soil, and require to be watched carefully for some time, as worms are very apt to throw them out of the soil, or drag them on one side, but they need but little else until spring, when the beds should be top-dressed, stakes put, and as the flower-stems arise, to be thinned out, both as to the number of stems and buds; there are, in fact, few flowers easier of cultivation than the Pink.

The Rev. George Jeans (Fig. 1) is so named after one of the most genuine florists it was ever our privilege to know, whose loss is mourned by a large circle who knew him, not only in this capacity, but as a ripe scholar, an accomplished gentleman, and a truly Christian pastor. *Lord Herbert* (Fig. 2) is also a flower of great refinement.

We hope that some further encouragement may be given to the growth of this beautiful flower, for we feel confident that were more prizes to be offered for it, it would not only stimulate amateurs to attempt its cultivation, but the general public would feel greatly interested in seeing a larger number of stands exhibited.

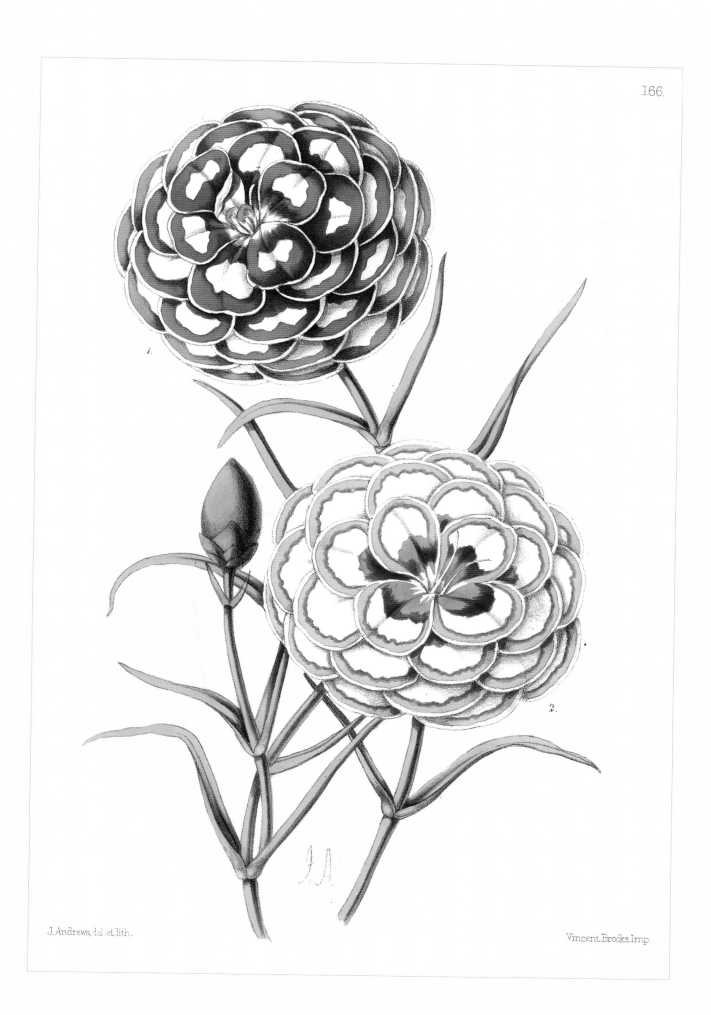

J. Andrews, del. et lith.

Vincent Brooks, Imp.

Horticultural tastes vary: some can only see beauty or desirable objects in flowering plants; others consider the beautiful foliage which many display to be superior even to flowers; graceful forms are attractive to another class (the lovers of ferns being oftentimes our greatest enthusiasts), while curious and strange forms have their devotees amongst others. For the latter class we have figured a remarkable plant, which has been exhibited lately by Mr. Wm. Bull, and has obtained first-class certificates.

The Bromeliads, to which this plant belongs, contain many curious forms, and we observe that in order to encourage their growth a prize was offered at the June Show of the Royal Horticultural Society, by Major Trevor Clarke. In the collection which obtained the first prize, exhibited by Mr. Williams, of Holloway, were two kinds of *Hechtia*, variegated *Pine Apple*, *Jugmannia grandis*, *Nidularia Meyendorfii*, *Puya recurvata*, and other curious plants, so that it is probable this class may be much more sought after than heretofore, nothing giving a greater stimulus than the offering of such special prizes.

Pitcairnia tabulæformis was first sent to Europe by M. Ghiesbreght, the indefatigable collector of M. Ambroise Verschaffelt, of Ghent; it was obtained by him at Chiapas, Mexico, and is very unlike any other Pitcairnia known; the leaves are regularly produced one above the other, and so closely as to retain an almost flat appearance, even when the plant is of large size; before flowering it has more the appearance of a *Sempervivum*; the tuft of flowers is produced in the centre of the plant, and as in the case of many of the genus, is comparatively insignificant; the individual flowers are of a deep orange, and contrast prettily with the light-green of the plant, although it is for its curious form that it will be most valued.

J. Andrews, del. et lith.

One half life size.

Vincent Brooks, Imp.

Amongst the flowers which have lately received the attention of hybridizers is the well-known and common garden flower, whose improved progeny we now have the pleasure of presenting to our friends, from drawings of some very distinct kinds raised and exhibited by our excellent friend Mr. Salter, of the Versailles Nursery, Hammersmith, by whom we have been obligingly furnished with the following particulars.

The Pyrethrum was, about the year 1853, taken in hand by the late well-known French cultivator M. Themistère, when it first sported in colour from the old *P. roseum*. About three years afterwards the first Anemone-flowered variety was obtained; and since then the improvement has been so progressive and rapid that flowers have been produced equalling in beauty and size some of the best of our Anemone-flowered Chrysanthemums, to which it is closely allied. There is also another variety with reflexed petals, and when duly improved, as we have no doubt it will be, we shall have flowers blooming in the earlier months of the year rivalling the best of the chrysanthemums in the later months. They will moreover be excellent plants for the ornamentation of the border, and as they come up easily from seed there will be no difficulty in their cultivation. Mr. Salter advises that the seed be sown in a gentle hotbed or warm greenhouse in July, and pricked out about September, when they will bloom freely in the following summer; while if sown in spring and pricked out in May, they will bloom in September or October, although they will not make such fine plants or bloom so freely as when autumn-sown. The height of the varieties which we have figured, and indeed of most of those which Mr. Salter has considered worthy of raising, is from a foot to eighteen inches. As to soil, they are not very particular, and will indeed grow almost anywhere, although, like most other flowers, they repay care and attention. As the Pyrethrum is perfectly hardy and herbaceous, it can be easily propagated by division of the roots; while, as it also seeds freely, those who are fond of watching the development of new varieties can save their own seed, having first obtained some good kinds to save seed from. We subjoin Mr. Salter's description of the varieties figured.

Roseum album (Salter), fig. 1; bright rose with white centre, very double, about 3 inches diameter, of dwarf habit and about 12 to 15 inches high, very fine and distinct. *Lysias* (Salter), fig. 2; large dark-red rose, very double, 3 inches diameter and from 18 to 24 inches high, fine large striking flower. *Princess Alexandra* (Salter), fig. 3; a pure white, very double, from 2 ½ to 3 inches diameter, of dwarf habit, about 12 inches high, by far the finest white yet out.

J. Andrews. del. et lith.

Vincent Brooks, Imp.

Persian Ranunculus, Fidelia and Linden

Our earliest recollections of floriculture are connected with this beautiful flower. And as some considerable attention has been drawn to the Ranunculus lately, we have given in our present number an illustration of two very beautiful varieties raised by Mr. Carey Tyso, of Wallingford, who is so well known for the success with which he has cultivated and hybridized it.

That the Ranunculus should not be more extensively grown is due, we think, to two causes, – it is somewhat difficult of culture where the soil is hot or the situation dry; thus with ourselves, in a garden exposed to the full force of the sun's rays we find it very difficult (especially in a dry season) to grow it with any degree of success, although some few years ago, when we had a moist spring and cool summer, it prospered very well. And then it interferes with the universal mania of "bedding out." They do not come into flower until the middle of June, and the beds cannot be emptied until the end of the month, and it would sadly interfere with the "geometric design" or the "chromatic arrangement" to have a bed empty at that period; and when to this is added that it receives very little encouragement at our great flower-shows, it is not wonderful that it should have been so little grown.

In saying this, we do not wish to discourage any one from attempting its growth; on the contrary, our object in figuring these very beautiful varieties is rather to give a stimulus to it, and to second the efforts which have been made towards that end. There are few gardens, comparatively speaking, situated as our own is; and in some cool and shady corner, not under the drip of trees, it will thrive very well. The capriciousness of bloom which used to be the complaint with regard to the old Dutch varieties does not apply now; owing to the success of those who have hybridized them, a race of fine blooming and strong-growing varieties has been obtained. The Scotch raisers (amongst whom Mr. Lightbody, of Falkirk, stands pre-eminent) and some English growers, especially Mr. Tyso, have for years seeded them and obtained some most beautiful flowers, both in self-colours and spotted and edged varieties. And we sincerely hope that when, another season, the Royal Horticultural Society revises its schedule, it will recollect the claims of this universal favourite, whose exquisite symmetry of form and brilliancy and delicacy of colour make it so deservedly a ladies' flower.

The varieties which we now figure are *Fidelia* (fig. 1) and *Linden* (fig. 2). We think that there are few persons but will acknowledge that such lovely flowers ought to be extensively cultivated.

1

2

J. Andrews, del. et lith.

Vincent Brooks, Imp.

We are already indebted to Japan and Northern China for some of the most beautiful and hardy of our flowering shrubs, many additions having been made of late years to their number through the unwearied labours and intelligence of Mr. R. Fortune and Mr. J.C. Veitch, and we think that the plant which we now figure is likely to prove another valuable addition; indeed, we have heard the opinion expressed by some most experienced growers of plants, that it is the most valuable of the hardy plants which we owe to those gentlemen.

When we consider how universally popular evergreen shrubs are, and to how many purposes they may be and are applied, any addition to the flowering kinds must be hailed with much satisfaction. Now the Raphiolepis which we figure possesses many qualities which entitle it to consideration: "it grows," as we are informed by Mr. Veitch, to whom we owe its introduction, "to the height of eight to ten feet, and forms a very handsome shrub; the leaves are large, ovate, and of a dark glossy green colour; the flowers are white, and produced in spikes, four to six inches long; they are moreover sweet-scented, and they are succeeded by dark, glaucous-purplish berries, much resembling those of the Portugal Laurel, so that whether in foliage, flower, or fruit, it is attractive; no wonder then that," Mr. Veitch adds, "we consider it to be one of the very best of the evergreen shrubs recently introduced."

The landscape gardeners of another generation will certainly have great facilities for carrying out their plans, when the new trees and shrubs, plain and variegated, become more widely distributed and more generally known; they will not fail to add a greater charm to those gardens and parks which are already one of the horticultural glories of our country; even now we see what the *Deodars*, *Araucarias*, *Wellingtonias*, etc., are doing in this respect, and will be still further manifest when we get such shrubs as *Raphiolepis ovata* into general use.

J. Andrews, del. et lith.

Vincent Brooks, Imp.

Rhododendron, Prince of Wales
(Rollison's)

About sixteen or seventeen years ago, Messrs. Rollison, of Tooting, received from their Collector, Mr. Henshall, a new Rhododendron, which has been known since amongst growers of stove and greenhouse plants as *R. javanicum*; he found it on Mount Salak, in the island of Java, at a range of from 4000 to 7000 feet on the volcanic range of hills which runs throughout the length of the island; it was in some instances epiphytal, but more frequently it was found on the sides of the mountain, forming a shrub from seven to ten feet in height. This fine variety was figured in the 'Florist' for 1852, a period when Dr. Hooker's Sikkim Rhododendrons were exciting considerable expectation.

Considerable difference of opinion existed as to its proper treatment. Mr. Cole, then gardener to Mr. Collyer, of Dartford, one of the best plantsmen of the day, had treated it as a stove plant, and under such treatment it had so well thriven, that he was enabled to grow it into a good specimen-plant in the course of two years. The Messrs. Rollison, we are told on the other hand, treated it as they did their Indian Azaleas, and under this it also flourished. In the hands of so thoroughly practical and scientific a firm it was not likely to remain, however, under these doubtful conditions; it was used for hybridizing, and one of the results of their success is the very beautiful variety which we now, through their courtesy, have the pleasure of figuring, as the result of a cross between it and *Rhododendron retusum*, which they have named *Prince of Wales*, and describe as a conservatory or greenhouse plant, a showy and beautiful variety, with good foliage.

The various species of this genus, whether they are hardy or not, are to be regarded as plants of great beauty and excellence; those which have been sufficiently hardy to stand our winters also endure a considerable amount of soot and smoke. One of the most interesting sights that we ever recollect seeing was at Saltwood, near Hythe, in Kent, in the grounds of Archdeacon Croft; in a small valley at the end of his shrubbery, in the centre of which was a piece of water, were planted a large number of what are ordinarily termed American plants. Rhododendrons, Kalmias, Azaleas, etc., completely filled the space; a thick fog had, however, obscured the valley, but when, as the warm June sun dispersed it, the whole gradually burst upon our view, a more beautiful sight could not possibly be imagined.

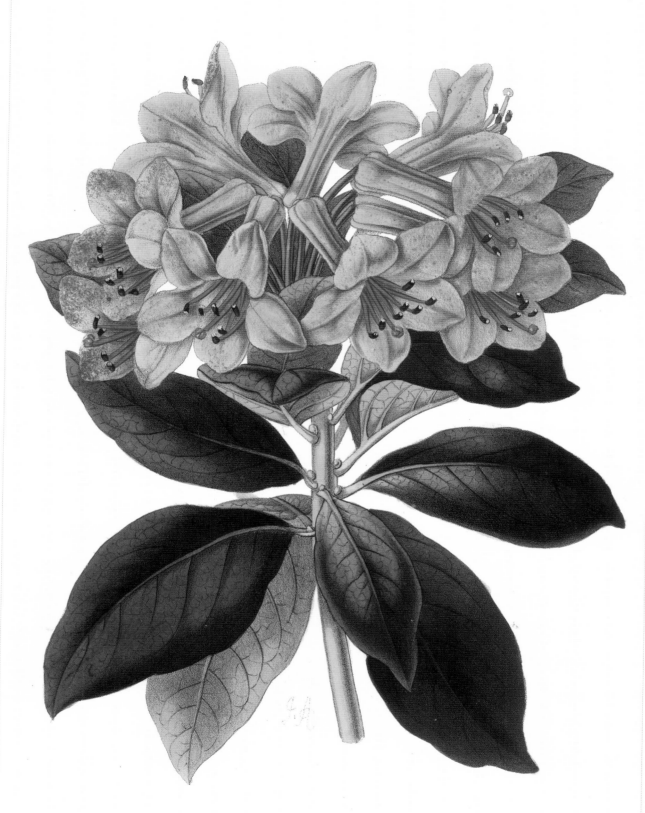

J. Andrews, del. et lith.

Vincent Brooks, Imp.

The raisers of both hardy and greenhouse Rhododendrons seem to be vying with one another as to who shall produce the greatest novelties in their respective classes, and our pages testify with what great success; Mr. Rollison's *Prince of Wales* and Mr. Veitch's *Princess Alice* amongst the more tender kinds, Mr. Prince's *Countess of Devon* and Mr. Young's *Princess of Wales* amongst the hardy ones which we have already figured, displaying great variety of colour and beauty of appearance; while that now presented to our friends in the exquisite drawing of Mr. Andrews will show that the improvement has by no means reached its limit.

Messrs. Veitch and Son, of Chelsea, are the fortunate raisers of this most beautiful variety, and to them we are indebted for the opportunity of figuring it and also for the following notes concerning it: – "*Princess Helena* is a seedling, reared from *Rhododendron jasminiflorum*, crossed with a scarlet species imported by us, but never sent out. The tubes of the flower are much longer than in any other variety that I know, and the flowers are of a more glossy colour than in any that we have before obtained. It is a very free bloomer, and I am confident will be a great acquisition. It is of course more nearly like *Rhododendron Princess Royal* than any other, but it is quite distinct from that variety in shape of flower, habit, and foliage, as well as colour." It will be seen that the colour both of the tube and lobes of the flower are of a delicate soft pink, striped with darker shades of the same colour and most delicately tinted. The foliage is of a rich dark glossy green, which throws up the colour of the flower with great effect, and altogether we must concur in the very high estimate which as been formed of it by the Messrs. Veitch.

The cultivation of greenhouse Rhododendrons calls for little remark, and we should think must be pretty generally understood; yet the plants which are exhibited from time to time in collections do not seem to manifest that skill which we might expect. Probably the more free-flowering character of many of the new varieties may lead to our seeing better plants, as they can thereby be exhibited in dwarfer character than the older ones; and if the ideas of exhibiting plants in a more natural form than they have been of late years are carried out, some of these fine showy flowers may take the place of many of the *weedy* plants, which are only tolerated because they will bear twisting and torturing to any extent.

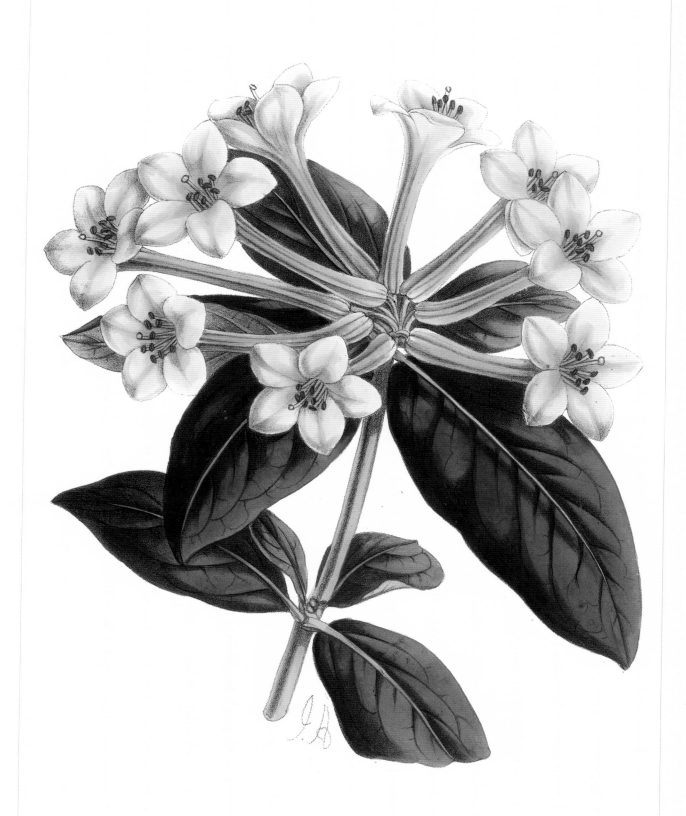

J. Andrews, del et lith.

Vincent Brooks, Imp.

Rhododendron, Princess of Wales (Young's)

The county of Surrey has long been famous for the successful manner in which what are ordinarily called American plants are cultivated there, the names of Standish, Godfrey, Waterer, Noble, and others having obtained a world-wide reputation; nor is it simply in their cultivation that they have been so successful, but also in originating new varieties, – more especially has this been the case with the Rhododendron, a large proportion of the kinds which appear in our catalogues having been raised there. To these successful hybridizers we have now to add another name; Mr. Young, of the Milford Nurseries, near Godalming, having justly won his right to take his position amongst them, – a fact, we think, sufficiently apparent from the beautiful variety which forms the subject of our Plate having been raised by him. He has also raised another most desirable kind, *Prince of Wales*, which we regret not being able to figure at the same time; but where the truss of bloom occupies so large a space, it is impossible to do so.

The claims of the Rhododendron as an ornamental shrub have not been as much regarded as they ought to have been, many persons imagining that unless they have a peaty soil it is impossible to attempt their growth. This is a mistake; they will, of course, flourish best in such a soil, as their luxuriance in the peaty hills of Surrey abundantly testifies, but they will also thrive well in many soils when not of a very heavy nature, and even then the addition of peat and sand (which by the aid of railways can now be procured almost everywhere) will enable them to be cultivated with a very fair share of success: we have ourselves found that the drying easterly winds near the sea are a much greater obstacle to their growth than anything in the soil. When grown in such situations, they must be carefully protected from the wind by other trees or by artificial protection.

Rhododendron *Princess of Wales* is well described by its raiser as quite a novelty: the truss is compact, and the individual flowers of good substance, while the foliage is dark glaucous green, and the whole character of the plant very effective. *Prince of Wales* is a brilliant rose shaded with purple, with black marking on the upper petals. Both are late-flowering, the latter being in full bloom at the end of June. They thus possess the necessary requisites of a first-class Rhododendron, and are unquestionably desirable additions to this noble class of hardy evergreen shrubs.

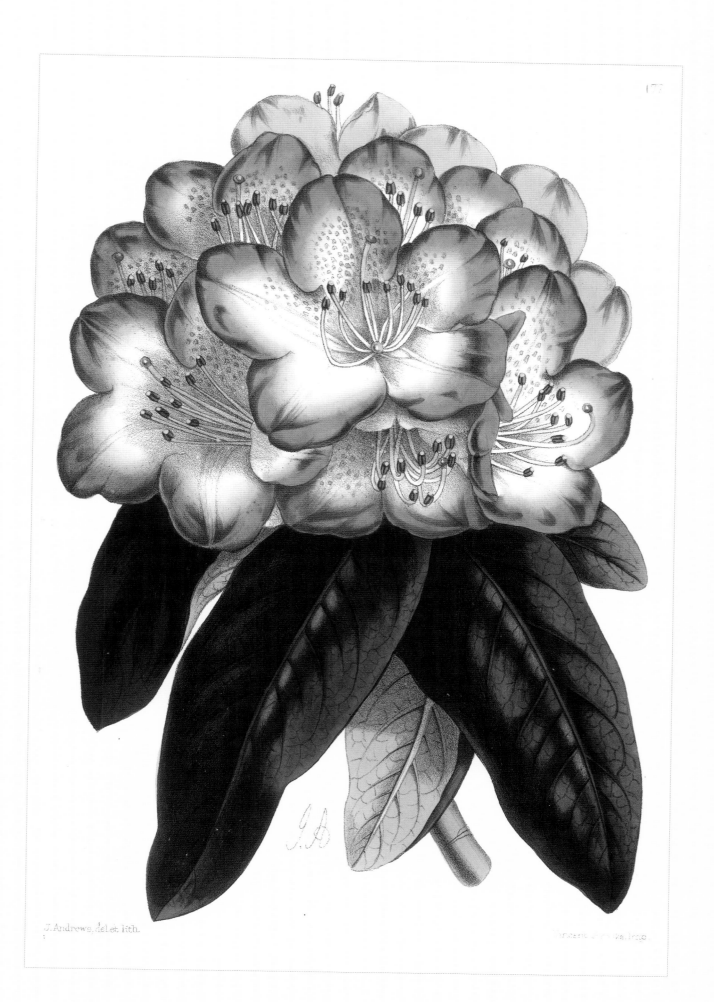

J. Andrews, del. et lith.

A Rhododendron! would be, we doubt not, the involuntary exclamation of any one on first seeing this remarkable species, far more resembling, in its flowers at least, a Correa or Thibaudia than any of those many varieties of Rhododendron known to our gardens or greenhouses. It was exhibited at a meeting of the Floral Committee in May of the present year, and attracted a good deal of attention from its "variety, beauty, and remarkable form;" and a first-class certificate was awarded to Mr. Wm. Bull for it.

A somewhat interesting notice of it appears in the 'Scottish Farmer,' in which the writer questions, whether "it be really a new species, but a specimen of the rare *Rhododendron Keysii* at a less advanced state of flowering than that from which Sir Wm. Hooker took the drawing of *R. Heysii* figured in the 'Botanical Magazine,' t. 4875; at the same time we admit that this is not altogether clear, and that Mr. Bull has better grounds for holding his specimen to be a distinct species than the makers of many species which have never been challenged." The writer then proceeds to notice the peculiarities of each of the two varieties, and especially remarks on one remarkable distinction, viz. that *R. Keysii* has the trusses of flowers on the old wood, while those of *R. Thibaudiense* are terminal. We believe that the opinion of English botanists is in favour of their being distinct.

"We do not know," the writer adds, "any Rhododendron which more directly and, as it were, by its mere outward appearance, vindicates the title of the genus to be classed among the Heaths. It is no uncommon thing to hear non-botanical horticulturists wonder what Rhododendrons have in common with Heaths, except liking a peaty soil. If we could show them this plant in flower, no other answer would be needed. No great heat is required in its cultivation; it was in a cool greenhouse covered with a Vine that the plant which Sir Wm. Hooker described was grown. Mr. Bull's treatment of his plant was also what is called cool treatment – protection from frost or cold, but very moderate heat."

Rhododendron Thibaudiense is a native of Bhootan, from whence so many forms of the genus have been introduced.

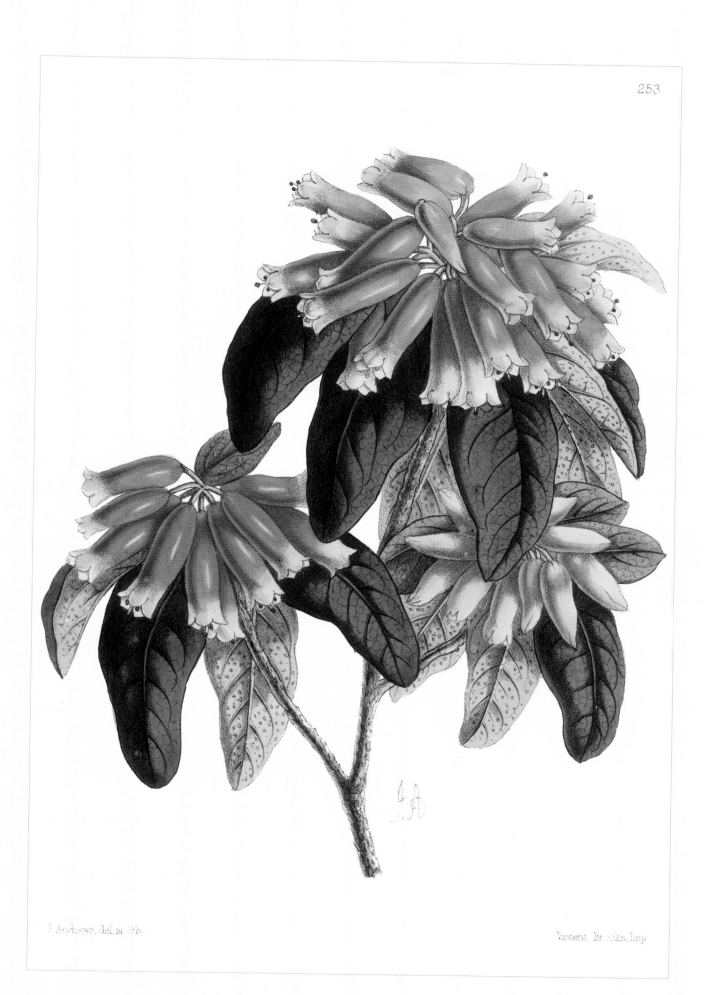

J Andrews, del. et lith

Vincent Brooks, Imp

As no flower is so extensively cultivated as the Rose, we feel that there are few, if any, of our subscribers who will not feel an interest in seeing some of those new varieties which from time to time are introduced by either home or foreign raisers of seedling flowers; and as we have lately figured an interesting variety of English origin, we now give one of the best French varieties of the past season, a flower that doubtless will appear in many a winning stand at the exhibitions of the present year.

It has been frequently observed, and with a great amount of truth, that it is very difficult to form a correct judgment of new Roses, from the blooms exhibited during the first season, when they only appear in the stands of some of the leading growers, for sale; when, however, a flower has acquired a good name when first shown, it is rarely that it loses it afterwards, although many flowers have had to endure neglect for the first season, their merits being only discovered later; and hence, when judgments are passed on new flowers, it very often happens that lovers of the Rose in various parts find fault with it. We may, with perhaps but little fear of being very far wrong, consider the following as amongst the best of the seventy or eighty varieties of last year: – *Alpaïde de Rotatier*, clear rose with satin-like gloss; *André Leroy d'Angers*, rich dark velvety purple; *Duchesse de Morny*, a fresh pale-rose, reverse of petals silvery, shape excellent; *Claude Million*, an imbricated crimson-scarlet flower; *Kate Hausburg*, clear rose-coloured flower; *Eugène Verdier*, deep violet-purple, of excellent form; *Madame Derreulx Douvillé*, bright pink or tender rose, shape excellent, and large, very free blooming; *Madame Victor Verdier*, a bright cherry-red, figured by us last year; *Pierre Notting*, deep blackish-red, of good form and substance, one of the best Roses of the year. There are others which are well spoken of, but we have not had an opportunity of seeing them, and without that it is impossible to form an opinion, the description of the French raisers being of a most high-blown character.

Bernard Palissy, raised by our friend M. Margottin, of Bourg la Reine, near Paris, is a seedling from that fine flower of M. Margottin's raising, *Jules Margottin*, but it differs from it very much in shape, being an expanded Rose, somewhat flat, instead of being cupped, the colour is a bright reddish-carmine, the habit of the plant is excellent, and we are convinced the flower will add to M. Margottin's fame as a raiser.

J.Andrews, del. et lith.

Vincent Brooks, Imp.

When we were in Paris last year M. Eugène Verdier brought to us the blooms of a Rose which, in our opinion, was one of the best that we had seen, and we are glad to find that both on the Continent and at home this opinion has been endorsed by some of our most celebrated rose-growers, for on all sides it has been brought under our notice. We saw it very fine at Lyons; a very beautiful row of it at Vitry, near Paris, was very attractive; while in many of our winning stands of new roses this year it occupied a prominent place; and it was only the other day that in going over Mr. Frazer's, of Lea Bridge Nursery, his rose foreman pronounced it to be one of the very best roses of the year. It is the rose we now figure.

We have been of late years so inundated with roses of the crimson class (the greater portion of them being the issue of *General Jacqueminot*) that the raisers of new roses on the Continent seem inclined to turn their attention more to the lighter-coloured flowers. There is no doubt that we want roses of this class and also white flowers (a class in which we are still very deficient), and hence we were glad to notice during a visit paid lately to the rose gardens of Lyons and Paris, that the most promising roses of the year are the lighter-coloured ones; while we think that few flowers of the present season will take a higher position than the one we now figure and *Joséphine Beauharnais*, a seedling of *Louise Peyronney*, and strongly marked with the character of that fine flower.

Miss Margaret Dombrain was, as we have said, raised by M. Eugène Verdier, and is a seedling of that fine old rose *La Reine*. It is a flower of large and globular form; the colour is a bright rosy-pink, somewhat between its parent *La Reine* and *Comte de Nanteuil*; the petals are large and the flower very full; the foliage ample, and the flowers borne well above it. Like its parent it is at times somewhat difficult to open, although not to the extent that *La Reine* is, and in the row we saw at Vitry there was not one unexpanded bloom; despite this, we believe it will be found to be one of the best (if not the best) roses of the present season.

J. Andrews, del. et lith.

Vincent Brooks, Imp.

That our English rose-growers are determined not to allow the French nurserymen to have all the honour and profit of introducing new Roses has been already demonstrated; and we can now with some degree of confidence appeal to our judgment in this matter, as having been abundantly confirmed by the experience of the past season, – those which have already been figured by us, *John Hopper* and *Lord Clyde*, having taken a prominent position at the various rose-shows held throughout the kingdom this year. We have now great pleasure in adding another to the list, with the belief that *King's Acre* will prove a worthy compeer of the two already named.

The continued drought of the past summer acted very injuriously on the autumn blooming of the Rose: in some very extensive rose-grounds that we visited in the latter part of August the flowers were very scarce and very much out of character, and the autumn exhibition at the Crystal Palace bore testimony to the same fact, even although the copious rain had put an end to that long season of dry weather which had previously prevailed. It was then with no little surprise that about the middle of August we received a box of very beautiful blooms from Mr. Cranston, the well-known rose-grower of King's Acre, Hereford. There was something so fresh and beautiful about them, the colour was so bright and fresh, and the shape was so good, that we immediately hailed it as a valuable addition to our English-raised Roses. It was accompanied by a note from Mr. Cranston, stating that the habit of the plant was very vigorous, the foliage large and good, and that it had withstood, as a seedling, the terrible winter of 1861. He also added, what we can well believe, that during the proper Rose season it was far finer than when we saw it, and that it was in truth a superb Rose.

We may here say that, amongst the new Roses of the past season, we have, in addition to those mentioned in a previous number, seen very fine *Pierre Notting* and *Kate Hausbury*; but from the large number of flowers sent over we do not think that above six or seven are likely to obtain a permanent place in our rosaries.

Mr. Cranston says: "*King's Acre* is a fine bright vermilion rose; reverse of petals satiny; the flowers are extra large, cupped, of remarkable depth, and exquisitely formed, having large, smooth, shell-shaped petals of fine substance; the foliage is ample, and of a fine rich dark-green colour; the habit of growth is vigorous and robust, flowering abundantly and throughout summer and autumn."

J. Andrews, del. et lith.

Vincent Brooks, Imp.

When visiting the well-known establishment of M. Margottin, at Bourg-la-Reine, near Paris, the autumn before last we were particularly struck with a new Tea-Rose; its bold and vigorous growth, and the erect manner in which it bore its flowers up, augured well for its future popularity.

We need not say how much valued Tea-scented Roses are by not only those who grow collections of the Queen of Flowers, but by every one for whom flowers have any charm. There is so much delicacy of colour and such exquisite fragrance in them, that this is not to be wondered at. To our mind, there is hardly anything in the wide range of Flora's dominion more lovely than an opening bud of *Devoniensis*; its shelly wax-like petals, and the beautiful tinge – sometimes of blush, at others of delicate yellow – in its centre, combined with its beautiful form, tend to make it, what it is indeed, a perfect gem. There are others, such as *Elia Sauvage*, *Madame William*, and *L'Enfant Trouvé*, whose beautiful tints of yellow are unequalled, save in that most capricious (but when obtainable) grand Rose, *Cloth of Gold*. We have not, it is true, obtained bright colours amongst them as yet, but amongst the dreams of the future we may anticipate a Tea-Rose with the form and fragrance of *Devoniensis* combined with the colour of *Géant des Batailles* or *Eugénie Appert*. It would wellnigh make the fortune of the raiser.

The first Rose of this group was introduced, we believe, from China about the year 1810, and since then, by carefully hybridizing, a large number of varieties have been obtained. Many of these, though much lauded in their day, have passed out of growth, having given way to better and more vigorous kinds, for this is the most difficult of all the groups to grow. We must, however, except such Roses as *Gloire de Dijon*, which is without doubt one of the hardiest Roses grown, having stood the severe winter of 1860-61, when all other Roses were utterly destroyed.

The more general method of growing them is in pots, and we have found during the summer that no place is better adapted to their growth than a tiffany-house: the shade is grateful to the tender shoots, which are apt to get scorched, and in boisterous situations to be bruised by the wind. In winter they will require the protection of glass.

Comtesse Ouvaroff is a fine erect-flowering Rose. In colour it is a beautiful soft-shaded rose; but no description can give so good an idea of it as Mr. Andrews's faithful portrait.

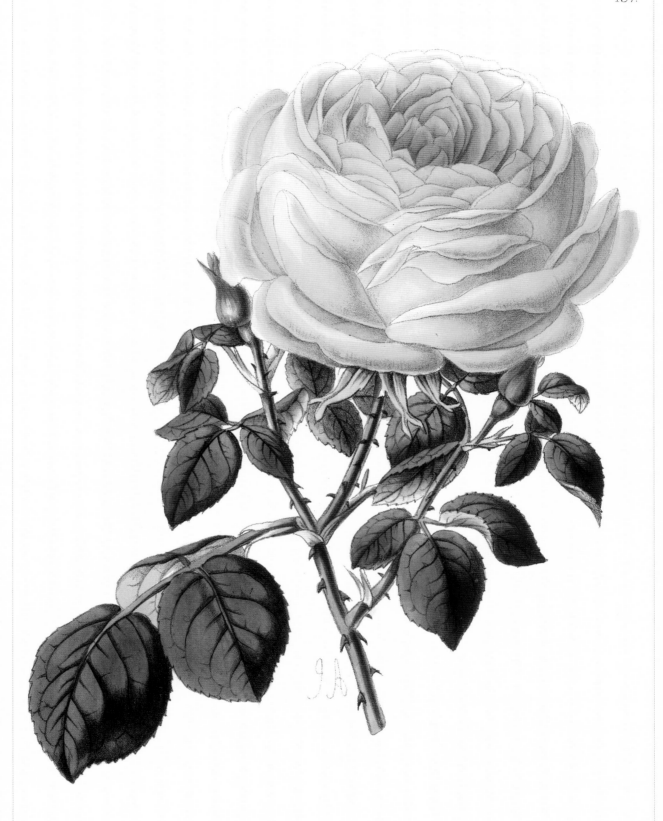

J. Andrews, del. et lith.

Vincent Brooks, Imp.

One of the most remarkable things connected with the recent discoveries of botanical treasures in Japan by Mr. R. Fortune and Mr. H.J. Veitch was the immense variety of variegated plants which were there cultivated. This variegation was to be seen not only in shrubs of all kinds, – for there were variegated Camellias and Tea-plants, – but in forest trees, the beautiful *Thuiopsis dolabrata variegata* for example; while *Retinospora*, *Osmanthus*, *Acer*, and other fine trees were found with golden and silver markings, and even such humble things as the Saxifrage, – almost justifying the statement of Dr. Siebold, that he could make a variegated form of any plant.

It is surely strange that while we, with our advanced tastes on the subject of horticulture, are only just now beginning to see the advantage of introducing these variegated forms into our landscape gardening, for centuries this singular people have been quite alive to their value, and have cultivated so many forms of variegated plants, many of which, if proved to be hardy in our climate, will be very valuable; and great as are the treasures which have been brought to us by the indefatigable labours of our countrymen, there is good reason to hope that the recent operations in Japan, the opening-up of the inland sea, and the greater facilities likely to be given to European enterprise, may be the means of adding still further to our list of useful and beautiful things, – not so much so perhaps as in other countries, for the Japanese being great lovers of gardening, are likely enough to have obtained from their own country those things most useful to them, as well, as we know they have done, importing them from other countries.

The humble little Saxifrage is a general favourite amongst cottagers, where suspended in the window it grows vigorously and freely; its place is likely, we think, to be supplied ere long by the curious and pretty *Saxifraga Japonica tricolor* we now figure; the beautiful and bright variegation of the leaves varying from white to bright pink, with the under side of the foliage a lightish crimson, being likely to make it a general favourite. Its cultivation will be of the very simplest character, but care must be taken not to pot it into rich soil, for the tendency will be then to return to the plain-leaved form; it is also easily propagated, producing as it does many little plants in the form of runners, in the same manner as the older and well-known plant.

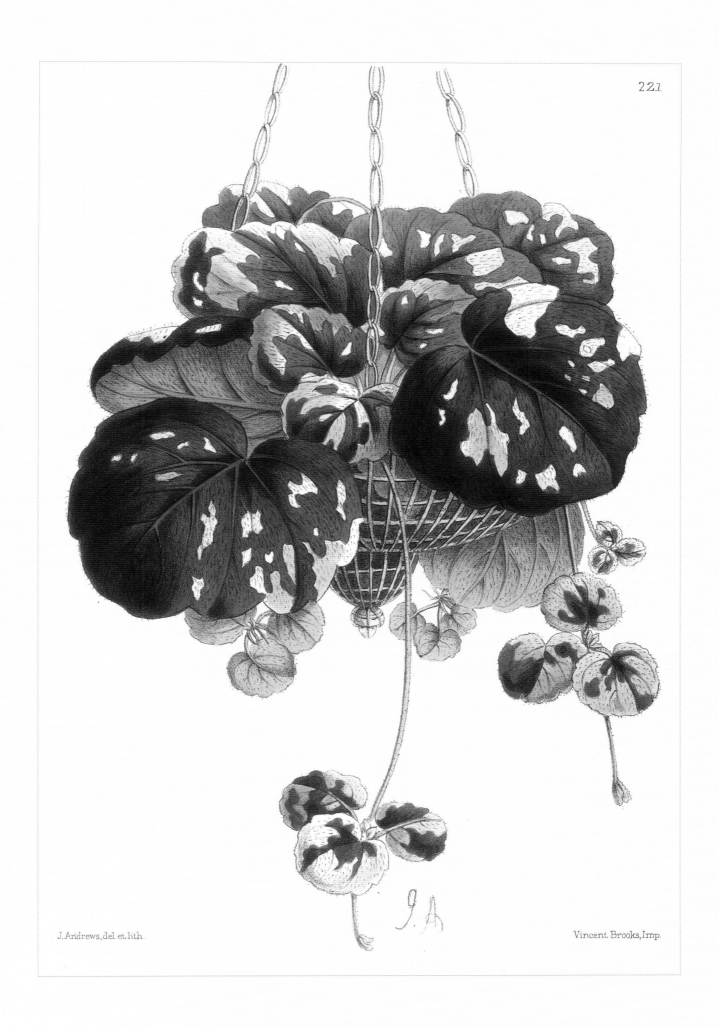

J. Andrews, del. et lith.

Vincent Brooks, Imp.

Many of the species of Siphocampylus are already known as useful, stove European shrubs, producing flowers of a brilliant colour, and continuing a long time in bloom; and from what we have seen of the species now figured, we believe it is likely to prove a much more effective one, in these respects, than any of those hitherto known.

As the taste for flowers increases, and the desire for them for the various decorative purposes for which they can be used extends, it becomes more than ever necessary to have a supply of such plants as will best meet these wants. People generally have but little idea of the extent to which this is carried, and of the immense supply that is necessary to meet this growing demand. Whole establishments in the neighbourhood of both London and Paris are devoted to the production of forced flowers, while the quantity required for cut blooms would seem absolutely incredible, hence flowers that give a profusion of bloom and that continuously, must supersede those which merely produce a few flowers now and then; gardeners will soon discover which are most likely to be of use to them, and we believe the plant now figured is likely to be of that character.

Siphocampylus fulgens, for the opportunity of figuring which we are indebted to Mr. Bull, of Chelsea, is described by him as "a free-flowering effective plant, introduced from South America, and is a great acquisition to our stoves, for it perpetuates its showy blossoms nearly throughout the year. It is of compact habit, foliage dark green, ovate, acuminate, the blossom rich orange-scarlet, with yellow throat; being such a free bloomer, and producing its attractive flowers over such a lengthened period, it is a most desirable decorative plant, added to which, its flowers are extremely useful for bouquets." This latter point, in the winter months, greatly increases the value of the plant.

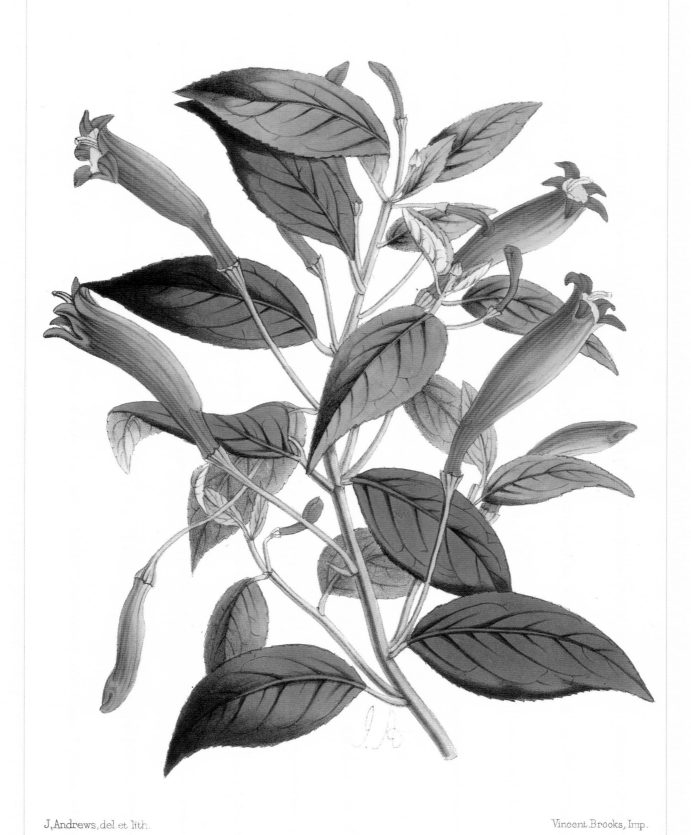

J. Andrews, del et lith.

Vincent Brooks, Imp.

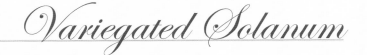

Among the requirements of modern society, which demand the attention of horticulturists, one of the newest has been that of plants for the decoration of the dinner-table; the ponderous epergues and centre-dishes formerly in vogue are giving way to the more natural and equally beautiful flowering and berry-bearing plants which have for some time been used in various parts of the Continent; and we feel sure that it is a taste that every lover of nature will ardently wish may become more and more popular.

During the past season somewhat of an impetus was given to the taste, an offer having been made by a Fellow of the Royal Horticultural Society, of a prize of five pounds for a collection suitable for the purpose. These collections were staged at the September show of that Society, but we cannot say that the results were such as we should have anticipated, and regret that a prize was awarded at all; it would have, we think, led to greater improvement, if, as in the case of tubs for the conservatory, it had been withheld, for the conditions required by the donor were certainly not fulfilled in those which obtained it. The plants ought to be grown on single stems, and the foliage to be of sufficient height not to interfere with the guests, – points which were certainly absent in those which obtained the prize; it has had the effect, however, of setting many thinking on the point.

The plant which we have now figured (anxious as we are to afford our readers an opportunity of seeing the best things suitable for each branch of popular gardening) is a variegated variety of *Solanum capsicastrum*, the bright-orange-red-coloured berries, and the clean neat-looking foliage, making it very suitable for the purpose: it has been introduced to the horticultural world by the enterprising firm of Messrs. E.G. Henderson and Co., of St. John's Wood; is of very easy culture, and grows well as a standard. They also suggest its use as an edging plant.

The following plants have been recently recommended in the 'Journal of Horticulture' as suitable for the purpose: – *Rivina lævis, Callicarpa purpurea, Thyrsacanthus rutilans, Cactus truncatus, Dielytra spectabilis, Begonia fuchsioides, Ardisia crenulata, Amaranthus melancholicus ruber, Coleus Verschaffeltii, Poinsettia pulcherrima, Pandanus Javanicus variegatus, Cyathea dealbata, Cyathea Smithii, Pteris argyræa, Pteris tricolor*, and many other of the Ferns; and individual taste will suggest many others.

J.Andrews,del.et lith.

Vincent Brooks, Imp.

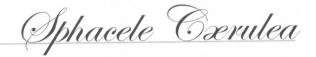
During the last autumn, Mr. Bull, of Chelsea, had in his establishment a plant which attracted the attention of all who visited it, it was so profusely covered with bloom, and was evidently so free in habit and so easily managed; although only in an 8-inch pot, it had thirty-seven spikes of bloom on it of a delicate lavender blue, and believing it to be likely from its character and season of blooming to be a useful plant, we have figured it in our present Plate.

The demand for flowers for decorative purposes, both for drawing rooms and also for bouquets, is now so great, that it is almost impossible to keep pace with it, and a curious statement appears in a late number of the 'Revue Horticole,' of the clever manner in which turnips and beet-roots are made to do duty as Camellias in the Paris markets. In London the demand is continuous, although reaching its height in the season from Easter to the end of June, when fortunately flowers are more plentiful; but at Brighton, where the season is from October to Christmas, it required a great deal of ingenuity to adapt the different flowers to that season for blooming, and we were much struck some years ago with the manner in which the Brighton nurserymen were able to cater for the demand of their customers both in fruit and flowers. For all such purposes, we cannot doubt that this plant will be found very useful, especially for its colour; it is easy to get flowers of different shades of red, pink, crimson, etc., but blue flowers are more scarce. Mr. Bull says of it, that it is a useful winter-blooming plant. It is soft-wooded, with thick ovate serrated foliage, and if cultivated in a warm greenhouse, produces its pretty blue flowers all through the winter in the most abundant manner."

Sphacele cærulea is amongst the new plants introduced by Mr. Bull during the present season, and to him we are indebted for the opportunity of figuring it.

J. Andrews, del. et lith.

Vincent Brooks, Imp.

New Holland, so rich in flowers belonging to the class to which Swainsonia belongs, has already contributed some very beautiful plants of this genus, one of which we figured in our former volume, and we have now the pleasure of adding this very delicate and bright-coloured species to our illustrations; for the opportunity of doing so, we are indebted to Mr. B.S. Williams, of the Victoria Nursery, Holloway.

The seeds of *Swainsonia magnifica* were received by Mr. Williams from Australia with some other miscellaneous seeds, and first flowered with him in 1863. It was then considered sufficiently good to merit a further trial; and when it flowered in 1864, proved to be quite distinct from any other Swainsonia known. "The flowers are large as *Clianthus magnificus*, while the soft graceful growth of the Swainsonia adds greatly to its beauty. It produces its long pendent racemes of delicate bright-coloured pink flowers very abundantly, and is well adapted for a cool greenhouse, either grown as a specimen plant, or planted out in a border for pillars and trellis-work." When grown from seed, it is better to soak the seeds slightly in warm water, if they have been kept any time; but if sown as soon as ripe, this will be unnecessary; they should be placed either in a stove or slight hotbed. The soil which is best suited to these young plants (which should be potted off as soon as sufficiently strong for the purpose) is half-fibrous loam and half peat, together with a good proportion of silver sand.

We think that there can be but little doubt that the Swainsonias, and many of these Australian plants, would succeed in some of the sheltered nooks of Devonshire and Cornwall in the open air, against a south wall, as we have seen many of them growing and flowering freely at Angers, in France; and if, as we are told, *Banksia*, and such-like plants, succeed there, why should not the Australian climbers also? There is no doubt that the increased desire to obtain effect in our gardens will contribute to such results.

J. Andrews, del. et lith.

Vincent Brooks, Imp.

There are some flowers which are popular because of their rarity, and others because of their commonness, and a few perhaps for the associations that are connected with them; for there are few things with which the memory of past days is more thoroughly connected than some of our commonest flowers. The garden of our childhood, the place where we have gathered some and seen others growing, are amongst those things which cling the closest to us; and few flowers are in the latter sense more popular than the Sweet-William.

But we should not for such reasons as these have decided on figuring this pretty flower, but because it has shared, amongst others, the skill and energy of the hybridizer, and can boast of great improvement and progress. Some years ago it was taken in hand by Mr. William Hunt, of High Wycombe, who established for himself a reputation connected with the flower, having obtained both brilliancy of colour and rotundity of form. Since then various other growers, both in the north and south of England, have followed in the same course, and from time to time many beautiful stands have been exhibited at the various horticultural exhibitions, where they have always attracted great admiration. The stand exhibited by Mr. Hale, of Stoke Pogis, near Slough, was amongst those florists' flowers so much admired by the Princess of Wales at South Kensington in July last, and from it we have selected two varieties for our illustration.

Like the Calceolaria, there is no necessity for obtaining varieties, for from a package of seed as good flowers can be obtained as from cuttings, and hence the value of these improved sorts; and then they are so perfectly hardy that they may be left very much to themselves. The seed requires to be sown in summer, and when the young plants are sufficiently large to handle they should be pricked out into a seed-bed, and then again removed to the place where they are to bloom. Like every other plant, however hardy it may be, it is sure to compensate the grower for any extra trouble bestowed upon it. A careful preparation of the soil, and attention to weeding and watering, will always ensure a finer bloom; treated in this way, it will continue to produce in succession fine heads of bloom; and although deficient in that which many of its allied species possess in perfection, fragrance, it yet, by its masses of flower and splendour of colour, compensates for this defect.

J.Andrews, del.et lith.

Vincent Brooks, Imp.

When we can say of a new greenhouse creeper that it bids fair to rival, if not surpass, the lovely *Lapageria rosea*, we are perhaps giving it the very highest praise it is in our power to offer, and this may safely, we think, be said of the very beautiful flower which we now figure, and for which we are indebted to Mr. Prince, of the Exeter Nursery, and we cannot do better than give his description of their treatment of it.

"Our plant, which is now twenty feet long, with numerous branches, is growing in a mixture of rough peat, loam, and coarse sand, with abundance of drainage, and plenty of pieces of broken brickbats, crocks, sandstone and old lime rubble mixed in with the soil. Occasional syringing and copious supplies of water to the roots during the summer and autumn promote luxuriant growth. It may be requisite now and then to cut back vigorous shoots which have flowered, in order to bring up fresh flowering stems. From the pendent position of the flowers, it is obvious that this beautiful climber can be seen to better advantage trained to a rafter on the roof of the conservatory than if put up against a wall. I have alluded to its comparative hardiness, in support of which, and in addition to the general lowness of the temperature of our show-house, I may say, in conclusion, that we had a plant of it growing luxuriantly on an eastern wall out of doors all last summer and autumn."

The flowers of this beautiful creeper are nearly five inches across. The colour of the sepals and petals, of which there are five each, is a brilliant carmine-crimson. The tube is white, surrounded by a blackish-purple ring; the stamens and pistils protrude from this for two and a half to three inches. These flowers are suspended on long slender footstalks, about a foot in length, so that they hang clear from the foliage, and are described as having the appearance of brilliant parachutes suspended in the air.

M. Van Volxem, who brought it from New Granada to Europe, says that the thermometer often descends in those regions to freezing-point, and hence it might seem, coupled with Mr. Prince's statement, as if it would succeed well in a cool greenhouse; but it is well to add that a writer in one of our contemporaries, who has grown it successfully for two years, questions whether this holds good, except in such a climate as Devonshire, and describes his experience with it, stating that it has flourished best with him in a temperature of from 50° to 55° at night, and on sunny days 10° higher, during the past winter. Wherever it does succeed it will prove a most valuable acquisition.

289.

J. Andrews, del. et lith.

Vincent Brooks, Imp.

The labours of those who visit distant countries in search of new plants are viewed in a different light by the botanist and the horticulturist. The former looks to them as likely to bring some new contributions to the cause of that science he loves so well, – some new species, or rediscovery of some lost one, or some new and abnormal form, which may perhaps bear on a long-cherished theory; while the latter, caring generally but little for these things, is influenced by the beauty or ornamental character of the plants he sees, and (shall we say it?) by their marketable value at home. It sometimes occurs that both are interested in the same production; a plant may be interesting in a scientific point of view, and also valuable for decorative purposes; one such instance is that of the Japanese plant we now figure, through the kindness of our friend Mr. Standish, of the Royal Nurseries, Ascot and Bagshot.

Thunberg's Tricyrtis was exhibited by Mr. Standish, to whom it had been sent home by Mr. R. Fortune, from Japan, under the name simply of *Tricyrtis* (sp.), but has since, as will be seen from the extract we append from the 'Botanical Magazine,' been referred by Sir W.J. Hooker to *Tricyrtis hirta*. It is, as will be at once seen, a very peculiar-looking flower, reminding one rather of an orchidaceous plant, the curiously-spotted flowers being produced in considerable quantities, and rendering it, especially if it be, as supposed by Mr. Standish, hardy, a most interesting addition to the herbaceous border, of which there are symptoms that we shall see a much larger number than has latterly been the case.

"The rediscovery," says Sir W.J. Hooker, in the 'Botanical Magazine,' of the Japanese *Uvularia hirta* of Thunberg, as represented in the beautiful subject of the present plate, enables us to correct the synonymy of the Himalayan *Tricyrtis pilosa* of Wallich, figured in Tab. 4955 of this Magazine, in so far as that plant was erroneously (though doubtfully) referred to this by its discoverer. Dissimilar as the original *T. hirta* is from the *T. pilosa*, it is not easy to seize on any further differential characters than are to be found in its more hairy habit, larger, longer style, pilose ovary, and more numerous and far more beautiful flowers; and the doubtful reference by Wallich, nearly forty years ago, of his Himalayan plant to that of Thunberg (of which he had seen no specimens, and of which neither flowers nor fruit were described), is a remarkable instance of the sagacity of that very distinguished botanist."

"It grows four to five feet high, and the copious blossoms which appear on the axils of all the upper leaves, and which are of a pearly white dotted with clear purple, render it as singular-looking as it is beautiful."

J.Andrews, del. et lith.

Vincent Brooks, Imp.

Tropæolum *Ball of Fire* was raised by Mr. Harman, of Uxbridge, who has a small garden, and raises on this piece of ground numbers of flower roots for the market, and collects seeds to sell again. The plant came up accidentally from seed raised from *T. elegans*, the Crystal Palace bedding variety; the colour being so brilliant, and of that peculiar tint of the *Tom Thumb* Geranium, attracted at once attention. The other plants were removed away, and every chance given to it. Every day brought out its peculiarly high and telling colour. From a distance it seemed, as a gentleman standing by me observed, like a ball of fire, hence its name. It is of the true *elegans* habit, hairy and short-jointed, and a most abundant bloomer; indeed, bunches or little bouquets at the axils of the leaves make their appearance all over the plant, rendering it a brilliant mass of flower, and the flowers stand well up above the foliage. In colour it is brighter than *Eclipse*, or any sort already out, for comparisons have been made for that purpose.

While the Tropæolum is valuable as a bedding plant, it has also other advantages. Cuttings struck early in the summer make very nice plants for pot-culture, growing rapidly, and blooming freely during the winter months. We have some plants of *Eclipse*, which, although struck late, are now, during the dull weather of December, daily opening their brilliant scarlet blossoms. When planted out they grow very freely, requiring a light but rich soil, and the bed or ribbon (for they are used for both) should be carefully gone over every few days, removing superfluous shoots, and training the larger ones; the dwarf habit, however, of *Eclipse* and *Ball of Fire* render this a less needful matter than with some of the older varieties.

The very correct drawing of Mr. Andrews renders any further description unnecessary. He has endeavoured to give an idea of its free-blooming character, but it is impossible to correctly portray its great brilliancy of colour; we are convinced, however, that it will prove as great a favourite next season as *Eclipse* has been during the present one.

J. Andrews, del et lith.

Vincent Brooks, Imp.

We noticed at one of the fortnightly meetings of the Royal Horticultural Society in April, two plants of Tropæolum blooms very neatly arranged and having a most charming appearance, and were not surprised to find that they received a special certificate from the Floral Committee. We were also pleased to see that they had been sent by a new exhibitor, Mr. Williams, of Fortis Green Nursery, for we are always glad to see a new and successful raiser of any description of flower.

The value of the different varieties of Tropæolum has long been recognised, and many of our leading horticulturists have "sent out" varieties of the different sections, some being dwarf and adapted for pot-culture, others being of larger habit and better calculated for covering trellis-work, and others making a brilliant display in the bedding-out system so universally practised.

Those we now figure are of strong growth, and will consequently be fitted for places where it is desired to cover spaces with brilliant flowers and handsome foliage. *Beauty* (Fig. 1) is a large flower of a delicate sulphur-yellow; the petals well formed, and in the centre of each towards the base a deep maroon-crimson spot, contrasting remarkably well with the pale yellow round. *Attraction* (Fig. 2) is of smaller growth; the colour a deep orange-yellow with scarlet blotches, also very effective. In addition to these, we are informed by Mr. Williams that he has a brilliant crimson flower of good habit, called *Sunset*, which will be let out at the same time as those figured. We have no doubt that the acknowledged skill of our various horticulturists will appropriate these to the places most suited for them; and we think that Mr. Williams, by the manner in which he showed them, has given a valuable hint as to the effective manner in which they may be used for dinner-table stands and other decorative purposes of a similar character.

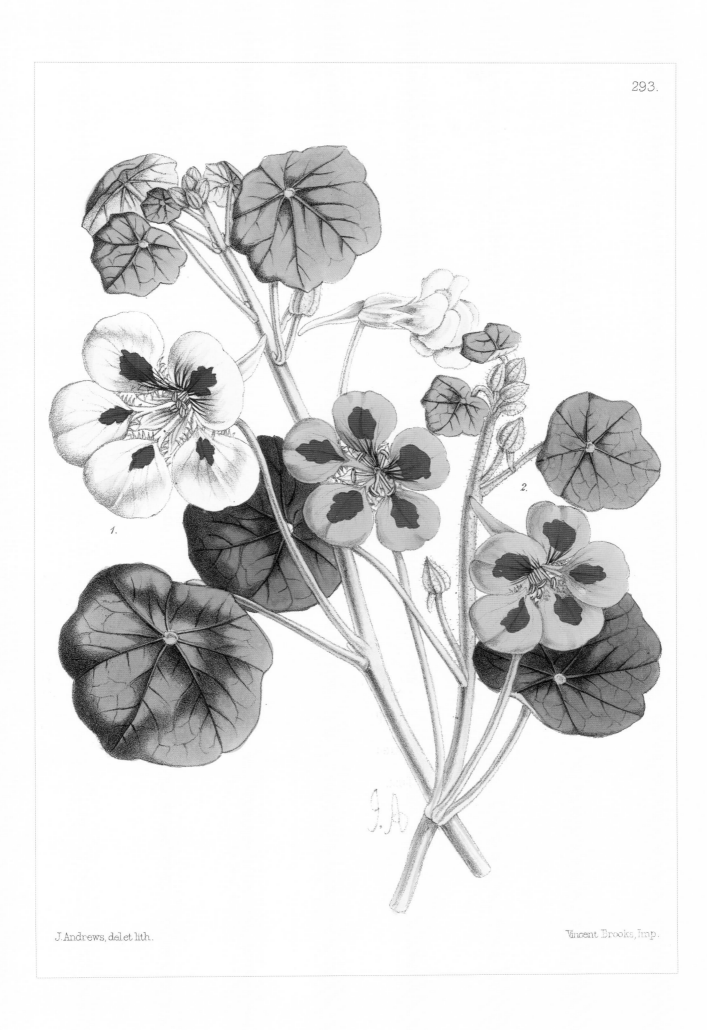

1.

2.

J. Andrews, del. et lith.

Vincent Brooks, Imp.

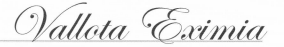
Among those numerous varieties of Cape bulbs which we have had for so long a time in our greenhouses, there is not one more worthy of cultivation than the well-known *Vallota purpurea*; and yet it is not by any means so extensively cultivated as we might have expected, for it presents no difficulty in its treatment, and with even a small number of bulbs a succession of bloom may be kept up for a long period, and that at a time of year when flowers are more scarce than in the summer.

The method of treatment which we have ourselves adopted is of the very simplest character. As soon as the bulbs have done flowering we cut off the flower-stem as low down as possible, and then re-pot them (this occurs generally some time in November). The compost that we use is one composed of good yellow loam and leaf-mould, in about equal proportions, with a good mixture of silver sand. As soon as the bulbs are potted they are gently watered, and placed in the greenhouse, where they will be excluded from frost, and kept in a growing state all the winter, although it will be necessary to be cautious in not over-watering them. They will, it is true, take a good deal, but no plant will endure for long defective drainage. As soon as the days begin to lengthen and more sunlight is obtained, we water more freely, and thus excite their growth. They may, during the summer, be placed in a cold pit out of doors, or in a cool part of the greenhouse, and during this period may receive a plentiful supply of water, and be kept in a vigorously-growing state. As they show their flower-stems they may be brought into the greenhouse or sitting-room, where they will expand their beautiful crimson flowers very rapidly, the number on each stem varying from four to eight, according to the size of the bulb, about half the number being expanded at one time, and with even a small collection we have had bulbs in flower from the beginning of September to Christmas. Another recommendation that this bulb has, is, that it increases very rapidly, throwing off a number of offsets.

The variety of Vallota which we now illustrate is named *Eximia*, was exhibited by Mr. Wm. Bull, of King's Road, Chelsea, at a meeting of the Floral Committee of the Royal Horticultural Society, for whom it obtained a first-class certificate. It is of the same shade of colour as *Purpurea*, and is chiefly distinguishable for its white throat, with crimson feather, not unlike what is seen in some varieties of Gladioli.

There are two classes of persons for whom the raisers of Verbenas endeavour to cater; those who require them for exhibition, and those who only need them for bedding purposes. A variety may be, and very often is, suitable for both; but really show flowers do not, as a rule, make the best plants for out-of-door work. Of the many beautiful varieties raised and exhibited by Mr. Perry, of Castle Bromwich, near Birmingham, few are valuable for out-of-door work; nor can blooms, such as he produces, be obtained except from pot-plants. He used formerly to grow them in frames; but even that, he informed us, interfered with the cleanliness of the bloom, so that now he only grows them in pots.

Amongst bedding Verbenas *Purple King* is the typical plant; and the attempt of raisers of seedlings has been (although, as yet, unsuccessfully) to obtain the same dwarf habit and freedom of bloom in other colours that it presents as a purple flower; while another object eagerly sought after has been to obtain a thoroughly blue flower. There are several which are so called, such as *Mrs. Moore*, *Garibaldi*, *Blue Bonnet*, etc. etc.; but they are either not blue, or their habit is such as to prevent their being of any service as bedding plants; but in the Verbena, which we now figure, Mr. Bull, of Chelsea, believes he has supplied this long-felt want, for his description of it is as follows: – "This unique and interesting variety supplies the long-felt desideratum amongst bedding Verbenas, viz. a really blue variety. This is not only a rich blue colour, but its habit is free, close, and compact, just such as a Verbena ought to be; it will, therefore, be very valuable for that purpose, as well as for ribbon ornamentation, and all out-of-door decoration."

The great variety in colour in bedding flowers, has led to the exclusion of Verbenas of the same shade; but in such colours as these there can be no substitute, and we are therefore glad to welcome what seems to be so valuable an addition.

We have only to add that it will be let out by Mr. Bull in April.

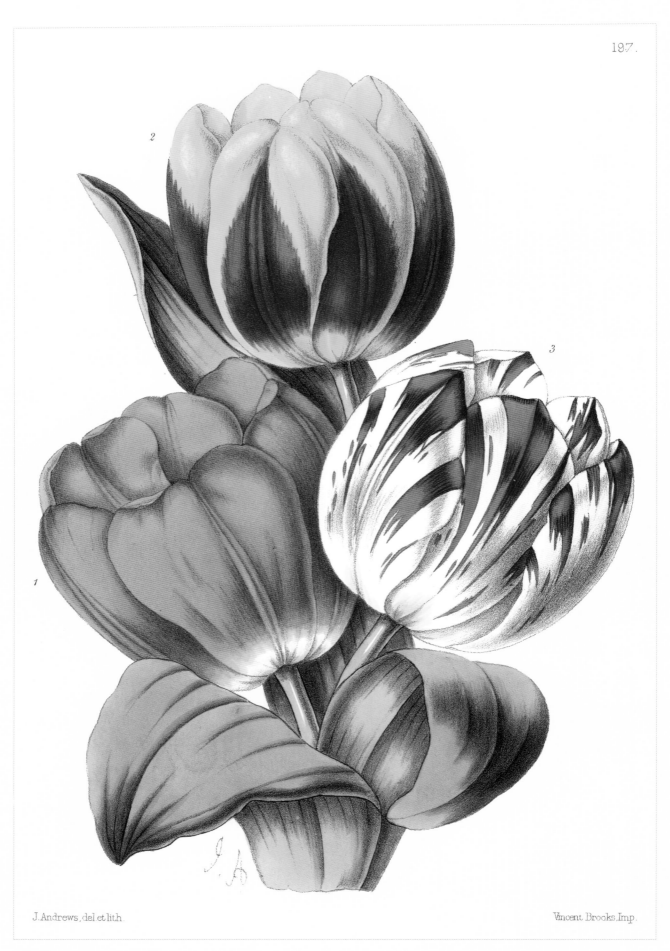

J. Andrews, del. et lith.

Vincent Brooks, Imp.

Varieties of Early Tulips – Proserpine, Keizerkroon, Roi Pepin